Man Ray

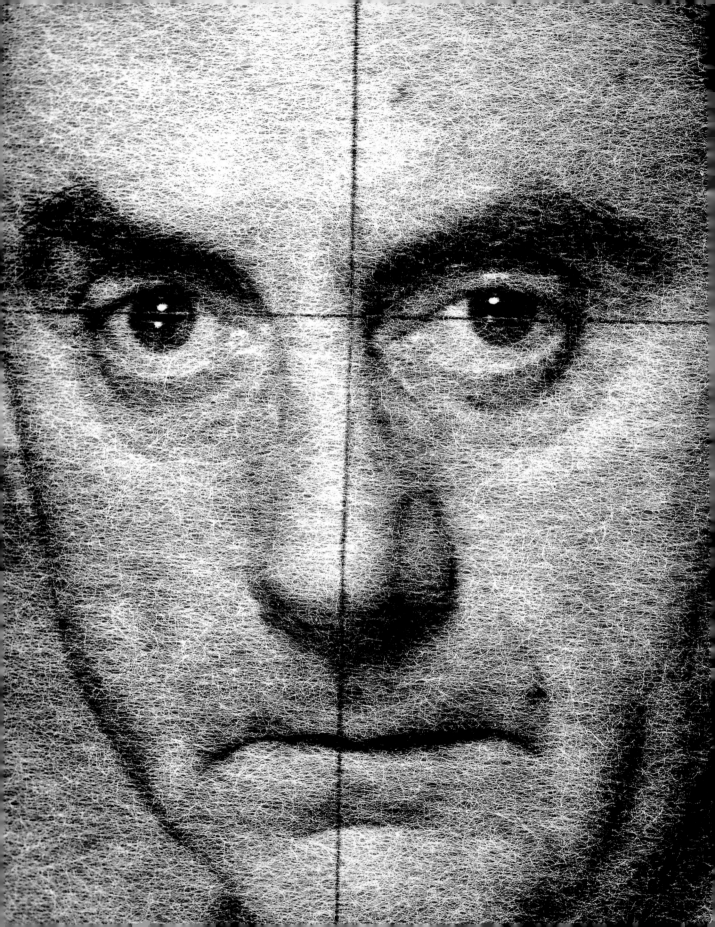

Man Ray

1890–1976

Essays by Emmanuelle de l'Ecotais and Katherine Ware
A personal portrait by André Breton
Edited by Manfred Heiting

TASCHEN
KÖLN LONDON LOS ANGELES MADRID PARIS TOKYO

Acknowledgements

Man Ray was the most inventive photographic artist of the 20th century. His creative mind gave us solarization, the rayograph, the artistic use of optical surface manipulation and the pairing of positive and negative prints, not to mention his play on words in titles with his surrealistic and Dada vocabulary. He also gave the photographic art market a first wake-up call when fraudulent dating of prints from his negatives surfaced in the early nineties. His disinterest in precise authentication, selection and cropping of his prints made from his negatives – with or without his supervision – by several print makers, whom he entrusted with his printmaking after returning to Paris in 1951, will continue to haunt historians and collectors alike. As one of his dealers once noted, Man Ray was playful in confusing precise information on so many aspects of his life and work and was pleased to tell one fact about a particular situation to a visitor in the morning and something else to another visitor in the afternoon.

Man Ray enjoyed a widely published interest in his work – not only during his lifetime but continuing after his death in 1976. During the research for this project I came across a variety of titles, dates and image croppings for the same negative and reproduced in different books and publications. The Man Ray estate today is not set up to shed light on these varieties and it goes without saying that this publication – though using all reliable sources of information – will not resolve all the problems inherent to this aspect of Man Ray's work. His titles are very often as unique as the work itself, frequently depicting the uniqueness of the French language and its erotic and poetic ambiguities. In those instances we have kept the original French titles without translation.

There are two foremost institutions associated with the work of Man Ray because of their vast holdings of original prints: the J. Paul Getty Museum in Los Angeles and the Musée national d'art moderne Centre Georges Pompidou in Paris, which since 1994 is also home of Man Ray's negatives. I am particularly grateful to Weston Naef, Curator of Photographs at the Getty Museum, who – as always – was extremely helpful in my pursuit and gave me excess to the museum's holdings. I am also thankful to Katherine Ware, for contributing to this project and writing the biographical essay. The staff of the Getty Museum, in particular Julian Cox, Jacklyn Burns, and Ellen Rosenbery, who were very helpful in providing the necessary informations and reproductions from the museum material, must be given credit for their thorough efforts. My sincerest thanks goes to Alain Sayag, Curator of Photography at the Centre Pompidou and Emmanuelle de l'Ecotais who curated the monumental Man Ray retrospective exhibition in Paris in 1998 and co-authored its accompanying catalog. I am very pleased indeed and indebted to Emmanuelle de l'Ecotais for writing the outstanding essay on Man Ray's time in Paris, and to Alain Sayag who organized the reproduction material for the selected images from the Centre Pompidou's collection.

I am especially indebted to Gert Elfering, Miamy Beach, and Michael Senft, New York, for their willingness to provide reproduction material from their extensive collections. A large number of the images reproduced in this book were scanned directly from original prints from the collection of Gert Elfering thereby enhancing the technical quality for printing. Alain Paviot, Paris, provided reproduction material of important works from his collection and Virginia L. Green, New York, made reproductions available from her copy of Mr. and Mrs. Woodman. Without the cooperation of all these friends and associates this publication would not have been possible.

As always with a series like this one the editorial department at Taschen, Simone Philippi, Anja Lenze and especially Bettina Ruhrberg, together with the production teams at NovaConcept, Juliane Winkler and Jonas Kirchner, and at DruckConcept, Dieter Kirchner and particularly Christiane Rothe, were tremendously helpful and supportive throughout this project. Without the dedication and resourcefulness of this professional team I would not have been able to continue the enjoyable work of editing this series.

Manfred Heiting

Danksagung

Man Ray ist der wichtigste Innovator der künstlerischen Fotografie des 20. Jahrhunderts. Sein kreativer Geist schenkte uns die Solarisation, die Rayografie, die künstlerische Bearbeitung von optischen Oberflächen und die Kombination von Positiv- und Negativabzügen, ganz zu schweigen von den Wortspielen in seinen Titeln mit ihrem dadaistischen und surrealistischen Vokabular. Außerdem rief er auf dem Fotografie-Kunstmarkt Anfang der 90er Jahre das Bewußtsein für die betrügerische Falschdatierung der Abzüge von seinen Negativen wach, weil er selbst kein Interesse am Echtheitsnachweis seiner Arbeiten hatte. Nach seiner Rückkehr nach Paris im Jahre 1951 überließ er Auswahl und Ausschnitt der Abzüge von seinen Negativen – ob mit oder ohne seine Überwachung – sehr oft verschiedenen Fotolaboranten. Wie einer seiner Händler einmal bemerkte, ging Man Ray sehr spielerisch mit Informationen um, die so viele Aspekte seines Lebens und seines Werkes betrafen. Er liebte es, Verwirrung zu stiften. Besonderen Gefallen fand er daran, einem Besucher am Morgen zu einer bestimmten Situation eine Erklärung zu geben und nachmittags einem anderen Besucher eine ganz andere.

Nicht nur zu Lebzeiten, sondern ungemindert auch nach seinem Tod im Jahre 1976 erfreute sich Man Rays Werk eines weitverbreiteten Interesses. Während meiner Nachforschungen für dieses Buch stieß ich auf eine Vielzahl von Titeln, Datierungen und Ausschnitten ein und desselben Negativs, die in verschiedenen Büchern und Publikationen reproduziert waren. Der Nachlaß des Künstlers bringt nicht immer Aufklärung in diese Verwirrung. Trotz Ausnutzung aller verläßlicher Quellen haben wir nicht alle Probleme lösen können, die mit diesem Aspekt von Man Rays Werk verbunden sind. Seine Titel sind häufig genau so einmalig wie die Werke selbst. Sie illustrieren in vieler Hinsicht die Einzigartigkeit der französischen Sprache mit ihrer erotischen und poetischen Vieldeutigkeit. Darum haben wir die französischen Originaltitel ohne Übersetzung beibehalten.

Es gibt zwei herausragende Institutionen für das Werk von Man Ray, weil sie einen großen Bestand an Originalabzügen besitzen: Das J. Paul Getty Museum in Los Angeles und das Musée national d'art moderne Centre Georges Pompidou in Paris, wo sich seit 1994 auch Man Rays Negative befinden. Besonders dankbar bin ich Weston Naef, dem Kurator für Fotografie am Getty Museum, der mir – wie immer – äußerst hilfreich bei meinen Nachforschungen zur Seite gestanden hat und mir den Zugang zu den Museumsbeständen ermöglichte. Ebenso dankbar bin ich Katherine Ware, die mit ihrem biografischen Essay einen wichtigen Beitrag zu diesem Projekt geleistet hat. Dank für all ihre Bemühungen gebührt auch den Mitarbeitern des Getty Museum, vor allem Julian Cox, Jacklyn Burns und Ellen Rosenbery, die stets behilflich waren, die Informationen und Reproduktionen aus den Museumsbeständen zu beschaffen. Mein herzlichster Dank gilt Alain Sayag, dem Kurator für Fotografie am Centre Pompidou, und Emmanuelle de l'Ecotais, die gemeinsam die großartige Man-Ray-Retrospektive 1998 in Paris kuratierten und den Katalog herausgaben. Ich bin Emmanuelle de l'Ecotais sehr dankbar für den ausgezeichneten Essay über Man Rays Pariser Zeit und Alain Sayag ebenso dafür, daß er das Reproduktionsmaterial für die Bilder, die aus der Sammlung des Centre Pompidou stammen, bereitgestellt hat.

Besonderen Dank schulde ich Gert Elfering, Miami Beach, und Michael Senft, New York, für ihre Bereitschaft, Abbildungsmaterial aus ihren umfangreichen Sammlungen zur Verfügung zu stellen. Eine große Zahl von Bildern konnte direkt von den Originalabzügen aus der Sammlung Gert Elferings gescannt werden, wodurch die Druckqualität wesentlich verbessert werden konnte. Alain Paviot, Paris, hat Material zur Reproduktion von bedeutenden Werken aus seiner Sammlung zur Verfügung gestellt, und Virginia L. Green, New York, hat Reproduktionen ihrer Kopie von Mr. and Mrs. Woodman ermöglicht. Ohne die Mitarbeit all dieser Freunde und Kollegen wäre dieses Buch nicht zustande gekommen.

Wie immer bei der Herausgabe einer Serie wie dieser war das gesamte Lektorat bei Taschen, Simone Philippi, Anja Lenze und vor allem Bettina Ruhrberg, eine enorme Hilfe; auch das Herstellungsteam von NovaConcept in Berlin, Juliane Winkler und Jonas Kirchner, und das Team bei DruckConcept, Dieter Kirchner und besonders Christiane Rothe, waren stets mit ihrer Unterstützung zur Stelle. Ohne den Einsatz, das Können und die Findigkeit dieses Teams wäre ich nicht in der Lage gewesen, die schöne Arbeit an der Herausgabe dieser Serie fortzuführen.

Manfred Heiting

Remerciements

Man Ray fut l'artiste photographe le plus inventif du XXᵉ siècle, et sans doute l'esprit le plus créatif dans ce domaine. On lui doit la solarisation, le rayogramme, la manipulation des surfaces optiques à des fins artistiques, le couplage des épreuves positive et négative et, dans le titre de ses œuvres, une foule de jeux de mots qu'il fabriquait à l'aide de son vocabulaire dada et surréaliste. On lui doit aussi d'avoir, pour la première fois, tiré de sa torpeur le marché de l'art photographique lorsque, au début des années 1990, on s'avisa que la datation portée sur certains tirages était frauduleuse. Longtemps, les historiens et les collectionneurs seront hantés par son manque d'intérêt pour la précision de l'authentification, de la sélection et du recadrage des épreuves qu'obtinrent, sous sa surveillance ou non, plusieurs laboratoires photo auxquels il confia le soin de développer ses négatifs après son retour à Paris en 1951. Comme un de ses marchands en fit un jour la remarque, il s'amusait à brouiller les pistes sur de très nombreux aspects de sa vie et de son œuvre, et, entre le matin et l'après-midi, il aimait donner des renseignements contradictoires à différents visiteurs.

L'œuvre de Man Ray a fait l'objet d'un vif intérêt éditorial, non seulement de son vivant mais aussi après sa mort en 1976. Au cours des recherches que j'ai effectuées pour ce travail, je me suis rendu compte que le titre, la date et le cadrage de certaines photographies pouvaient changer considérablement d'une publication à une autre. Aujourd'hui encore, la succession de Man Ray n'est pas prête à faire la lumière sur ces disparités, et il va sans dire que le présent ouvrage, même s'il a mis à profit toutes les sources d'information fiables, ne résout pas tous les problèmes liés à cette dimension de son œuvre. Le titre des œuvres est souvent aussi unique que les œuvres elles-mêmes. Nombreux sont ceux qui n'ont de sens qu'en français, avec toutes les ambiguïtés érotiques et poétiques dont la langue peut être porteuse. Le cas échéant, nous les avons donc conservés dans la langue originale sans les traduire.

Deux institutions majeures, en raison du très grand nombre d'originaux qu'elles possèdent, sont associées à l'œuvre de Man Ray : le musée J. Paul Getty de Los Angeles et le Musée national d'art moderne du Centre Georges Pompidou à Paris, qui abrite également, depuis 1994, les négatifs de l'artiste. Au musée Getty, ma reconnaissance va tout d'abord à Weston Naef, conservateur du département photographique : comme toujours, il m'a été d'une aide extrêmement précieuse dans mes recherches et il m'a donné accès au fonds du musée. Je remercie également Katherine Ware d'avoir participé au projet en rédigeant l'essai biographique sur Man Ray. Parmi le personnel, je ne saurais omettre Julian Cox, Jacklyn Burns et Ellen Rosenbery, qui se sont aimablement efforcés de me communiquer les renseignements nécessaires et les reproductions des documents du musée. J'exprime mes plus vifs remerciements à Alain Sayag, conservateur du département photographique du Centre Georges Pompidou, ainsi qu'à Emmanuelle de l'Ecotais, commissaire de la gigantesque rétrospective Man Ray à Paris en 1998, et co-responsable du catalogue de cette exposition. C'est avec plaisir que je témoigne ma gratitude à Emmanuelle de l'Ecotais, qui a écrit le texte remarquable sur la période parisienne de Man Ray, et à Alain Sayag, qui a organisé la reproduction des images sélectionnées dans les collections du Centre Georges Pompidou.

Je suis tout particulièrement redevable à Gert Elfering, de Miami Beach, et à Michael Senft, de New York, d'avoir permis la reproduction de certaines pièces de leur vaste collection. Une grande partie de l'iconographie présentée dans l'ouvrage a été directement scannée à partir des épreuves originales que possède Gert Elfering, ce qui a nettement amélioré la qualité technique de l'impression. Alain Paviot, de Paris, a également permis la reproduction d'œuvres importantes de sa collection, et Virginia L. Green, de New York, a fourni des images de Mr. and Mrs. Woodman. Sans la coopération de ces amis et collaborateurs, l'ouvrage présent n'aurait pu voir le jour.

Comme toujours dans cette série, le département éditorial des éditions Taschen, et en l'occurrence Simone Philippi, Anja Lenze et surtout Bettina Ruhrberg, ainsi que Juliane Winkler et Jonas Kirchner du groupe de production NovaConcept, Dieter Kirchner et surtout Christiane Rothe chez DruckConcept m'ont apporté une aide et un soutien précieux tout au long de l'élaboration de ce livre. Sans le dévouement, l'ingéniosité et le professionnalisme de cette équipe, je n'aurais pu poursuivre le travail passionnant que représente la responsabilité de cette série.

Manfred Heiting

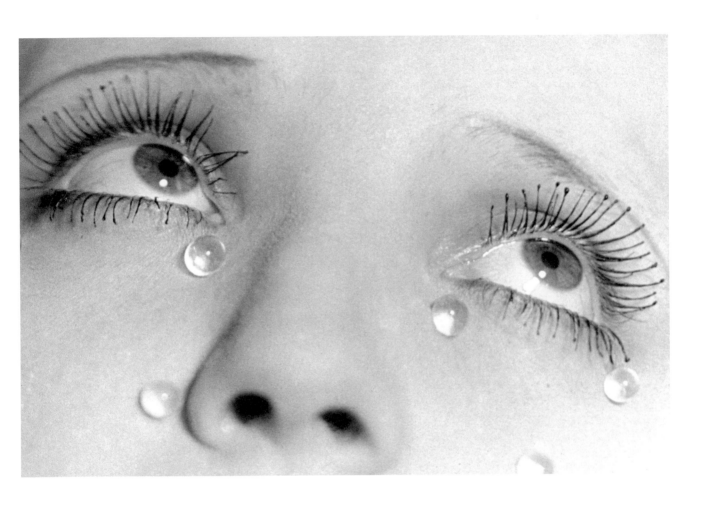

Les Larmes
c. 1932

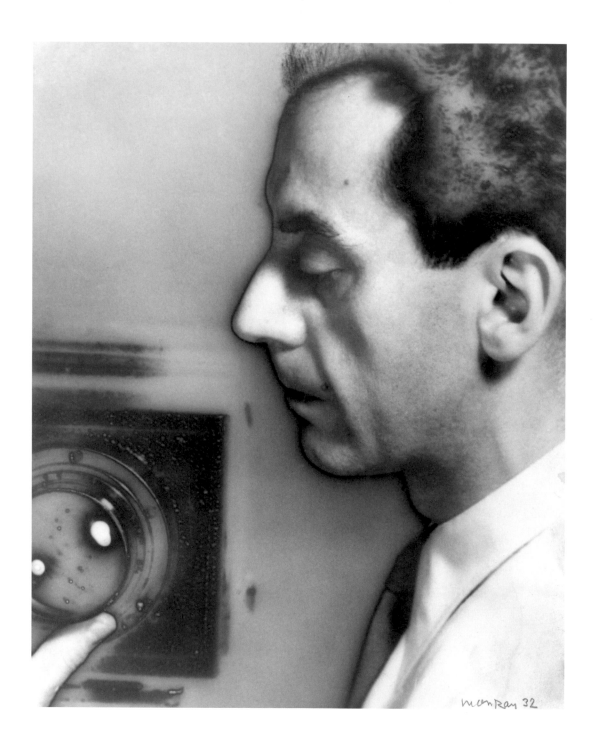

Self-Portrait
1932

Contents
Inhalt
Sommaire

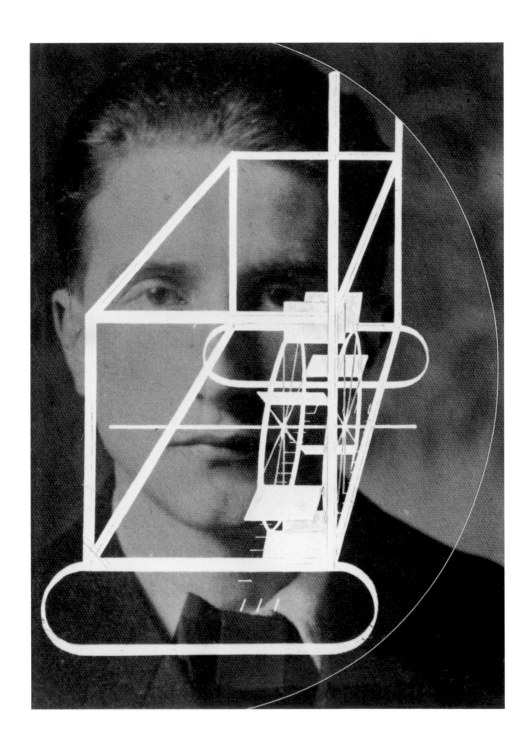

Marcel Duchamp et sa glissière contenant un moulin à eau [en métaux voisins]
c. 1923

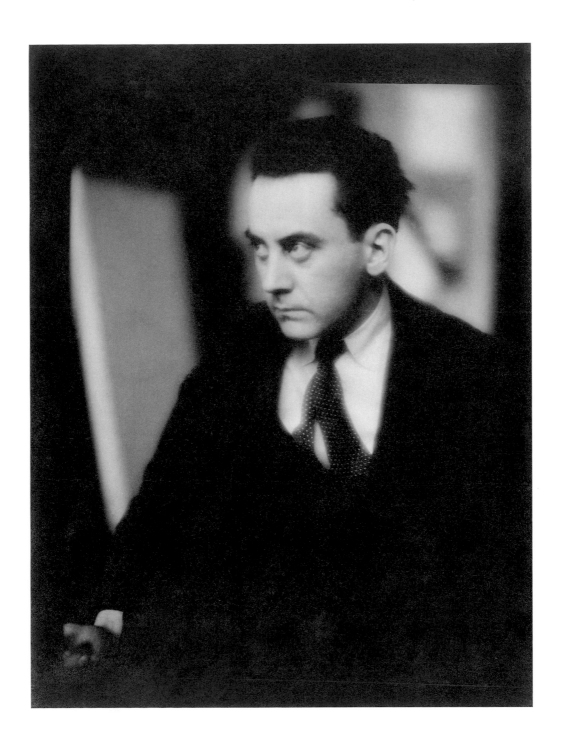

Self-Portrait
1924

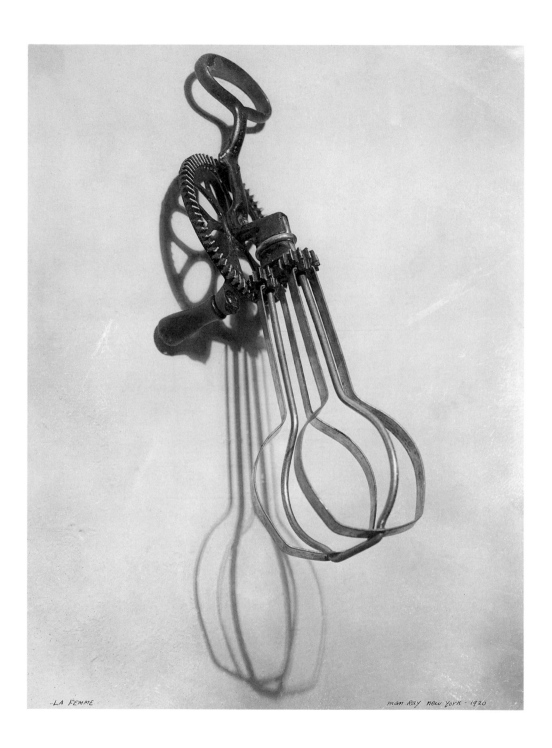

La femme
1920

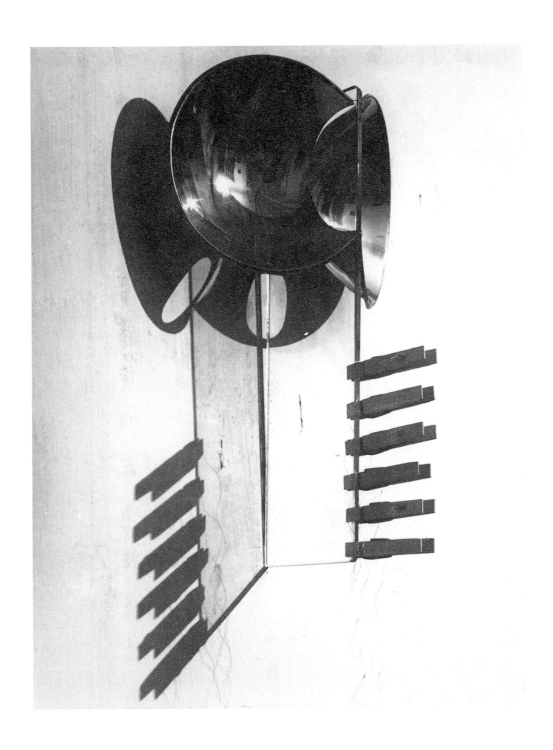

Integration of Shadows
1919

On Man Ray

Extract from "Le Surréalisme et la Peinture", Paris 1927
Translated from the French by Simon Watson Taylor[1]

Über Man Ray

Auszug aus » Le Surréalisme et la Peinture «, Paris 1927
Übersetzung aus dem Französischen von Manon Maren-Grisebach[1]

À propos de Man Ray

Extrait de « Le Surréalisme et la Peinture », Paris, 1927 [1]

André Breton

Almost at the same time as Max Ernst, but in a different and, at first sight, almost opposite spirit, Man Ray also derived his initial impetus from photographic precepts. But far from entrusting himself to photography's avowed aims and making use, after the event, of the common ground of representation that it proposed, Man Ray has applied himself vigorously to the task of stripping it of its positive nature, forcing it to abandon its arrogant air and pretentious claims. If, as Ramón Lulle has stated, "the mirror is a diaphanous body disposed to receive all the figures that are presented to it", then one cannot say as much for the photographic plate, which begins by requiring that these figures assume favorable attitudes, or goes even farther and takes them unawares at their most fugitive moments. The photographic print, considered in isolation, is certainly permeated with an emotive value that makes it a supremely precious article of exchange [and when will all the books that are worth anything stop being illustrated with drawings and appear only with photographs?]; nevertheless, despite the fact that it is endowed with a special power of suggestion, it is not in the final analysis the faithful image that we aim to retain of something that will soon be gone for ever. At a time when painting, far outdistanced by photography in the pure and simple imitation of actual things, was posing to itself the problem of its reason for existence and resolving the problem in the manner we have described, it was most necessary for someone to come forward who should be not only an accomplished technician of photography but also an outstanding painter; someone who should assign to photography the exact limits of the role that it can legitimately claim to play, and guide it towards other ends than those for which it appears to have been created – in particular, the thorough exploration on its own behalf, within the limits of its resources, of that region which painting imagined it was going to be able to keep all to itself. It was the great good fortune of Man Ray to be that man. Indeed I would consider it

Fast zur selben Zeit wie Max Ernst, aber in einer etwas anderen geistigen Verfassung, auf den ersten Blick beinah entgegengesetzt, ging Man Ray ebenfalls vom fotografischen Abbild aus; weit davon entfernt, ihm ganz zu vertrauen, benutzte er es nur von Fall zu Fall, je nach seinen eigenen Intentionen, je nach dem Gemeinsamen, das es uns in der Wiedergabe vermittelt. So nahm er ihm mit einem Schlage das Positive, damit es die arrogante Haltung verlor, die sich die Fotografie anmaßte, sich nämlich als das auszugeben, was sie gar nicht ist. Wenn tatsächlich eben für Raimundus Lullus »der Spiegel ein durchsichtiger Körper ist, der alle Erscheinungen, die ihm vorgehalten werden, in sich hineinnehmen kann«, so läßt sich das vom fotografischen Abbild nicht behaupten, das von den Erscheinungen von vornherein ein vorteilhaftes Aussehen fordert und das dann nur das Äußerste und Flüchtigste an ihnen erfaßt. [...] An und für sich betrachtet gehört die Fotografie, da sie mit einem ihr eigenen Gefühlswert ausgezeichnet ist, zu den besonders kostbaren Ersatzobjekten. Wann übrigens wird man endlich aufhören, die vernünftigen Bücher mit Zeichnungen zu illustrieren, statt einfach nur mit Fotografien? Die Fotografie ist, obwohl sie eine besondere Suggestivkraft besitzt, doch bei genauerem Hinsehen nicht das treue Abbild, das wir von dem bewahren möchten, was nur allzubald verloren sein wird. So mußte, während die Malerei, die von der Fotografie in der bloßen und einfachen Nachahmung der wirklichen Dinge schon weit übertroffen war, sich die problematische Frage ihrer Lebensberechtigung stellte und sie, wie man sah, beantwortete, notwendig ein guter Techniker der Fotografie, der zugleich zu den besten Malern zählte, sich damit befassen, einerseits der Fotografie ihre Grenzen genau so weit abzustecken, wie sie eben ihren Anspruch ausdehnen darf, und andererseits sie für neue Zwecke zu nutzen, für die sie nicht erfunden zu sein schien. Namentlich mußte er im Rahmen seiner eigenen Möglichkeiten die Erforschung jenes Gebietes fortsetzen, das die Malerei glaubte für sich reservieren zu können. Es war Man Rays Glück,

Presque en même temps que Max Ernst, mais dans un esprit assez différent, à première vue quelque peu contraire, Man Ray est parti, lui aussi, de la donnée photographique mais, loin de se fier à elle, de n'utiliser qu'après coup, selon le but qui est le sien, le lieu commun de représentation qu'elle nous propose, il s'est appliqué d'emblée à lui ôter son caractère positif, à lui faire passer cet air arrogant qu'elle avait de se donner pour ce qu'elle n'est pas. Si, en effet, pour le même Raymond Lulle, «le miroir est un corps diaphane disposé à recevoir toutes les figures qui lui sont représentées», on n'en saurait dire autant du cliché photographique, qui commence par exiger de ces figures une attitude propice, quand il ne les surprend pas dans ce qu'elles ont de plus fugitif. Les mêmes réflexions s'appliqueraient du reste à la prise de vue cinématographique, de nature à compromettre ces figures non plus seulement dans l'inanimé, mais encore dans le mouvement. L'épreuve photographique prise en elle-même, toute revêtue qu'elle est de cette valeur émotive qui en fait un des plus précieux objets d'échange [et quand donc tous les livres valables cesseront-ils d'être illustrés de dessins pour ne plus paraître qu'avec des photographies?], cette épreuve, bien que douée d'une force de suggestion particulière, n'est pas en dernière analyse l'image *fidèle* que nous entendons garder de ce que bientôt nous n'aurons plus. Il était nécessaire, alors que la peinture, de loin distancée par la photographie dans l'imitation pure et simple des choses réelles, se posait et résolvait comme on l'a vu le problème de sa raison d'être, qu'un parfait technicien de la photographie, qui fût aussi de la classe des meilleurs peintres, se préoccupât, d'une part, d'assigner à la photographie les limites exactes à quoi elle peut prétendre, d'autre part de la faire servir à d'autres fins que celles pour lesquelles elle avait été créée, et notamment à poursuivre pour son compte, et dans la mesure de ses moyens propres, l'exploration de cette région que la peinture croyait pouvoir se réserver. Ce fut le bonheur de Man Ray que d'être cet homme. Aussi jugerais-je vain de distinguer dans sa production ce qui est portraits

fruitless to attempt to divide his artistic production into photographic portraits, photographs inappropriately called "abstract", and pictorial works properly so called. I know only too well that these three kinds of expression, signed with his name and fulfilling the same spiritual mission, are all bordered at their outer limits by the same conspicuous or inconspicuous halo. The very beautiful women who expose their tresses night and day to the fierce lights in Man Ray's studio are certainly not aware that they are taking part in any kind of demonstration. How astonished they would be if I told them that they are participating for exactly the same reasons as a quartz gun, a bunch of keys, hoar-frost or fern! The pearl necklace slips from the naked shoulders on to the white sand, where a ray of sunlight whisks it away. What was merely adornment and what was anything but adornment are abandoned simultaneously to the justice of the shadows. The caves are full of roses. The ordinary preparation to which one surface will shortly be submitted will not differ in the least from the preparation being applied to the other surface so that the most beautiful features in the world may be created on it. The two images live and die from the same trembling, the same hour, the same lost or intercepted glimmers of light. They are both nearly always so perfect that it is very difficult to realize that they are not on the same plane: one would have thought that they are as necessary to each other as is that which touches to that which is touched. Are they golden-haired or angel-haired? How can we distinguish the wax hand from the real hand?

For whoever is expert enough to navigate the ship of photography safely through the bewildering eddies of images, there is the whole of life to recapture as if one were running a film backwards, as if one were to be confronted suddenly by an ideal camera in front of which to pose Napoleon, after discovering his footprints on certain objects.

der geeignete Mann dafür zu sein. Ich halte es für Gerede, in seinem Werk zwischen dem, was fotografisches Porträt, was so unzutreffend abstrakte Fotografie genannt wird, und seinen eigentlichen malerischen Arbeiten zu unterscheiden. [...]
Die besonders schönen und so eleganten Frauen, die Tag und Nacht ihre Haare den entsetzlichen Lampen im Atelier von Man Ray aussetzen, wissen sicher nichts davon, daß sie sich damit für eine Demonstration hergeben. Ich würde sie sehr in Erstaunen versetzen, wenn ich ihnen klarmachte, daß sie daran teilhätten, und zwar im selben Sinn wie eine Quarzlampe, ein Schlüsselbund, wie der Rauhreif oder wie das Farnkraut. Ein Perlenkollier gleitet von den nackten Schultern auf das weiße Blatt, auf dem es von einem Sonnenstrahl eingefangen wird und nun zwischen anderen Bildelementen dort liegt. Das, was nur Schmuck war, wird jetzt dem Spiel der Schatten anheimgegeben, den Schatten zum Gericht überantwortet. Es gibt nur noch Rosen in den unterirdischen Höhlen. Die übliche Behandlung, die sogleich diesem Blatte widerfahren wird, unterscheidet sich in nichts von der, die jenem anderen Blatte widerfährt, um auf ihm das Kostbarste der Welt in Erscheinung treten zu lassen. Die beiden Bilder leben und sterben durch die gleiche Erschütterung, zur gleichen Stunde, im gleichen sich verlierenden oder plötzlich verlöschenden Schein. Sie sind beinah immer gleich vollkommen, es fällt schwer zu denken, sie existierten nicht auf derselben Ebene, man meint, sie seien einander so unentbehrlich wie das Berührte und das Berührende. Ist dies Gold- oder Engelshaar? Wie kann man die Wachshand von der wirklichen unterscheiden? Wer das Schiff der Fotografie sicher durch den nahezu unbegreifbaren Strudel der Bilder zu lenken versteht, der wird das Leben wieder in seine Fänge ziehen, so als ob man einen Film rückwärts drehen würde, so als ob es einer idealen Kamera gelingen würde, Napoleon vor sie hinzustellen, nachdem doch zuvor neu seine Spuren auf bestimmten Dingen entdeckt werden konnten.

photographiques, photographies dites fâcheusement abstraites et œuvres picturales proprement dites. Aux confins de ces trois sortes de choses qui sont signées de son nom et qui répondent à une même démarche de son esprit, je sais trop bien que c'est toujours la même apparence, ou inapparence, qui est cernée.
Les femmes très élégantes et très belles qui exposent jour et nuit leurs cheveux aux terribles lumières de l'atelier de Man Ray n'ont certes pas conscience de se prêter à une démonstration quelconque. Comme je les étonnerais en leur disant qu'elles y participent au même titre qu'un canon de quartz, qu'un trousseau de clés, que le givre ou que la fougère ! Le collier de perles glisse des épaules nues sur la page blanche, où vient le prendre un rayon de soleil, parmi d'autres éléments qui sont là. Ce qui n'était que parure, ce qui n'était rien moins que parure est abandonné simultanément au goût des ombres, à la justice des ombres. Il n'y a plus que des roses dans les caves. La préparation ordinaire qu'on fera tout à l'heure subir à la page ne différera en rien de celle qu'on fait subir à l'autre page pour y faire apparaître les plus chers traits du monde. Les deux images vivent et meurent du même tremblement, de la même heure, des mêmes lueurs perdues ou interceptées. Elles sont presque toujours aussi parfaites, il est bien difficile de penser qu'elles ne sont pas sur le même plan, on dirait qu'elles sont aussi nécessaires l'une à l'autre que ce qui touche à ce qui est touché. Sont-ce cheveux d'or ou cheveux d'ange ? Comment reconnaître la main de cire de la vraie main ?
Pour qui sait mener à bien la barque photographique dans les remous presque incompréhensible des images, il y a la vie à rattraper comme on tournerait un film à l'envers, comme on arriverait devant un appareil idéal à faire *poser* Napoléon, après avoir retrouvé son empreinte sur certains objets.

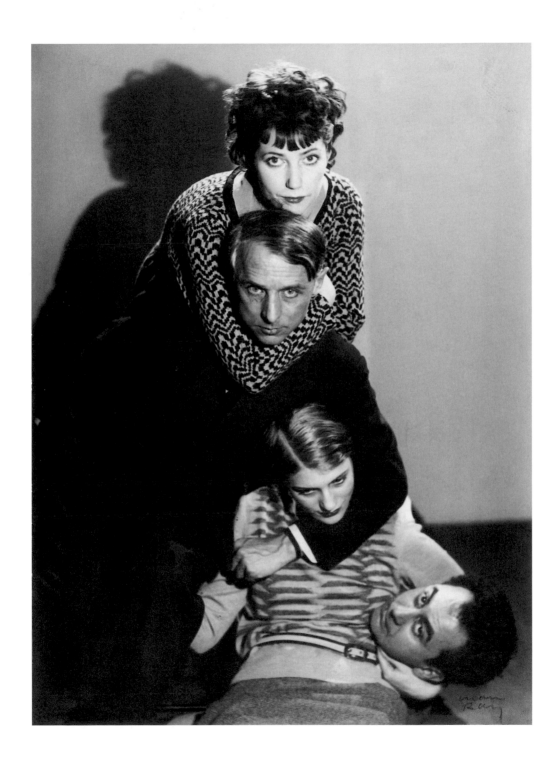

Marie-Berthe Aurenche, Max Ernst, Lee Miller, Man Ray
c. 1932

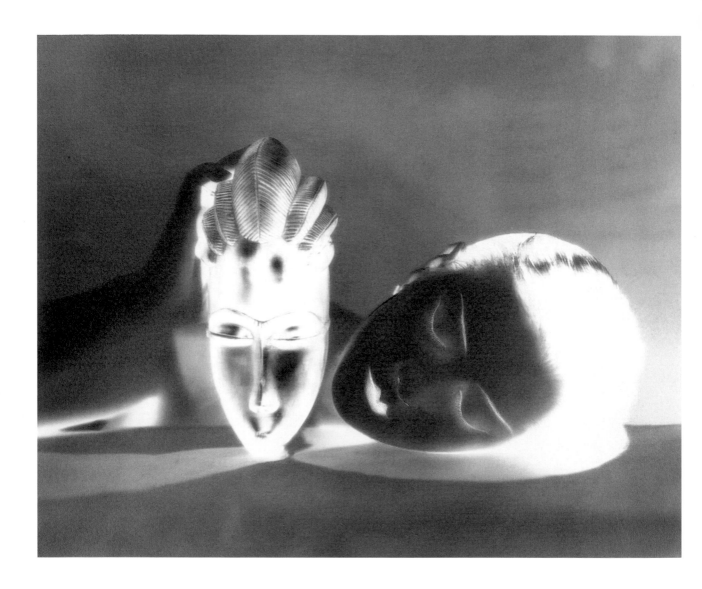

Noir et Blanche [reverse negative print]
1926

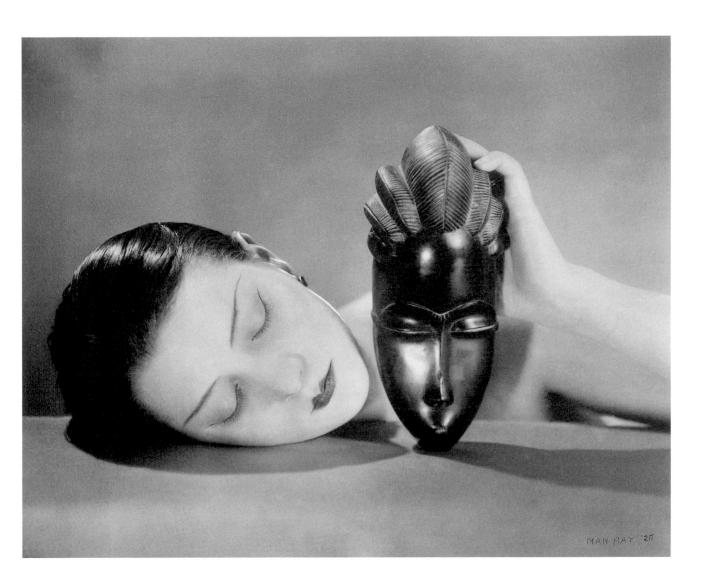

Noir et Blanche
1926

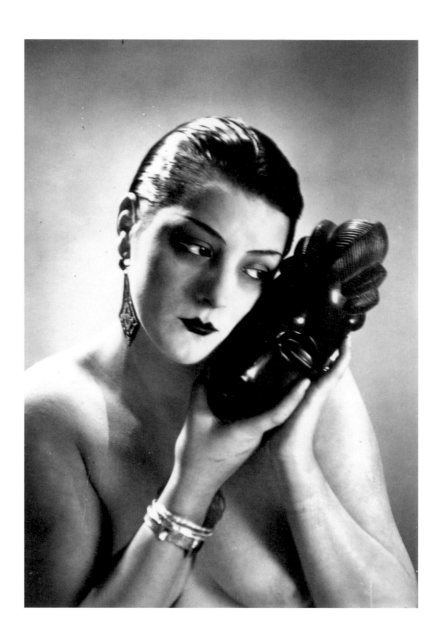

Noir et Blanche
1926

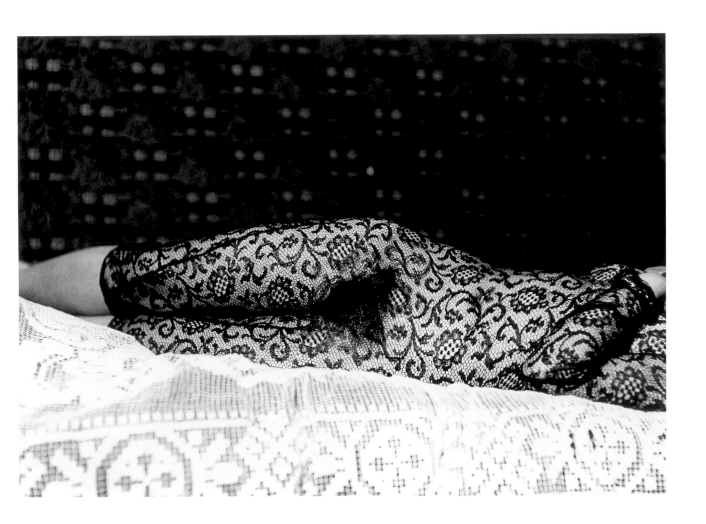

Untitled
c. 1925

Was die Wünsche betrifft, gibt es eigentlich keine so große Kluft zwischen dem Künstler und dem Betrachter. Allerdings kann sich der Künstler durch seine Mittel zu weit in technische Abenteuer hineinführen lassen und damit einen momentanen Bruch zwischen sich und dem Betrachter herbeiführen, der, von solchen »tours de force« zu stark beeindruckt, das ursprüngliche Thema aus dem Blick verlieren kann. Dennoch aber sind solche »tours de force« – ohne besondere Anstrengung durchgeführt – für den Künstler nichts weiter als eine Möglichkeit, sein Thema wirkungsvoller darzustellen.

As far as desires go, there is really not such a great gulf between the one who creates and the one who appreciates. Except, with the former his application may lead him too far into technical adventures, and thus create a momentary breach between himself and the spectator who, too impressed by tours de force, may lose sight of the original subject matter. And yet such tours de force when carried out without any special effort on the part of the artist, are merely means for making his subject matter more telling.

Vu sous l'angle du désir, l'abîme n'est vraiment pas si grand entre celui qui crée et celui qui juge. À ceci près que le premier, tout entier à sa tâche, risque de s'aventurer trop loin dans le recours à la technique, provoquant alors une scission temporaire entre lui et le spectateur, lequel pourra perdre de vue le sujet original à force d'être impressionné par des tours de force. Pourtant, s'ils sont accomplis sans effort particulier de la part de l'artiste, ces tours de force ne constituent que des moyens pour renforcer l'éloquence de son sujet.

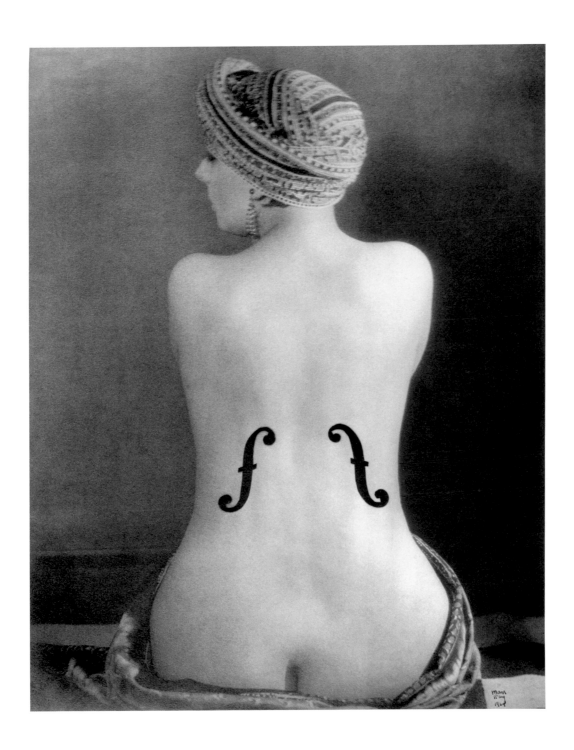

Le violon d'Ingres
1924

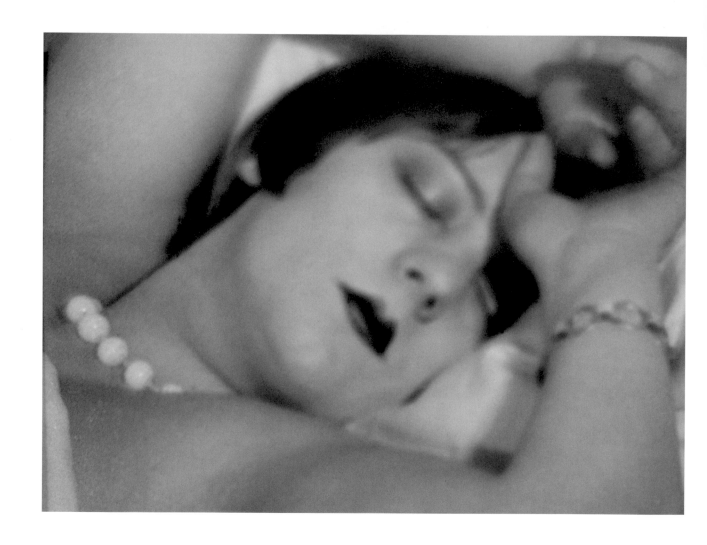

Kiki
1928

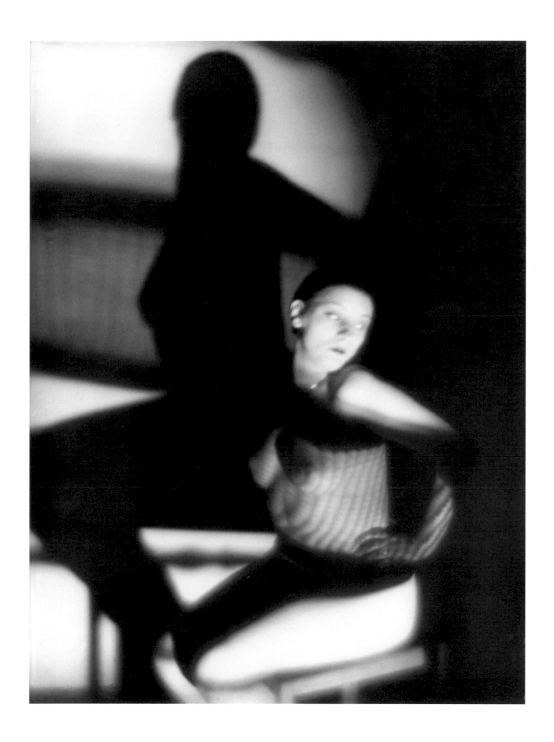

Kiki
c. 1923

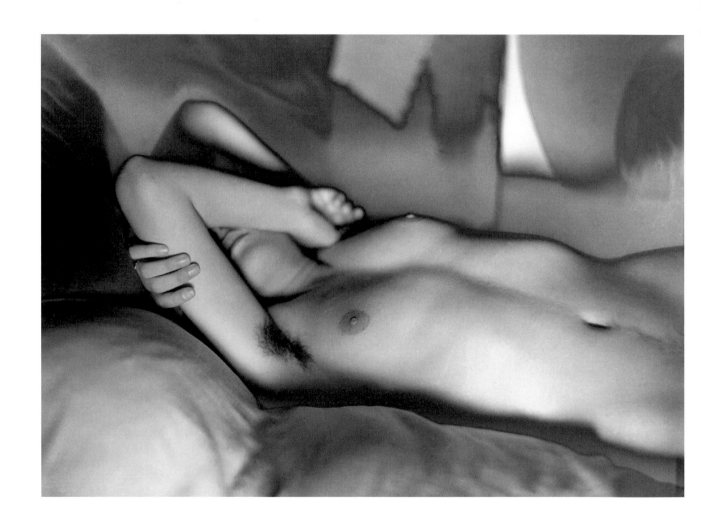

Meret Oppenheim
1933

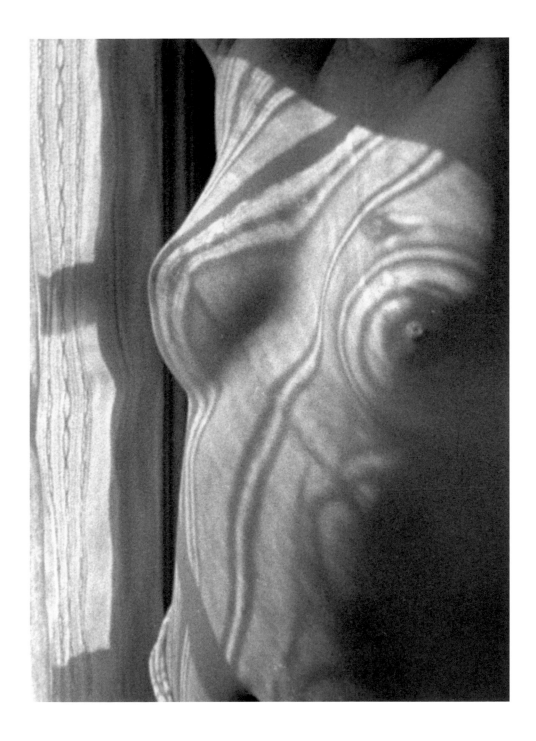

Retour à la raison
1923

Zwei oder drei Lampen [um schneller arbeiten zu können], irgendeine Linse auf einem lichtundurchlässigen Kasten [seit der Erfindung der Kamera hat es keinen Fortschritt gegeben] und eine Flasche Entwickler sind alles, was man braucht, um ein restlos überzeugendes Bild zu realisieren.

Two or three lights [for greater speed in working], any lens on a light-tight box [no progress has been made in cameras since their invention], and a bottle of developer, are sufficient for the realization of the most convincing image.

Il suffit de deux ou trois sources d'éclairage [afin d'accélérer le travail], de n'importe quel objectif monté sur un boîtier hermétique [la fabrication du matériel n'a fait aucun progrès depuis l'invention de la photographie] et d'une bouteille de révélateur chimique pour réaliser une image de l'espèce la plus convaincante.

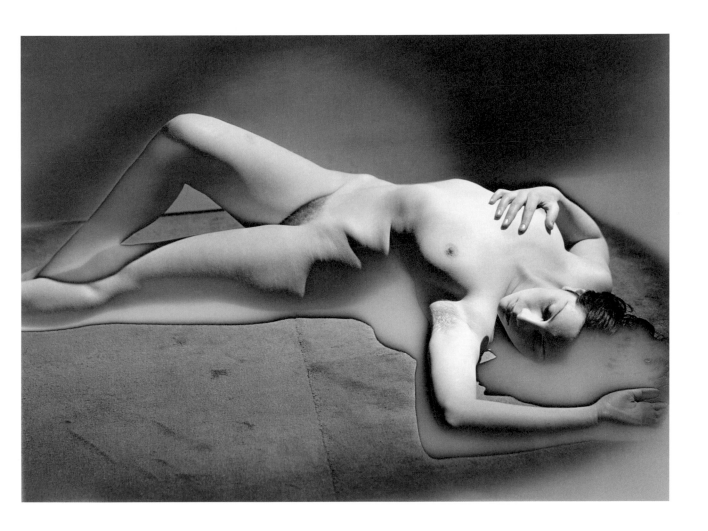

Primat de la matière sur la pensée
1932

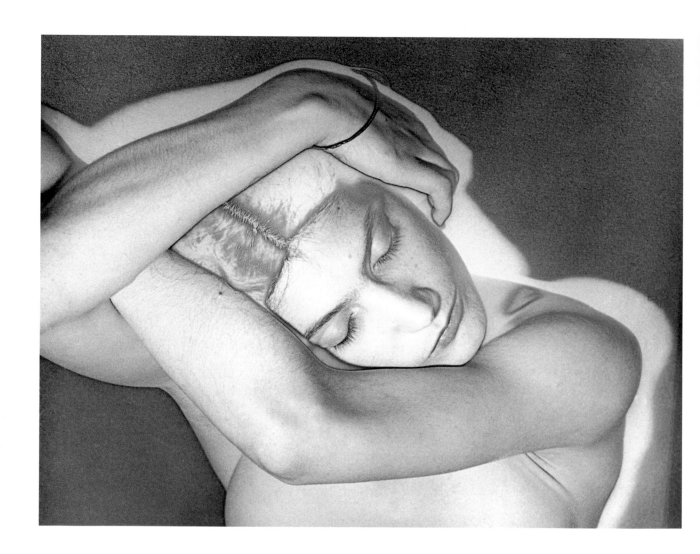

Untitled
1931

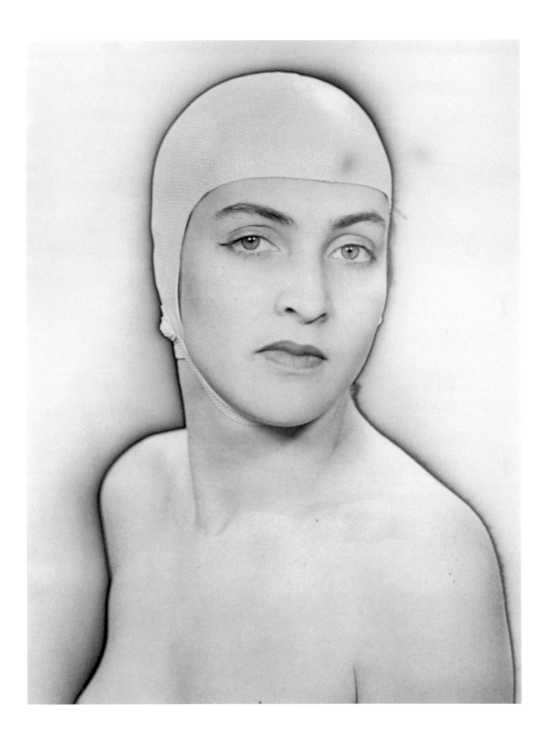

Meret Oppenheim
1932

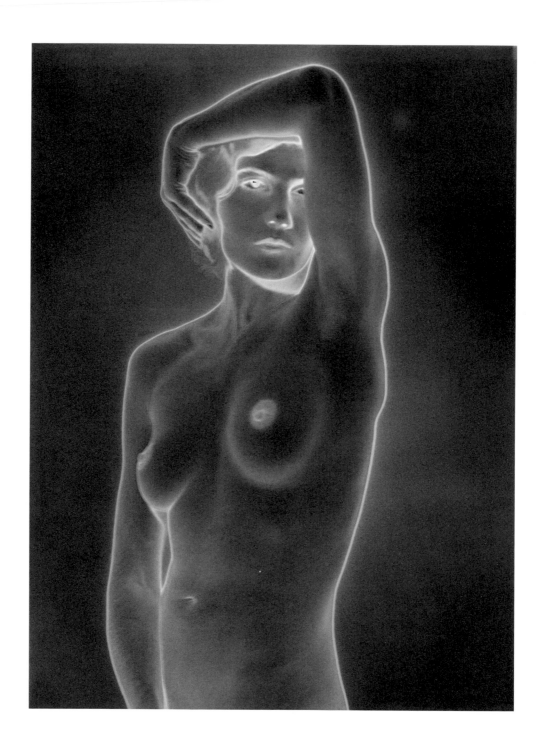

"Beauty in ultra violet" [*Published in Harper's Bazaar, 1940*]
c. 1931

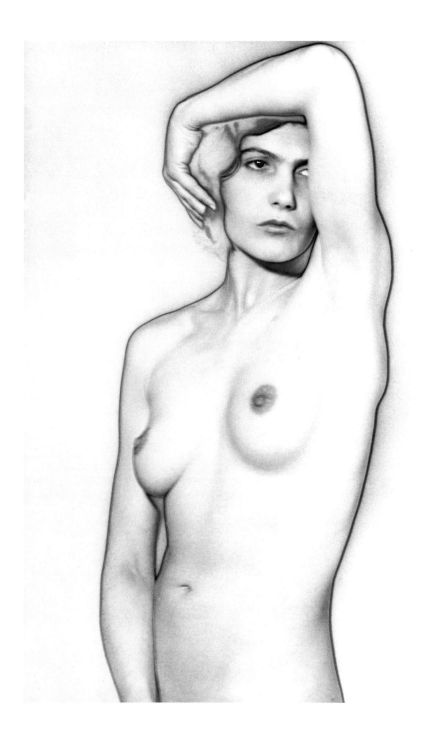

Untitled
C. 1931

Sehen Sie sich dieses Aktfoto an. Ein Freund hatte das Foto gesehen und sich in mein Modell verliebt. Er wollte ihr unbedingt vorgestellt werden. Ich sagte zu ihm: Komm her, sie ist bei mir. Und ich zeigte ihm […] das »Mädchen«: Es war ein Gipsabguß der Venus von Milo […]. Glauben Sie, daß der Fotoapparat das zu Wege gebracht hat?

Hey, look at this nude. A friend saw this photo, and he fell in love with my model. He wanted to be introduced to her, and wouldn't take no for an answer. I said to him: "Come round, she's at my place". And I showed him […] "the girl": it was a plaster model of the Venus de Milo […]. Do you think it's the camera that does that?

Tenez, regardez ce nu. Un ami avait vu cette photo, et il était tombé amoureux de mon modèle. Il voulait absolument lui être présenté. Je lui ai dit : viens, elle est chez moi. Et je lui ai montré […] « la fille » : c'était un plâtre de la Vénus de Milo […]. Vous croyez que c'est l'appareil qui a fait ça ?

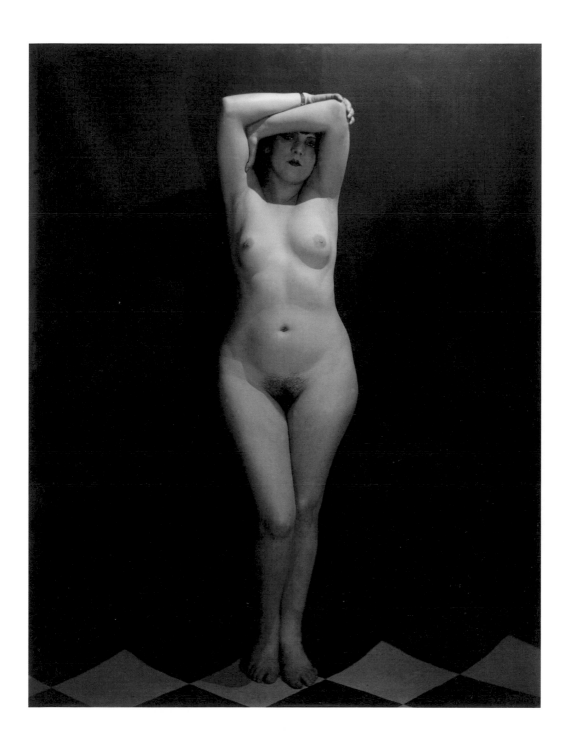

Kiki de Montparnasse
1923

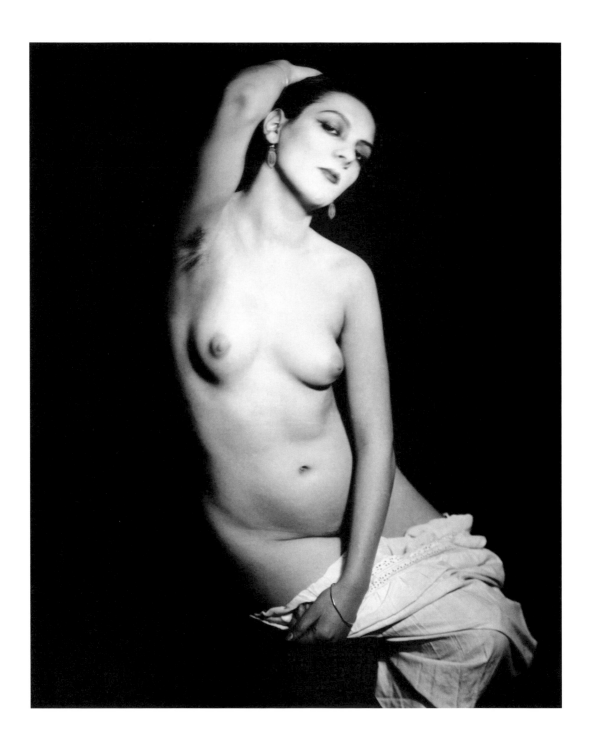

Kiki de Montparnasse
1922

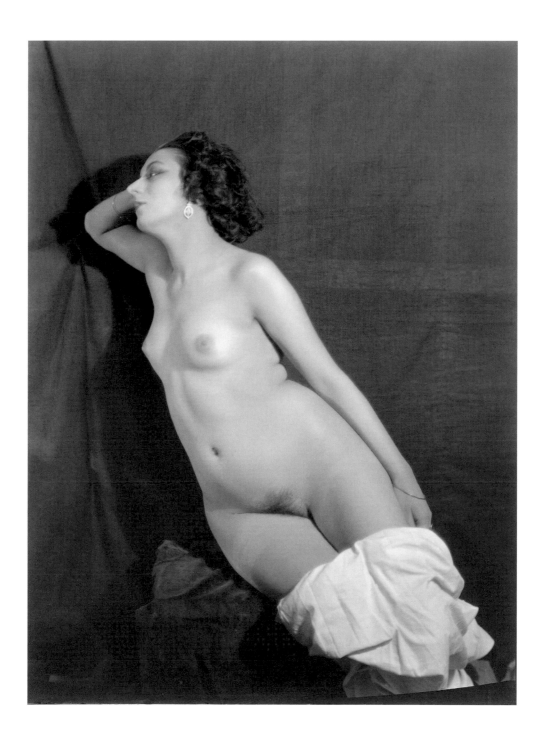

Kiki de Montparnasse
1922

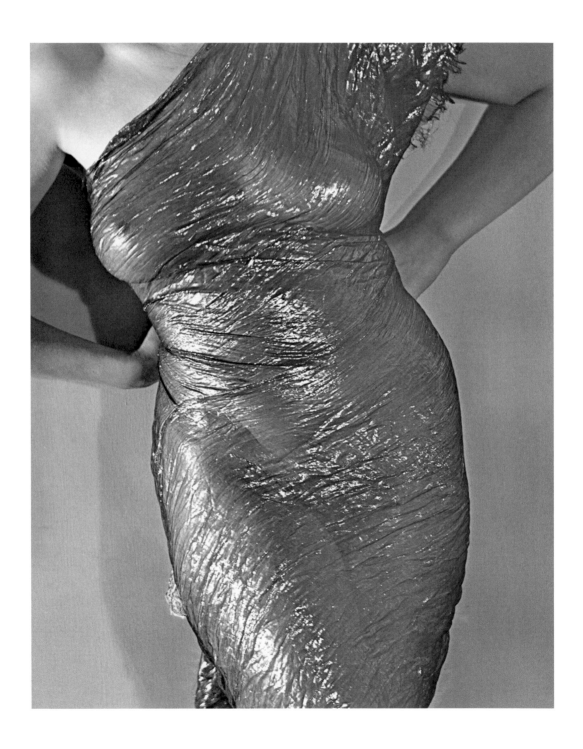

Anatomies
c. 1930

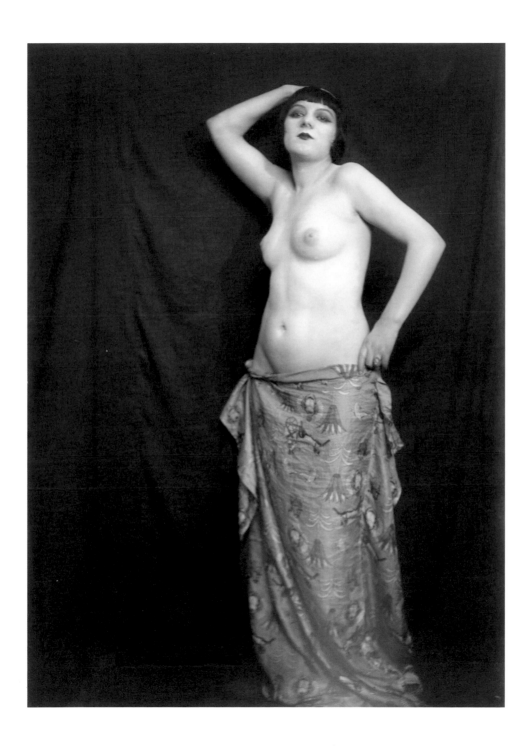

Kiki de Montparnasse
c. 1922

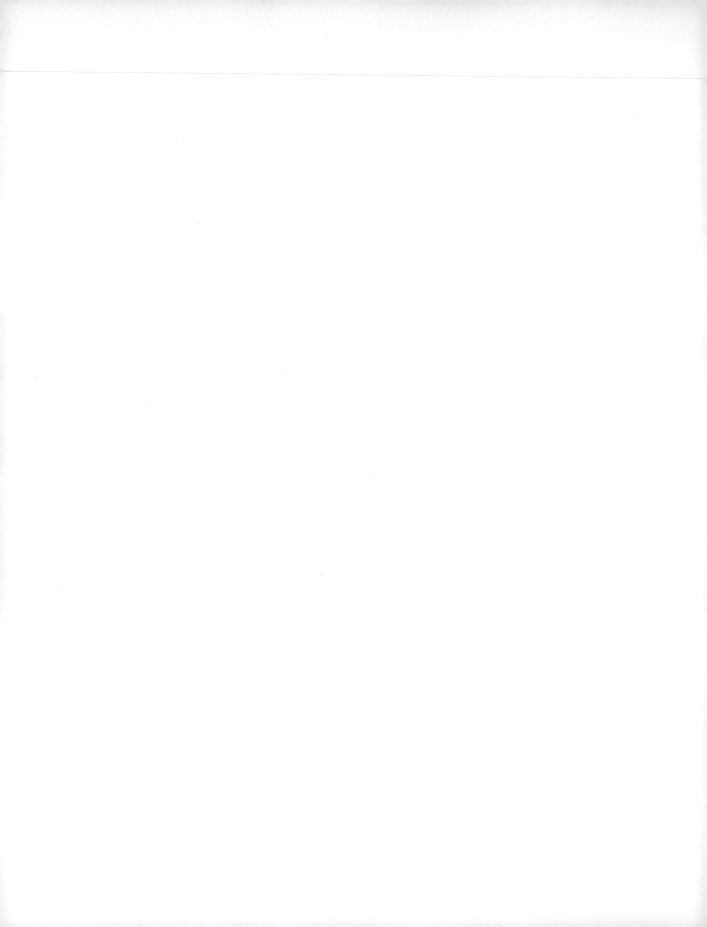

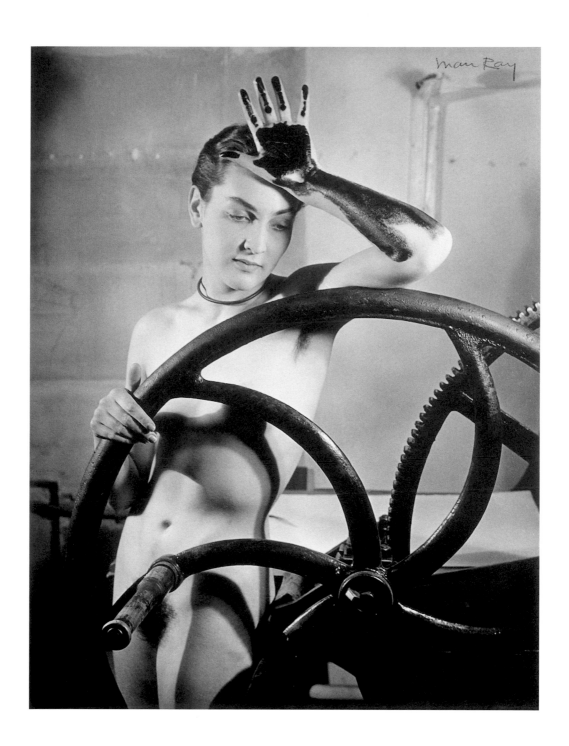

Erotique voilée [Meret Oppenheim]
1933

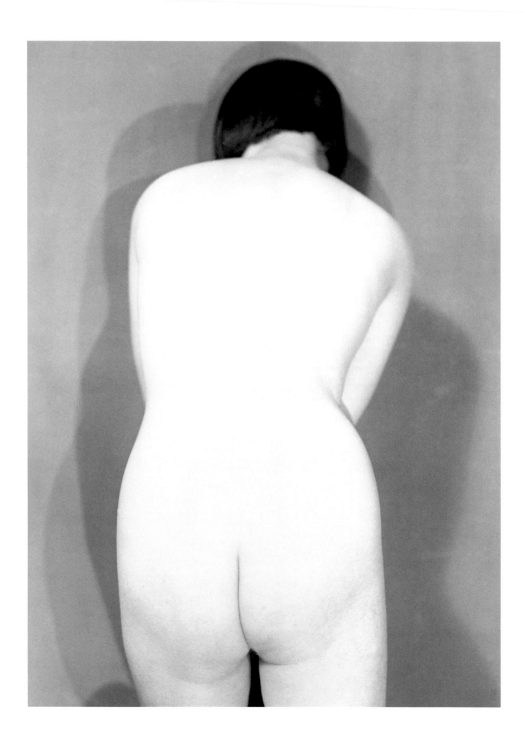

Untitled
1927

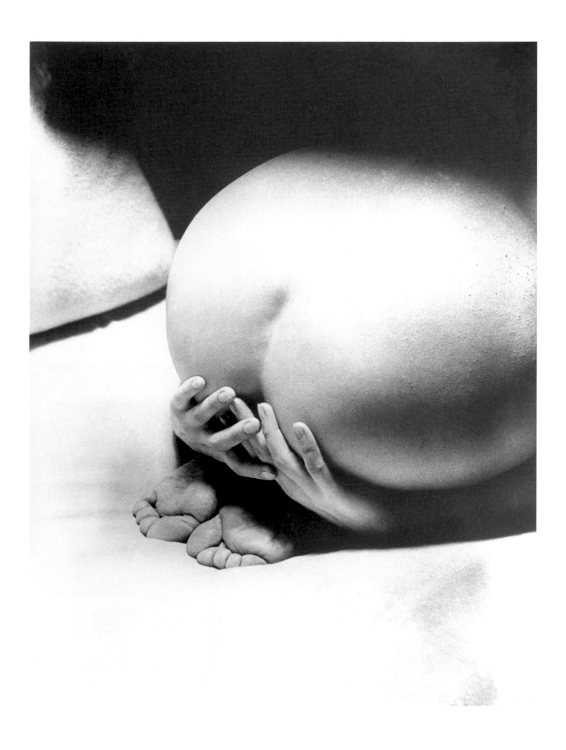

La Prière
c. 1930

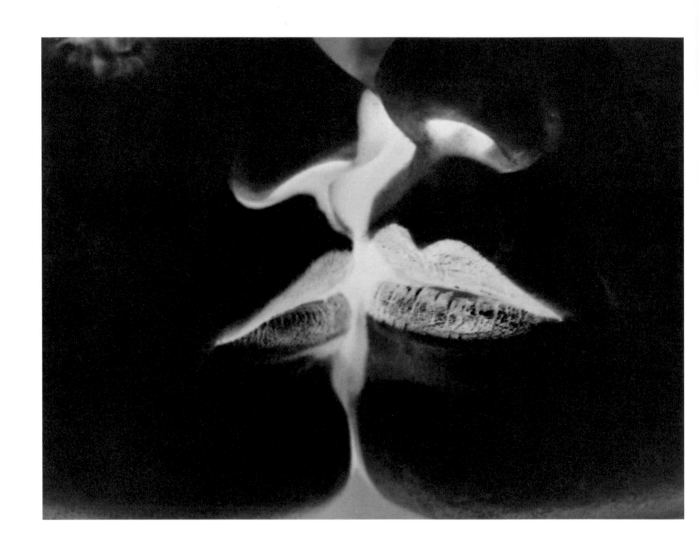

Le Baiser [negative print]
1935

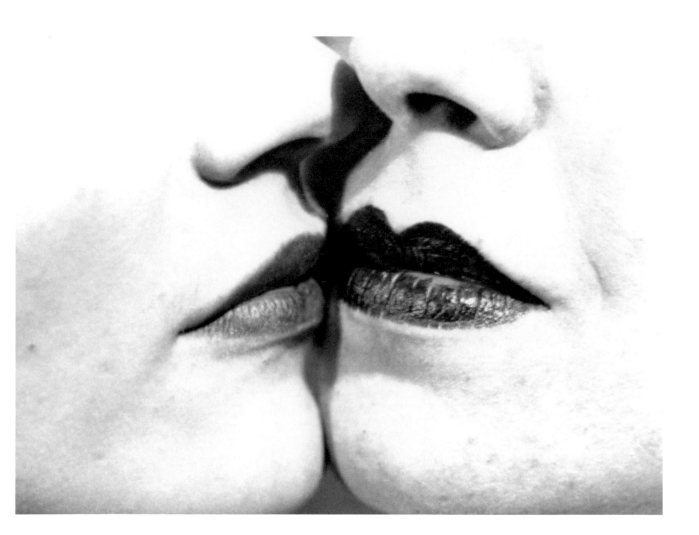

Le Baiser
1935

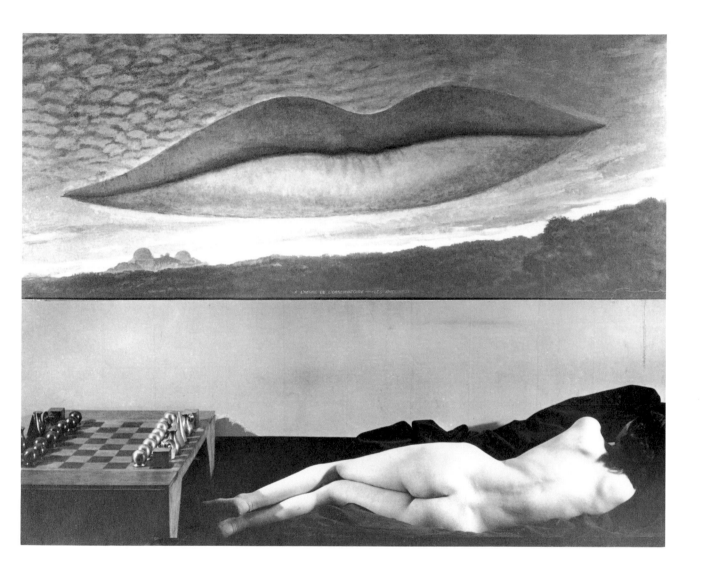

From the series «À l'heure de l'observatoire, les amoureux»
1934

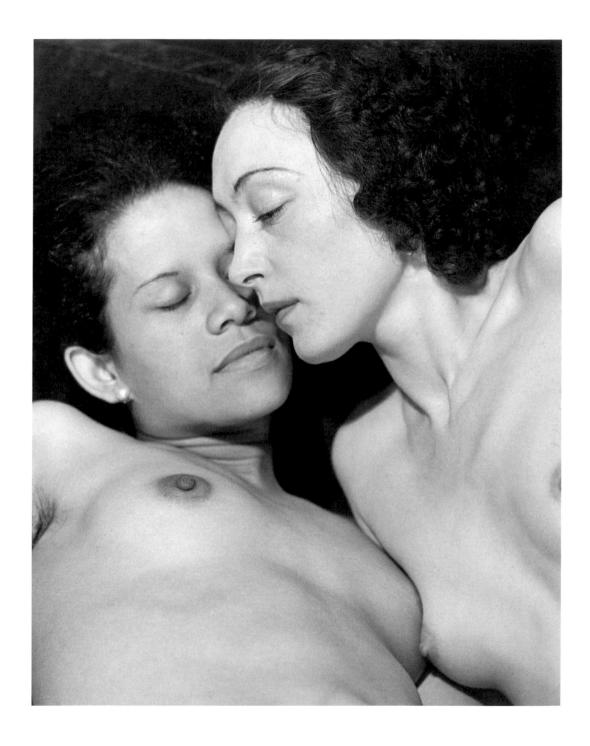

Ady and Nusch
1937

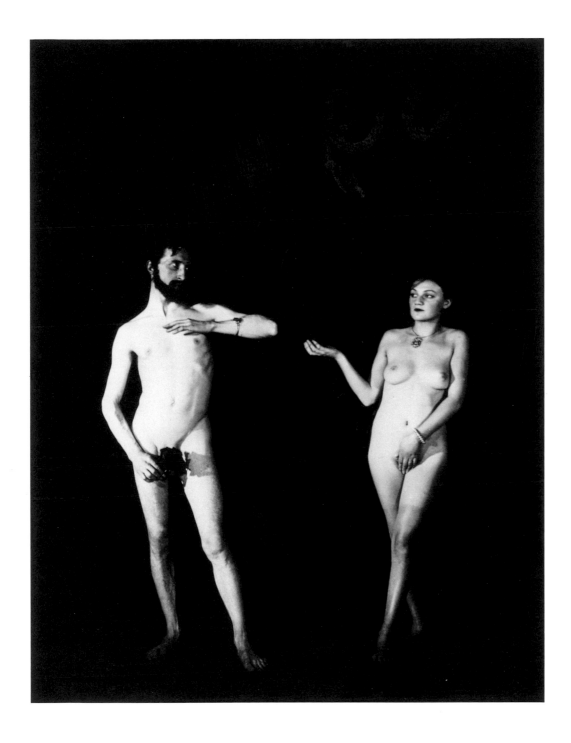

Ciné-sketch: Adam et Eve [Marcel Duchamp, Bronia Perlmutter-Clair]
1924

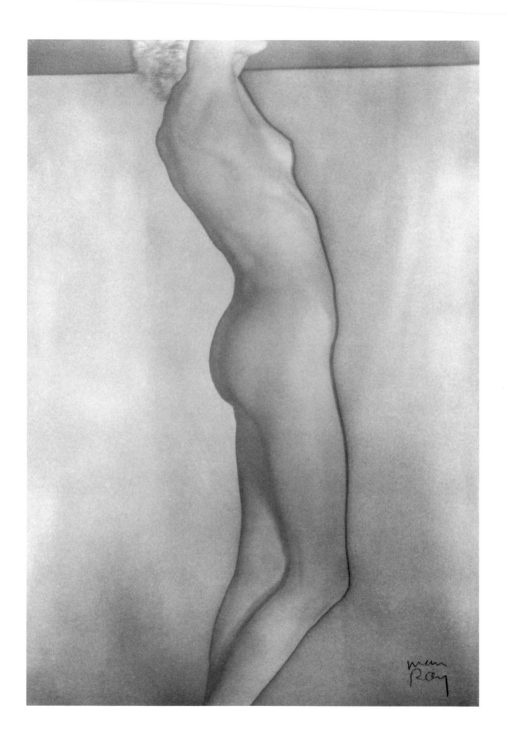

Untitled
1936

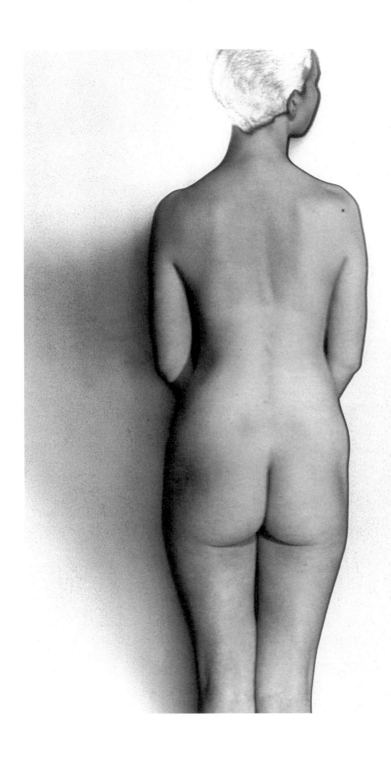

Untitled
C. 1931

Die Kunst variiert einfach in ihren Inspirationsquellen und ihren Entstehungs-prozessen. Die Kunst ein und desselben Menschen kann unterschiedlicher Art sein, je nachdem, wie es um seine Neugier und seinen Sinn für Freiheit bestellt ist.

Art simply varies in its sources of inspiration and in its modes of execution. It can vary within one man, depending on his curiosity and on his sense of freedom.

L'art varie simplement dans ses sources d'inspiration et dans ses modes d'exécu-tion. Il peut même varier chez tel ou tel individu, en fonction de sa curiosité et de son sentiment de liberté.

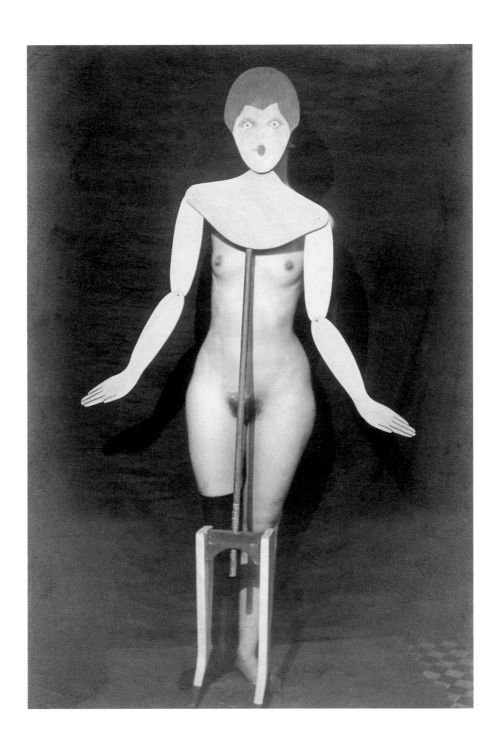

Coat Stand
1920

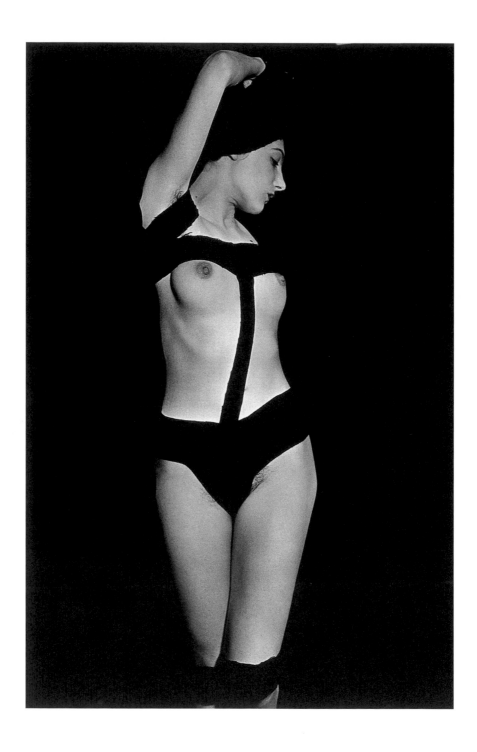

Blanc et Noir
c. 1929

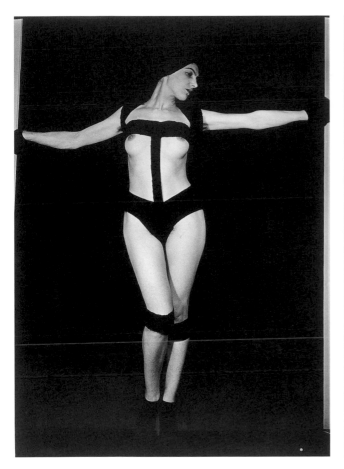
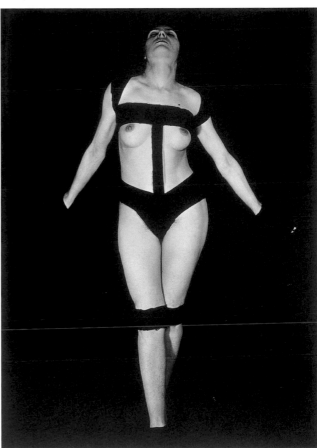

Blanc et Noir
c. 1929

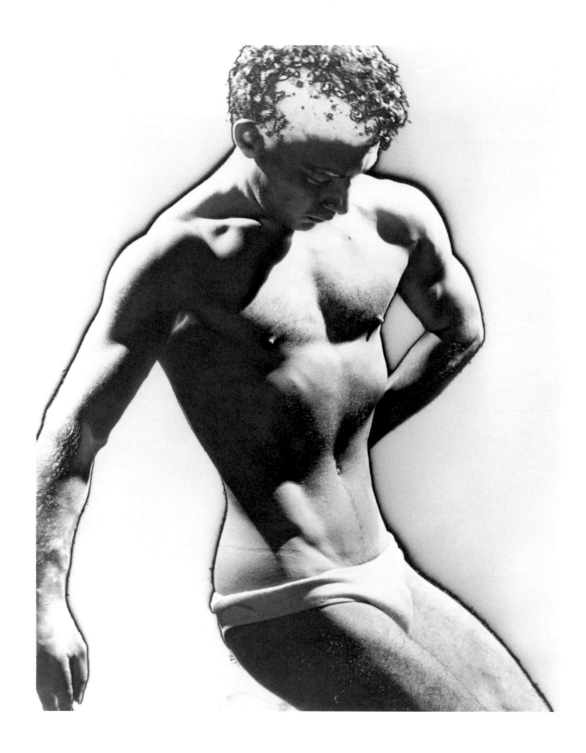

Untitled
1933

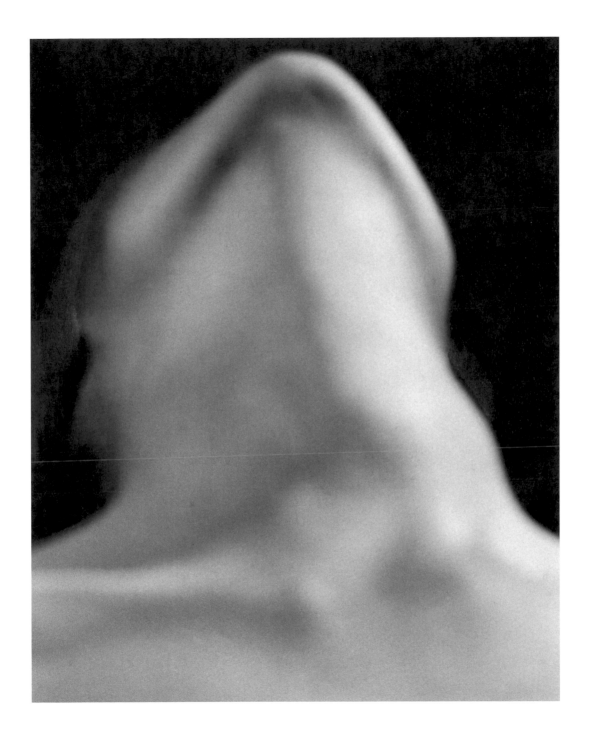

Anatomies
1929

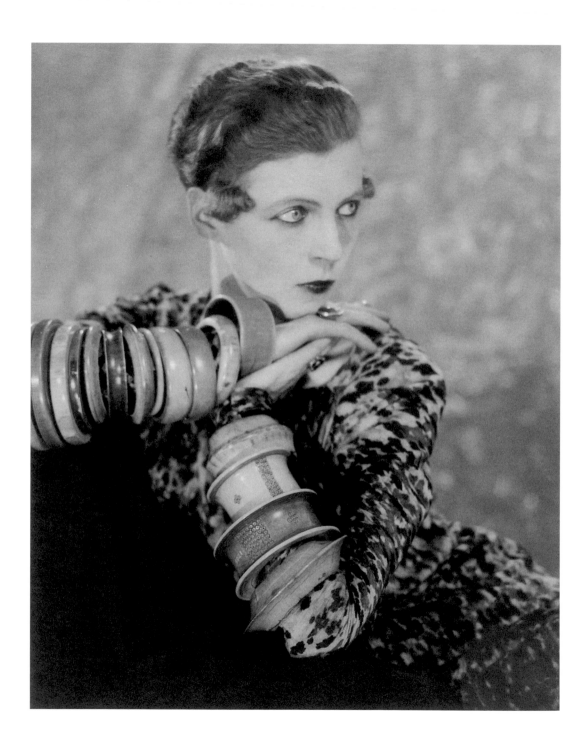

Nancy Cunard
1926

Träume haben keine Titel.

Dreams have no titles.

Les rêves n'ont pas de titre.

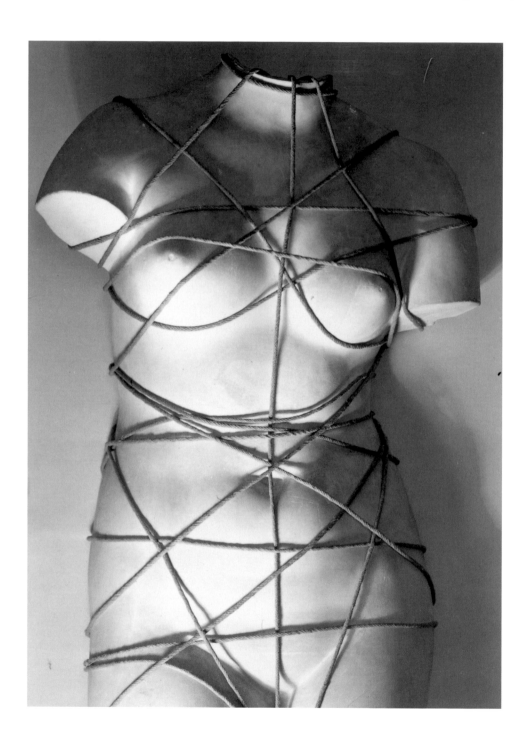

Vénus restaurée
1936

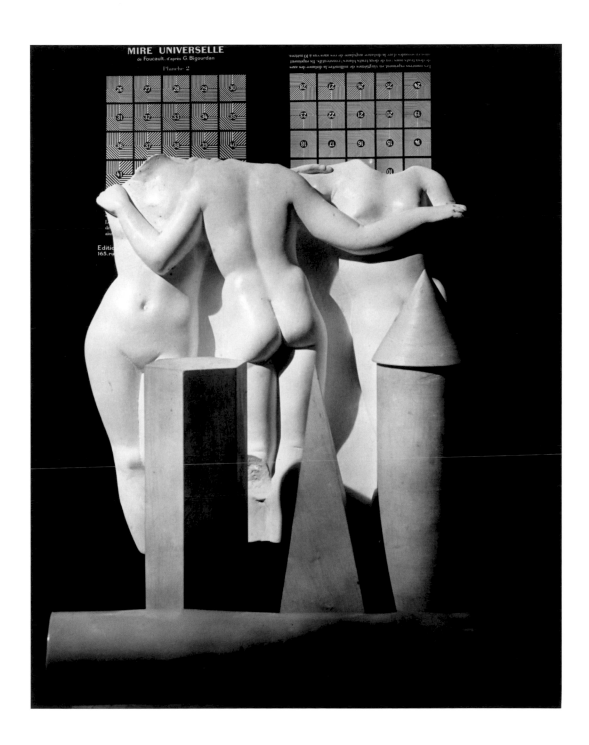

Untitled
c. 1936

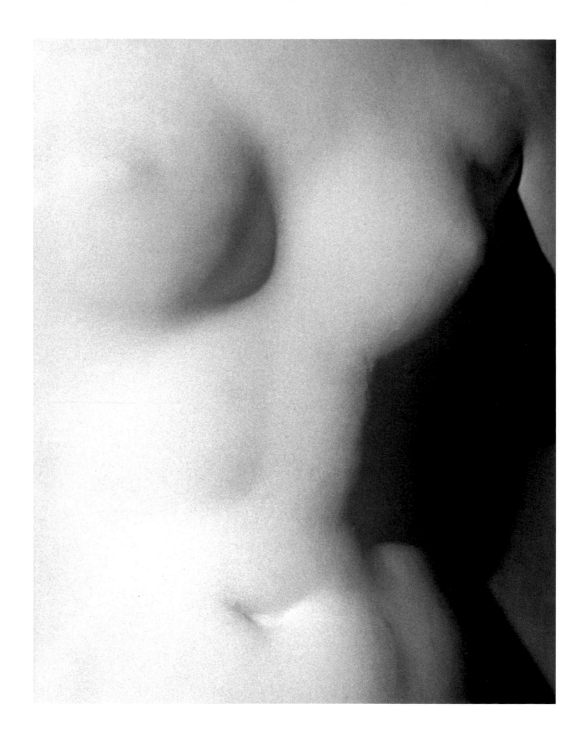

Untitled
1931

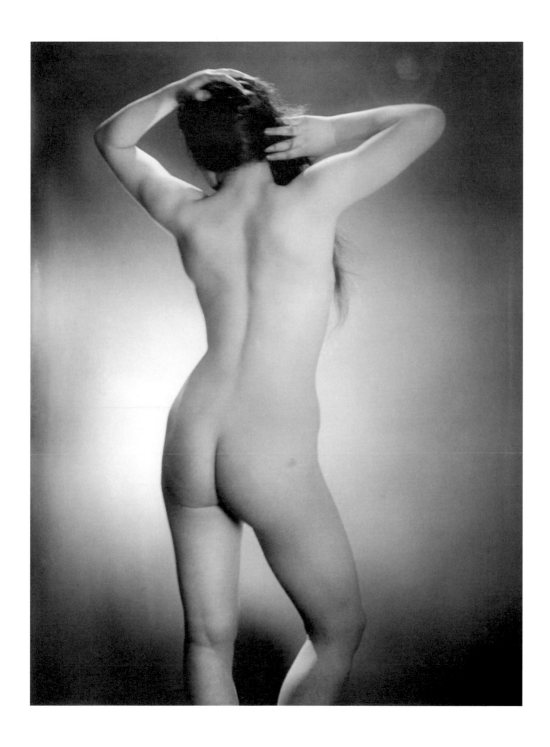

Chevelures
1937

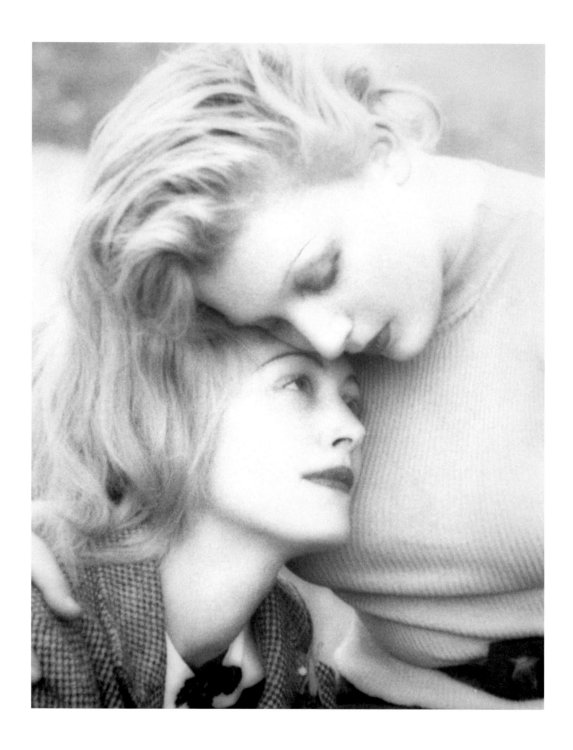

Nusch and Sonia
1935

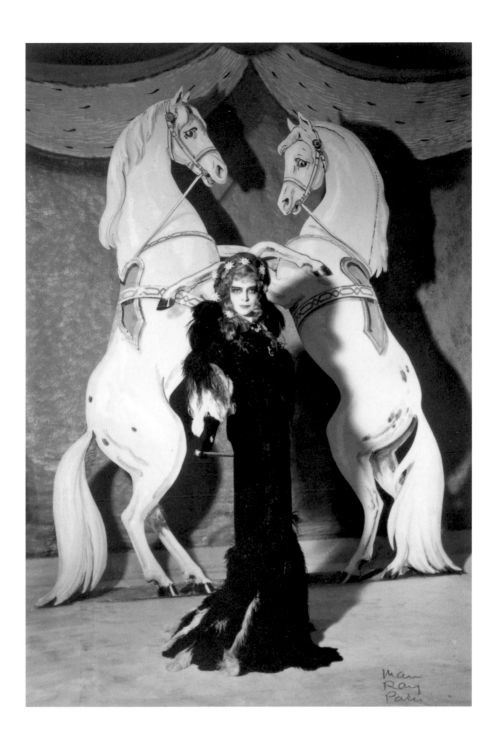

La Marquise Casati
1935

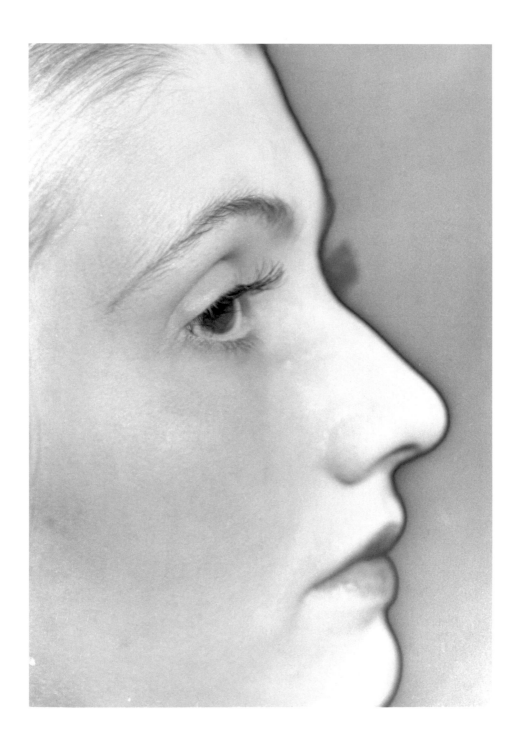

Untitled
c. 1930

Kein einziges Werk in diesem Œuvre kann als experimentell betrachtet werden. Die Kunst ist keine Wissenschaft.

Nor can any of this work be considered experimental.
Art is not a science.

On ne peut tenir non plus aucune de ces œuvres pour expérimentales. L'art n'est pas une science.

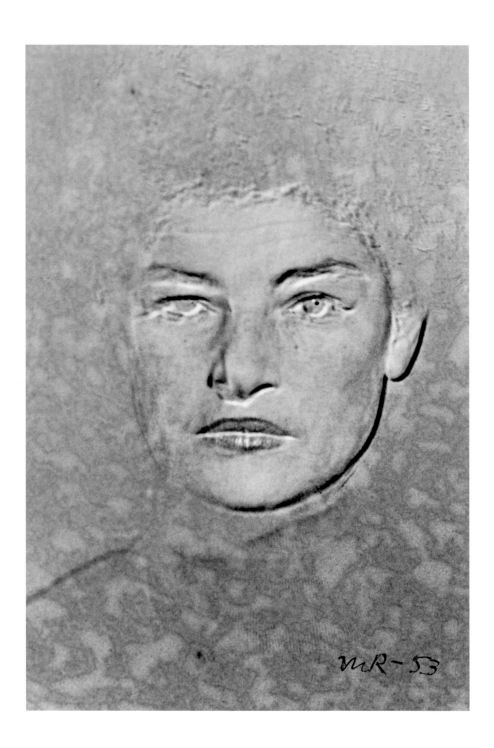

Portrait of a Poet [Juliet]
1953

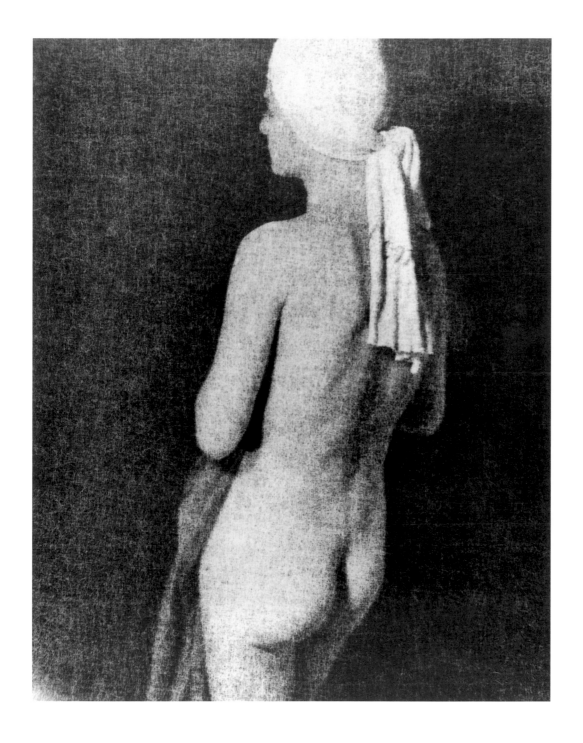

Juliet
c. 1945

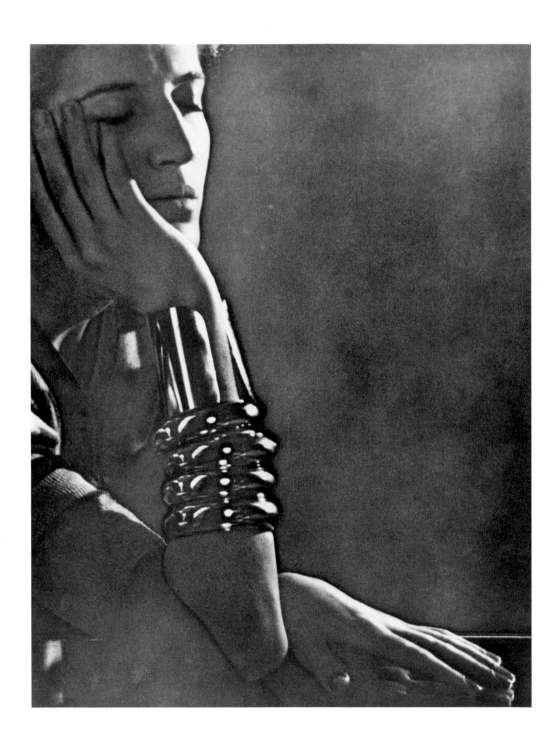

Jacqueline Goddard
c. 1932

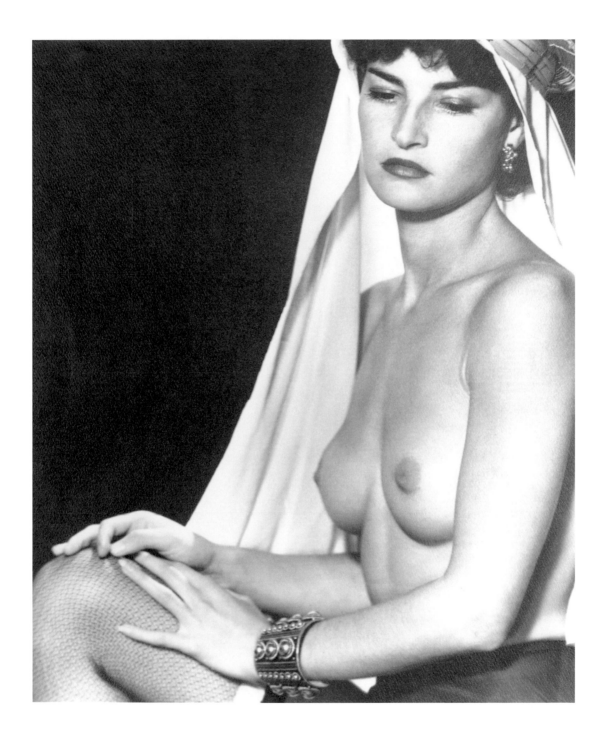

Juliet
c. 1946

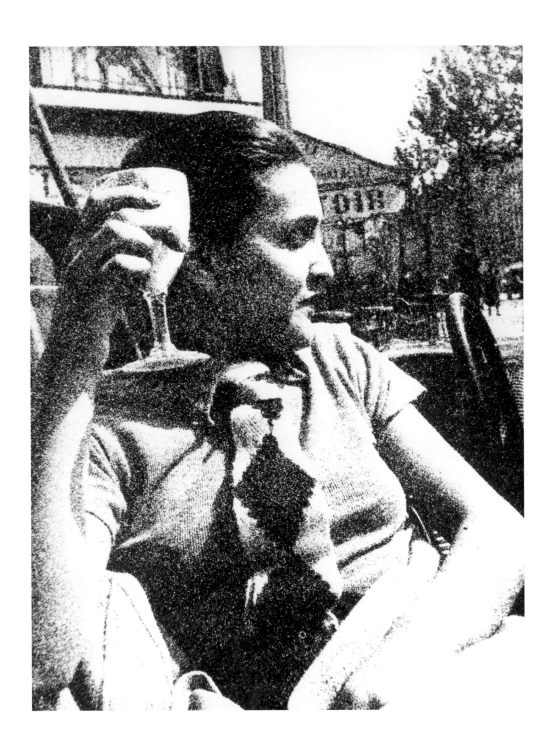

Meret Oppenheim
c. 1930

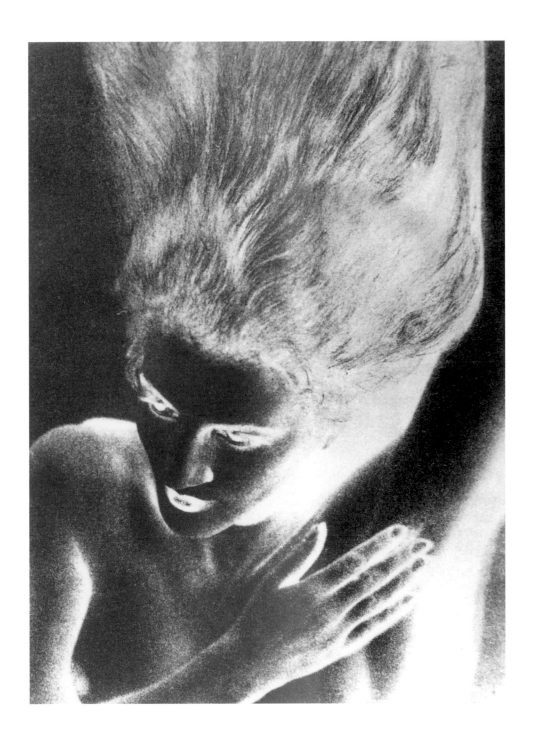

Jacqueline
1930

Chemist of Mysteries

The Life and Photographic Work of Man Ray

Chemiker der Mysterien

Das Leben und das fotografische Werk von Man Ray

Le chimiste des mystères

La vie et l'œuvre photographique de Man Ray

Katherine Ware

Man Ray was an artist unconstrained by rules who considered the medium in which he worked a mere convenience in the service of his ideas. Not only did he succeed in stretching the boundaries of what we consider photography, but he also challenged our notions of beauty to an extent that still informs our outlook today. Though he initially picked up a camera to photograph his paintings, Man Ray became one of the most inventive practitioners of photography in the twentieth century. By assembling a vocabulary of seldom-used darkroom techniques he freed photography from its reputation for recording the observable world and used it to create images drawn from the imagination. Little did he know that not much more than a decade after his death, this body of work – which he suppressed in the last decades of his life – would come to rank among the world's most highly respected collections, or that individual photographs from it would consistently command record prices at auctions.

Born Emmanuel Radnitzky in Philadelphia on August 27, 1890, Man Ray was the eldest child of Minya and Melach Radnitzky, a talented seamstress and tailor who had recently emigrated from Russia. By the time he was seven years old, the family had moved to Brooklyn, New York. As a child, Manny showed an interest in art, later recalling his first masterpiece as a particularly vivid drawing of the bombed battleship USS *Maine*. He was a good student and embarked on a course of training at Boys' High School including draftsmanship, architecture, engineering, and lettering that would prove useful throughout his life. His budding interest in painting drew him to Manhattan where he began to explore art museums and galleries. Upon graduation in 1908, the young Man turned down a scholarship to study architecture in order to pursue his ambition of becoming a painter. Though the decision was the source of family friction, the Radnitzkys accommodated their son by giving him a room to

Man Ray war ein Künstler, der sich keinen Regeln unterwarf, für den das Medium, in dem er arbeitete, nur ein Vehikel für seine Ideen war. Es gelang ihm, die Grenzen unserer Vorstellungen von der Fotografie auszudehnen und den herkömmlichen Schönheitsbegriff nachdrücklich und nachhaltig in Frage zu stellen. Er, der anfänglich mit der Kamera nur seine Gemälde dokumentieren wollte, befreite mit Hilfe selten verwendeter Dunkelkammertechniken die Fotografie von ihrem Ruf, der Dokumentation der Realität zu dienen. Man Ray schuf mit der Kamera Bilder, die aus seiner Phantasie hervorgegangen waren und die ihm den Ruf des schöpferischsten Fotografen unseres Jahrhunderts eintrugen. Er selbst allerdings distanzierte sich in den letzten Jahrzehnten seines Lebens von seinem fotografischen Werk, und er konnte kaum ahnen, daß seine Fotografien heute auf Auktionen Rekordpreise erzielen. Man Ray wurde am 27. August 1890 als Emmanuel Radnitzky in Philadelphia geboren. Er war das älteste Kind der Näherin Minya und des Schneiders Melach Radnitzky, die kurz zuvor aus Rußland in die USA eingewandert waren. Als er sieben Jahre alt war, zog die Familie nach Brooklyn, New York. Schon als Kind zeigte Manny künstlerische Interessen; sein erstes Meisterwerk war, wie er sich später erinnerte, eine äußerst lebendige Zeichnung des zerbombten Kriegsschiffs USS Maine. Er war ein guter Schüler, und von den Grundkenntnissen in technischem Zeichnen, Architektur, Ingenieurwesen und Typographie, die er sich in der High-School erwarb, profitierte er sein Leben lang. Sein starkes Interesse an der Malerei zog ihn oft in die Kunstmuseen und Galerien von Manhattan, und als er 1908 die Schule verließ, schlug er ein Stipendium für ein Architekturstudium aus, weil er Maler werden wollte. Obwohl dieser Entschluß bei seinen Eltern wenig Verständnis fand, ließen sie ihn schließlich in ihrem Haus ein Atelier einrichten. Man Rays früheste Gemälde waren *en plein air* gemalte Landschaften und Porträts seiner Geschwister, insbesondere seiner Schwester Dora.

Die prägenden Jahre seiner Entwicklung fielen in eine stürmische Zeit in der

Loin de se laisser emprisonner dans le carcan des règles traditionnelles, Man Ray considérait la forme dans laquelle il travaillait comme un simple moyen au service de ses idées. C'est ainsi qu'il a non seulement élargi les frontières de ce que nous entendons d'ordinaire par photographie, mais également mis en cause nos conceptions de la beauté, à tel point que son influence continue à se faire sentir encore aujourd'hui. Bien qu'au départ il ait simplement eu recours à l'appareil pour photographier ses tableaux, il s'est peu à peu imposé comme l'un des praticiens les plus inventifs du genre au XXe siècle. En recourant à tout un arsenal de techniques de développement rarement utilisées, il a pourfendu l'idée répandue que la photographie se bornait à archiver le monde visible et il s'en est servi pour donner forme à son imagination. Sans doute lui était-il difficile de soupçonner que ce pan de son œuvre [qu'il s'ingénia à nier ou à détruire dans les dernières années de sa vie] comportait des travaux qui, dix ans à peine après sa mort, allaient compter parmi les photographies les plus recherchées au monde et atteindre des records de prix dans les ventes aux enchères.

De son vrai nom Emmanuel Radnitzky, Man Ray naquit à Philadelphie le 26 août 1890. C'était le fils aîné de Minya et de Melach Radnitzky, émigrés russes de fraîche date qui exerçaient avec talent les professions de couturière et de tailleur. Avant son septième anniversaire, la famille avait déménagé pour s'installer dans le quartier de Brooklyn à New York. Dans son enfance, le petit Manny manifesta un intérêt certain pour l'art ; plus tard, il devait se souvenir que son premier chef-d'œuvre avait été un dessin haut en couleurs de l'USS Maine, un croiseur de guerre qui avait été bombardé. C'était un bon élève ; au lycée, il suit des cours de dessin industriel, d'architecture, de construction mécanique et de typographie qui allaient se révéler utiles toute sa vie. Sa passion naissante pour la peinture l'attirait à Manhattan, où il se mit à fréquenter les musées et les galeries d'art. En 1908, une fois ses études secondaires terminées, il refusa une bourse qui lui aurait permis de poursui-

use as a studio. Man Ray's earliest paintings were landscapes made *en plein air* and portraits of his siblings, especially his sister Dora.

Man Ray was at a receptive, formative stage of development during a tumultuous time in the art world. As artists in Paris struggled to portray the dynamic of modern European life using the Cubist style created by Pablo Picasso and Georges Braque, a New York group, known as *The Eight* or the *Ashcan School*, adopted a similar palette of dark colors to depict the gritty reality of American urban life with verisimilitude. Both the American and European approaches proved to be important influences on the young artist.

While still in high school Man Ray had discovered Alfred Stieglitz's gallery where work by European modernists such as Picasso, Paul Cézanne, and Auguste Rodin was displayed in the u.s. for the first time. The gallery had been opened in 1905 as an exhibition space for Stieglitz and his *Photo-Secession* group. Originally known as the Little Galleries of the Photo Secession, it came to be known as 291 after its house number on Fifth Avenue. After championing photography as a fine art in the early 1910s, Stieglitz next turned his attention to promoting modernist art. In addition to showing recent work from abroad, he nurtured a group of American painters with whom Man Ray was sometimes invited to dine. Stieglitz was a charismatic figure who lived his life in passionate support of art the rest of the world wasn't ready to accept. The paintings in his gallery often went unsold because the prices he assigned to them were based on his own high valuation of the work rather than what the market would bear. In 1913, Stieglitz mounted a retrospective exhibition of his own photographs at 291. His placement of photography on a par with painting and his powerful presence – the drooping grey moustache, dark cape, and uncompromising personality – made a lasting impression on the young artist.

Welt der Kunst. Während die Künstler in Paris mit Hilfe des von Pablo Picasso und Georges Braque entwickelten kubistischen Stils das dynamische Leben des modernen Europa wiederzugeben versuchten, griff eine als *The Eight* oder *Ashcan School* bekannte New Yorker Gruppe auf eine ähnliche Palette dunkler Farben zurück, um die harte Realität des amerikanischen Großstadtlebens wahrheitsgetreu darzustellen. Sowohl die amerikanischen wie die europäischen Strömungen übten einen wichtigen Einfluß auf den jungen Künstler aus.

Schon als Schüler an der High-School hatte er Alfred Stieglitz' Galerie entdeckt, die erste amerikanische Galerie, in der Arbeiten moderner europäischer Künstler wie Picasso, Paul Cézanne und Auguste Rodin gezeigt wurden. Sie war – zunächst unter dem Namen Little Galleries of the *Photo-Secession* – 1905 als Ausstellungsraum für Stieglitz und die Fotografen der von ihm gegründeten Gruppe *Photo-Secession* eröffnet worden und wurde [nach der Hausnummer an der Fifth Avenue] als 291 bekannt. Nachdem er sich in den ersten Jahren unseres Jahrhunderts für die Anerkennung der Fotografie als eigenständige Kunstform eingesetzt hatte, wandte Stieglitz sich der Förderung der Kunst der Moderne zu. Er stellte nicht nur neuere Arbeiten aus Europa aus, sondern nahm sich auch amerikanischer Maler an. Manchmal wurde Man Ray zusammen mit ihnen von Stieglitz zum Lunch eingeladen. Stieglitz war eine charismatische Persönlichkeit; er hatte sich der Förderung jener Kunst verschrieben, die der Rest der Welt nicht akzeptieren wollte. Die in seiner Galerie ausgestellten Gemälde blieben oft unverkauft, weil die Preise nicht dem Marktwert, sondern seiner eigenen hohen Wertschätzung entsprachen. 1913 zeigte Stieglitz in 291 eine Retrospektive seines eigenen fotografischen Werks. Seine Gleichsetzung der Fotografie mit der Malerei und seine imponierende Persönlichkeit – der tief herabhängende graue Schnurrbart, der dunkle Umhang und sein kompromißloser Charakter – machten einen nachhaltigen Eindruck auf den jungen Künstler.

vre des études d'architecture et mit tout en œuvre pour réaliser son ambition : devenir peintre. Même si cette décision ne fut pas sans provoquer quelques frictions au sein de la famille, les Radnitzky finirent par l'accepter et ils mirent à la disposition de leur fils une pièce de la maison. Il en fit son atelier et commença par peindre des paysages en plein air et des portraits de ses frères et sœurs, en particulier de Dora.

Pendant son adolescence et ses années de formation, Man Ray se montra réceptif à l'effervescence qui caractérisait alors le monde de l'art. Tandis qu'à Paris, dans la mouvance du style cubiste créé par Pablo Picasso et Georges Braque, les peintres s'efforçaient de représenter le chahut de la vie moderne en Europe, à New York, un groupe d'artistes connu sous le nom des *Huit* – ou *École de la Poubelle [Ashcan School]* – employait pareillement une palette de couleurs sombres pour montrer avec vraisemblance les dures réalités de la vie urbaine en Amérique. C'est ainsi qu'il subit très tôt la double influence de l'approche américaine et de la démarche européenne.

Il était encore élève au lycée quand il découvrit la galerie d'Alfred Stieglitz et, exposées pour la première fois en Amérique, des œuvres d'art moderne signées par Pablo Picasso, Paul Cézanne, Auguste Rodin, etc. Cette galerie avait ouvert ses portes en 1905 pour présenter les travaux de Stieglitz et de son groupe de la *Photo-Secession*. D'abord connue sous le nom des Petites Galeries de la *Photo-Secession*, elle fut bientôt rebaptisée « 291 », suivant le numéro de la Cinquième Avenue où elle était située. Après avoir ardemment défendu la photographie d'art dans les années 1910, Stieglitz s'attacha bientôt à promouvoir l'art moderne. Non seulement il exposait des œuvres étrangères récentes, mais il veillait sur un petit groupe de peintres américains avec lesquels Man Ray était parfois invité à dîner. Alfred Stieglitz possédait une personnalité charismatique, il passait sa vie à prendre fait et cause pour l'art que le reste du monde n'était pas prêt à accepter. Souvent, les tableaux qu'il exposait ne trouvaient pas acquéreurs parce qu'il leur attribuait des prix

In the early 1910s, Man Ray enrolled in life drawing classes at the National Academy of Design in New York, where he developed his drafting skills in a new direction. To support himself, Man Ray accepted a job designing maps and atlases at the McGraw Company in downtown Manhattan, which sustained him financially for the next six years. On lunch breaks, he continued to frequent the New York art galleries. He also took classes at the highly regarded Art Students' League and in 1912 began attending informal classes at the Ferrer Center. The evening art class was taught by none other than Robert Henri. The young artist took to heart Henri's emphasis on rapidity and realism and was proud of his ability to sketch a credible likeness in less than five minutes.

The heated debate about the value of modern art moved from obscure journals to the popular press when *The International Exhibition of Modern Art*, also known as the *Armory Show*, opened in New York in February 1913. The massive exhibition – 1200 paintings and sculptures – was intended to present a comprehensive look at modern art that would make it seem less threatening to the public. A range of works from America and Europe was shown, with a smaller section suggesting the "history" of modern art.

The *Armory Show* was remarkable in presenting not only the largest concentration of twentieth-century European art ever to be seen in the U.S. but also significant works by artists never previously exhibited there. Artwork from abroad included pieces by Paul Gauguin, Vincent Van Gogh, Constantin Brancusi, Henri Matisse, and Wassily Kandinsky. Representing the Americans were Marsden Hartley, John Sloan, Alfred Maurer, and Charles Sheeler among many others. Entering this whirlwind of ideas and sensations was an overwhelming experience for many visitors, even those primed by the smattering of contemporary works shown in commercial galleries.

1910 belegte Man Ray Aktzeichenkurse an der National Academy of Design in New York, um seine zeichnerischen Fertigkeiten weiterzuentwickeln und neue Richtungen einzuschlagen. Für die nächsten sechs Jahre fand er einen Job als Zeichner bei dem Landkarten- und Atlantenverlag McGraw Co. in Downtown Manhattan. Seine Mittagspausen verbrachte er oft in den New Yorker Kunstgalerien. 1911 belegte er Kurse an der hoch angesehenen Art Students' League, und von 1912 an nahm er an Kursen im Ferrer Center teil. Der Abendkurs in Kunst wurde von keinem Geringeren als Robert Henri geleitet. Der junge Künstler bewunderte dessen kühnen, heftigen Strich und war stolz auf seine Fähigkeit, in weniger als fünf Minuten eine realistische Skizze zeichnen zu können.

Als im Februar 1913 in New York die auch als *Armory Show* bekanntgewordene *International Exhibition of Modern Art* eröffnet wurde, griff auch die Tagespresse in die zuvor nur von einer interessierten Minderheit hitzig geführte Debatte über die moderne Kunst ein. Mit einem umfassenden Überblick wollte die gewaltige Ausstellung – 1200 Gemälde und Skulpturen – das breite amerikanische Publikum an die moderne Kunst heranführen. Sowohl amerikanische als auch europäische Künstler waren daran beteiligt, und eine kleinere Abteilung war der »Geschichte« der modernen Kunst gewidmet.

Die *Armory Show* war die größte Präsentation europäischer Kunst des 20. Jahrhunderts, die bis dahin in den USA zu sehen war, und viele Künstler wurden hier zum ersten Mal mit bedeutenden Werken dem amerikanischen Publikum vorgestellt. Zu den europäischen Künstlern zählten Paul Gauguin, Vincent van Gogh, Constantin Brancusi, Henri Matisse und Wassily Kandinsky, zu den vielen amerikanischen Teilnehmern Marsden Hartley, John Sloan, Alfred Maurer und Charles Sheeler. Viele Besucher, selbst die, die der zeitgenössischen Kunst schon in den New Yorker Galerien begegnet waren, waren überwältigt von den Ideen und Eindrücken, die hier auf sie

fondés sur la haute estime dans laquelle il les tenait, sans prendre en compte l'état réel du marché de l'art. En 1913, Stieglitz monta une rétrospective de ses propres photographies à la Galerie 291. La proximité ainsi recherchée entre photographie et peinture, la présence imposante de l'homme [avec sa moustache grise tombante, sa cape sombre, son caractère intransigeant] laissèrent une impression durable sur le jeune Man Ray.

Au début des années 1910, Man Ray s'inscrivit à la National Academy of Design de New York pour avoir l'occasion de développer ses talents dans une autre direction. Pour subvenir à ses besoins, il avait accepté un emploi de cartographe à la firme McGraw située dans le sud de Manhattan, et c'est ainsi qu'il gagna sa vie pendant les six années qui suivirent. À l'heure du déjeuner, il continuait à fréquenter les galeries new-yorkaises. Il prit aussi des cours à l'Art Students' League, qui jouissait d'une grande réputation, puis, à partir de 1912, au Ferrer Center. Le cours du soir y était assuré par nul autre que Robert Henri. Prenant à cœur la volonté d'accentuer rapidité et réalisme, le jeune Man Ray mettait son point d'honneur à réaliser en moins de cinq minutes un croquis ressemblant.

Lorsque, en février 1913, *l'International Exhibition of Modern Art* [Exposition internationale d'art moderne], également connue sous le nom d'*Armory Show*, ouvrit ses portes à New York, la controverse passionnée sur la valeur de l'art moderne déborda le cadre étroit de revues spécialisées et se répandit jusque dans les colonnes de la presse populaire. Cette gigantesque exposition, qui regroupait quelque 1200 tableaux et sculptures, avait pour but de présenter un panorama relativement exhaustif de l'art moderne pour redorer son blason aux yeux du public. Elle comprenait une sélection importante d'œuvres américaines et européennes, et même une petite section consacrée à l'histoire de l'art moderne.

À l'*Armory Show*, on put voir non seulement la plus grande concentration d'art européen du XXe siècle, mais aussi des œuvres d'artistes qui n'avaient

Man Ray visited the exhibition repeatedly and later commented that it took several months afterward to absorb all that he had seen there.

Thus engaged, Man Ray moved in the spring to an artist's colony in Ridgefield, New Jersey. Holed up at this pastoral retreat in the afterglow of the *Armory Show*, Man Ray began finding his way in a new style of painting, creating Cubist-inspired canvases in rich earth tones. In Ridgefield he imagined himself free of social and artistic constraints, living closer to nature like his literary heroes Walt Whitman and Henry David Thoreau. The colony was a gathering place for the Ferrer Center crowd. This sense of isolation with an elite group of outsiders reinforced Man Ray's determination to forge his own artistic path. Man Ray began an affair with the Belgian writer Adon Lacroix, whom he married in 1914. Lacroix was the former wife of Adolf Wolff – a friend of Man Ray's from the Ferrer Center – with whom she had a child. She became both an early muse and mentor, encouraging his artistic development and introducing Man Ray to the writings of French poets such as Stéphane Mallarmé, Arthur Rimbaud, Charles Baudelaire, and Guillaume Apollinaire.

Convinced that artists were best suited to capturing their own work on film, Man Ray acquired a camera and began to use it around 1914. He mastered the medium after a few months of independent study and some technical advice from Stieglitz. In addition to photographing his artwork, some of his earliest pictures in this medium are of Adon and her daughter Esther, along with occasional visitors. One such visitor, the French artist Marcel Duchamp, became a lifelong friend. Duchamp, on his first visit to America, was already infamous for his 1912 painting *Nude Descending a Staircase* which had been the focus of extensive ridicule in the American press when it appeared in the Armory Show two years earlier. Art collector Walter Arensberg had been squiring

einstürmten. Man Ray besuchte die Ausstellung mehrmals und sagte später, er habe Monate gebraucht, um alle diese neuen Eindrücke zu verarbeiten. Im Frühjahr zog Man Ray in eine Künstlerkolonie in Ridgefield, New Jersey. Unter dem Eindruck der *Armory Show* suchte er in dieser ländlichen Abgeschiedenheit neue stilistische Wege und malte vom Kubismus inspirierte Bilder in reichen Erdtönen. In Ridgefield fühlte er sich frei von gesellschaftlichen und künstlerischen Zwängen und lebte wie seine literarischen Helden Walt Whitman und Henry David Thoreau ein Leben in der Natur. Ridgefield war ein beliebter Treffpunkt für die Leute vom Ferrer Center. Dieses Leben in der Abgeschiedenheit und mit einer Gruppe progressiver Außenseiter bestärkte ihn in seinem Entschluß, seinen eigenen künstlerischen Weg zu finden. Er begann eine Affäre mit der belgischen Schriftstellerin Adon Lacroix, die er 1914 heiratete. Lacroix war mit Adolf Wolff – einem Freund Man Rays aus dem Ferrer Center – verheiratet gewesen, mit dem sie ein Kind hatte. Sie wurde Man Rays frühe Muse und Ratgeberin, ermutigte ihn in seiner künstlerischen Entwicklung und machte ihn mit den Schriften französischer Dichter wie Stéphane Mallarmé, Arthur Rimbaud, Charles Baudelaire und Guillaume Apollinaire bekannt. Um 1914 erwarb Man Ray eine Kamera, um seine Gemälde fotografisch zu dokumentieren. Er ließ sich von Stieglitz technische Ratschläge geben und eignete sich das Medium in wenigen Monaten an. Neben Reproduktionen seiner Gemälde finden sich unter seinen frühesten Fotografien Porträts von Adon und ihrer Tochter Esther sowie von Leuten, die ihn besuchten. Mit einem dieser Besucher, dem französischen Künstler Marcel Duchamp, schloß er eine lebenslange Freundschaft. Duchamp, der sich damals zum ersten Mal in Amerika aufhielt, war dort durch sein Gemälde *Akt, eine Treppe herabsteigend* von 1912, das in der *Armory Show* zu sehen gewesen und von der amerikanischen Presse mit Spott überhäuft worden war, zu skandalträchtiger Berühmtheit gelangt. Der Kunstsammler Walter Arensberg führte Duchamp

jamais été exposés aux États-Unis : parmi eux, Paul Gauguin, Vincent van Gogh, Constantin Brancusi, Henri Matisse et Wassily Kandinsky. Les Américains, pour leur part, étaient représentés par Marsden Hartley, John Sloan, Alfred Maurer, Charles Seeler, etc. En pénétrant dans ce tourbillon d'idées et de sensations, bien des visiteurs recevaient le choc de plein fouet, même ceux qui s'étaient familiarisés avec une poignée d'œuvres contemporaines grâce à des expositions ponctuelles dans des galeries commerciales. Man Ray revint maintes fois à *l'Armory Show*. À en croire ses déclarations ultérieures, il aurait eu besoin de plusieurs mois pour assimiler toutes ces nouvelles impression .

Profondément touché par ces œuvres, il partit s'installer dans une colonie d'artistes située à Ridgefield, dans le New Jersey, au printemps de cette année-là. Terré dans cette retraite bucolique, ruminant les souvenirs éblouis de l'Armory Show, il s'achemina peu à peu vers un nouveau style de peinture et s'inspira du cubisme dans des tableaux aux riches teintes brunes. À Ridgefield, il se sentait libéré des contraintes sociales et artistiques et, comme ses écrivains fétiches, Walt Whitman et Henry David Thoreau, il avait l'impression de vivre plus près de la nature. La communauté attirait les habitués du Ferrer Center. Ce double sentiment d'isolement et d'appartenance à une petite coterie de marginaux renforça Man Ray dans sa conviction de chercher sa propre voie artistique. Il entama une liaison avec la femme écrivain belge Adon Lacroix, qu'il épousa en 1914. Ancienne épouse d'Adolf Wolff, que Man Ray avait connu au Ferrer Center et dont elle avait eu une fille, Adon Lacroix devint rapidement son égérie, son modèle à penser : elle l'encouragea à développer ses dons d'artiste et lui fit lire les œuvres de poètes français comme Stéphane Mallarmé, Arthur Rimbaud, Charles Baudelaire et Guillaume Apollinaire.

Fort de l'idée que les artistes étaient les mieux placés pour photographier leurs propres œuvres, Man Ray se procura un appareil et commença à s'en

Duchamp around town, introducing him to a cultural vanguard more hospitably inclined toward his work. Man Ray's cottage was an inevitable stop on the tour. Conversation between the two artists at this initial meeting was hampered by a language barrier so they resorted to playing tennis. Nonetheless, they recognized each other as kindred spirits and soon became co-conspirators, collaborators, chess partners, and enduring friends. The two artists shared a penchant for elevating prosaic things to the esthetic status of fine art. One of their more famous joint creations was the invention of an alter-ego for Duchamp in 1920, a dowager named Rrose Sélavy [the name is a play on the phrase *Eros c'est la vie* ("eros is life")] who appeared in several photographs by Man Ray, was featured on a perfume label [ill. p. 129] designed by Duchamp, and even contributed an essay to Man Ray's 1934 book of photographs.

In 1915 Man Ray presented his first solo exhibition at the Daniel Gallery, one of several galleries that had opened in New York to support modern art after the *Armory Show*. Critics who reviewed his new work were not particularly impressed, though they praised the more tradition-al landscapes. Discouraged by this tepid reception, Man Ray declined an offer to be included in another show in order to concentrate on painting. Yet his debut did not go completely unappreciated. After the show closed, Chicago lawyer and collector Arthur Jerome Eddy – a man of prescient taste who was one of the top buyers of work from the *Armory Show* – visited the gallery and purchased six paintings.

With this vote of confidence and the $ 2000 it brought, Man Ray reduced his hours at the McGraw Company and took a studio in midtown Manhattan. Placing himself in the middle of the action, he embarked on a highly fruitful year. Whereas in New Jersey he sought retreat and concentration, in New York he craved stimula-

durch New York und machte ihn mit der kulturellen Avantgarde bekannt, die seinem Werk wohlwollend gegenüberstand. Natürlich gehörte auch Man Rays Zuhause zu den Stationen dieser Tour. Da bei dieser ersten Begegnung einem Gespräch zwischen den beiden Künstlern die Sprachbarriere im Wege stand, spielten sie statt dessen Tennis. Sie erkannten einander sogleich als geistesverwandte Seelen und wurden bald zu verschworenen Partnern in der Welt der Kunst und des Schachs. Beide hatten eine Vorliebe dafür, prosaischen Dingen den ästhetischen Rang schöner Kunst zu verleihen. Zu den bekannteren Ergebnissen ihrer Zusammenarbeit zählt 1920 die Erfindung eines Alter ego für Duchamp, einer Witwe namens *Rrose Sélavy* [eine Verballhornung von »Eros c'est la vie«], die nicht nur auf mehreren Fotografien von Man Ray und auf einem von Duchamp entworfenen Parfümetikett [Abb. S. 129] erschien, sondern sogar einen Essay für das Buch *Photographs by Man Ray 1920 Paris 1934* beisteuerte.

1915 hatte Man Ray in der Daniel Gallery, einer von mehreren Galerien für moderne Kunst, die nach der Armory Show in New York eröffnet worden waren, seine erste Einzelausstellung. Die Kritiker waren von seinen neuen Werken nicht sonderlich beeindruckt; sie lobten allerdings die traditionelleren Landschaften. Von dieser lauen Resonanz entmutigt, lehnte er ein anderes Ausstellungsangebot ab, um sich ganz auf seine Malerei zu konzentrieren. Zum Schluß war sein Debüt dann doch noch von Erfolg gekrönt. Nach Beendigung der Ausstellung kam der Chicagoer Anwalt und Sammler Arthur Jerome Eddy – ein Mann von weitsichtigem Kunstverständnis, der zu den wichtigsten Käufern bei der *Armory Show* gezählt hatte – in die Galerie und erwarb sechs Gemälde.

Ermutigt und um 2000 Dollar reicher, reduzierte Man Ray seine Arbeitszeit bei der McGraw Co. und mietete ein Atelier in Midtown Manhattan. Hier, mitten im Getriebe der Großstadt, begann für ihn ein ungemein ertragreiches Jahr. Während er in New Jersey Zurückgezogenheit und Konzentration

servir vers 1914. Au bout de quelques mois, après avoir travaillé en solitaire et glané des conseils techniques auprès de Stieglitz, il s'était rendu maître des opérations. Outre ses tableaux et ses dessins, il se mit à prendre des photographies d'Adon et de sa fille Esther, ainsi que de certains visiteurs qui venaient de temps à autre à Ridgefield. Avec l'un d'entre eux, l'artiste français Marcel Duchamp, il noua des liens d'amitié qui durèrent toute leur vie. C'était le premier voyage de Duchamp aux États-Unis, mais il jouissait déjà d'une réputation sulfureuse : son tableau intitulé *Nu descendant un escalier* avait été la cible d'attaques virulentes dans la presse américaine lorsqu'il avait été exposé à l'Armory Show deux ans plus tôt. Le collectionneur Walter Arensberg escorta Duchamp dans ses sorties. Il lui présenta l'avant-garde culturelle, qui était animée de sentiments moins hostiles à l'égard de son travail, et il ne put naturellement éviter le détour par la petite maison de Man Ray à Ridgefield. Séparés par la barrière des langues, incapables d'engager une véritable conversation lors de cette première rencontre, les deux artistes en vinrent à jouer au tennis. Mais cela ne les empêcha pas de se reconnaître mutuellement comme des frères spirituels, et c'est ainsi qu'ils devinrent rapidement complices, collaborateurs, partenaires aux échecs, amis fidèles. Tous deux voulaient élever la banalité prosaïque au même rang esthétique que l'art, et ils avaient pareillement tendance à choisir des objets ordinaires qui, une fois examinés de près, soulevaient leur admiration. Ensemble, en 1920, ils inventèrent à Duchamp son sosie resté célèbre : *Rrose Sélavy*, vieille douairière dont le nom sonnait comme «Éros c'est la vie». Elle apparut sur plusieurs clichés de Man Ray, fut représentée sur une étiquette de parfum [ill. p. 129] dessinée par Duchamp, et signa même un texte publié dans un livre de photographies de Man Ray en 1934.

En 1915, Man Ray présenta sa première exposition individuelle à la Daniel Gallery, laquelle comptait parmi les nouveaux espaces récemment ouverts à New York dans le but de promouvoir l'art moderne après l'Armory Show.

tion and connection. Evenings might be spent at the Arensbergs' high-spirited salon, populated by painters, composers, and minor celebrities. Duchamp was not far away, having rented a place downtown and working as a librarian while beginning to tinker with his *Large Glass* [1915-23]. Berenice Abbott, a young sculptor from Ohio, often joined Man Ray and Duchamp for dancing and carousing in Greenwich Village.

During the next year, Man Ray expanded his artmaking to include collages, assemblages, and sculpture, as well as, since 1917, paintings made with an airbrush. These "aerographs", as he called them, lent a photographic quality to their subjects that appealed to the artist. The necessary rapidity with which they were created and the absence of direct contact with the canvas delighted him. He had his second show at the Daniel Gallery in December 1916. For the first time Man Ray exhibited an assemblage: *Self-Portrait,* a painting of a doorway to which he attached a disassembled doorbell. The piece is an early example of Man Ray's attempt to engage his viewers actively. When visitors to the gallery pressed the buzzer, they were mystified to discover the bell did not ring. The artist found it humorous that his audience considered him "a bad electrician," but hoped they would be compelled to reach beyond the obvious to find some meaning in the assemblage.

In 1917 Stieglitz again devoted the walls of 291 to photography for the gallery's final exhibition. He featured the work of the American photographer and Stieglitz protégé Paul Strand, whose daring compositions bordered on abstraction. Such pictorial experimentation was being carried even further in London, where American photographer Alvin Langdon Coburn was using the camera to create non-figurative images he called "vortographs". While Strand's work was solidly grounded in figurative reality, Coburn removed all reference to the recognizable world in these pictures. Man Ray was involved in his own photographic adventures that year,

gesucht hatte, wollte er in New York Anregungen finden und Kontakte knüpfen, zum Beispiel in den Abendsalons der Arensbergs, wo sich Maler, Komponisten und andere interessante Leute trafen. Auch Duchamp hatte sich in New York niedergelassen, arbeitete als Bibliothekar und hatte die Arbeit an seinem *Großen Glas* [1915-23] begonnen. Und Berenice Abbott, eine junge Bildhauerin aus Ohio, traf sich oft mit Man Ray und Duchamp in den Tanzlokalen und Kneipen von Greenwich Village.

Im Laufe des nächsten Jahres erweiterte Man Ray seine Kunstproduktion um Collagen, Assemblagen und Skulpturen sowie seit 1917 um mit einer Spritzpistole gefertigte Gemälde. Diese Aerografien, wie er sie nannte, verliehen den dargestellten Sujets eine fotografische Eigenschaft, die ihm ebenso gefiel wie der Entstehungsprozeß: Die Farbe mußte schnell und ohne direkten Kontakt mit der Leinwand aufgetragen werden. Im Dezember 1916 hatte er seine zweite Ausstellung in der Daniel Gallery. Hier präsentierte Man Ray zum ersten Mal eine Assemblage: *Self-Portrait*, das Bild einer Tür mit einer darauf befestigten zerlegten Klingel. Wenn die Galeriebesucher auf den Knopf drückten, stellten sie verblüfft fest, daß kein Klingeln zu hören war. Der Künstler amüsierte sich darüber, daß man ihn für einen schlechten Elektriker hielt, hoffte aber, daß dem Betrachter der tiefere Sinn – seine aktive Einbeziehung in das Kunstwerk – nicht verborgen bliebe.

1917 stellte Stieglitz die Wände seiner Galerie 291 wieder einmal der Fotografie zur Verfügung. In der letzten Ausstellung, die er in diesen Räumen veranstaltete, zeigte er Arbeiten des amerikanischen Fotografen Paul Strand, den er protegierte und dessen kühne Kompositionen an die Grenzen der Abstraktion reichten. In London ging der amerikanische Fotograf Alvin Langdon Coburn noch weiter in diese Richtung und schuf mit der Kamera nichtfigurative Bilder, die er Vortografien nannte. Während Strands Fotografien fest in der figurativen Realität verankert waren, entfernte Coburn in seinen Bildern alle Verweise auf die erkennbare Welt. Man Ray war in

Dans l'ensemble, les critiques ne furent pas très enthousiastes devant ses dernières œuvres, leur préférence allant aux vues plus traditionnelles de paysages. Découragé par la tiédeur de cet accueil, Man Ray refusa la proposition qui lui était faite de participer à une autre exposition collective et se remit au travail. Ses débuts ne passèrent toutefois pas inaperçus. À l'issue de l'exposition, le collectionneur de Chicago Arthur Jerome Eddy, juriste de son état et amateur avisé [avec son flair caractéristique, il avait été l'un des plus gros acheteurs à l'Armory Show], se rendit à la galerie et fit l'acquisition de six tableaux de Man Ray.

Grâce aux 2000 dollars que lui rapporta la vente, Man Ray put réduire son temps de travail chez McGraw et s'installer dans un atelier situé en plein centre de Manhattan. Il se retrouvait ainsi au cœur de l'action. Commença alors une année fertile et décisive. Autant il était allé chercher de la concentration dans sa retraite du New Jersey, autant il avait soif d'émulation et de contacts à New York. Combien de soirées il passa dans le salon animé des Arensberg, en compagnie de peintres, de compositeurs et de célébrités de second ordre! Duchamp n'était pas loin: il louait un appartement en ville et, tout en travaillant comme bibliothécaire, il commençait à travailler sur son *Grand Verre* [1915–1923]. Berenice Abbott, jeune sculptrice arrivée de l'État d'Ohio, se joignait souvent à eux pour aller danser et faire la bringue dans Greenwich Village.

L'année suivante, Man Ray étendit le champ de ses activités artistiques et se mit à réaliser des collages, des assemblages, des sculptures, ainsi que, depuis 1917, des peintures au pistolet. Ces «aérographes», comme il les appelait, conféraient à leur sujet une dimension photographique qui était loin de lui déplaire. Il aimait la rapidité avec laquelle il devait les fabriquer et l'absence de contact direct avec la toile. Il entraîna une seconde exposition à la Daniel Gallery en décembre 1916. Pour la première fois, Man Ray présenta un assemblage intitulé *Self-Portrait* [Autoportrait], qui montrait une porte peinte

exploring the creative possibilities of *cliché verre* [glass negative]. This nineteenth-century printmaking process involved scratching an image onto a coated glass surface [such as the emulsion of a photographic plate] which could then be used as a negative to make photographic prints. Man Ray's use of the technique, to which he returned at intervals throughout his career, is characterized by a stark, linear drawing style.

Another of Man Ray's innovations during this period was his assortment of object-sculptures. These include an unfurled lamp shade [*Lampshade*, 1919] and a tangle of coat hangers [*Obstruction*, 1920], both titled and presented as works of art. More importantly, Man Ray's shift away from traditional subject matter and media increasingly involved the camera. His photograph *Moving sculpture* [1920] shows a line of laundered clothes twisting in the wind, while *8th Street* [1920] immortalizes a flattened tin can. These works constituted at once a celebration of the three-dimensional incarnation of discarded or pedestrian objects – many subsequently lost or destroyed – and of their reverent preservation as gelatin silver prints. This highly provocative work, stimulated by his relationship with Duchamp, flouted conventional esthetics and challenged the viewer's conceptions of beauty.

By 1920, Man Ray was actively engaged with photography and began exploring in earnest the medium's creative potential. His pictures from this period are full of the excitement of discovery. Having already mastered representational photography, Man Ray tried moving the camera during the exposure and tampering with lens clarity by applying gel to make images that did not reflect the observable world. Other more recognizable subjects were composed to surprise or shock viewers. These prints are mounted, signed, and dated, clearly indicating their status as independent works of art. The daring of Man Ray's vision was rewarded in the spring of that year

diesem Jahr in seine eigenen fotografischen Abenteuer verwickelt und erforschte die kreativen Möglichkeiten des *Cliché-verre* [Glasklischees]. Bei diesem im 19. Jahrhundert entwickelten Vervielfältigungsverfahren wird eine Zeichnung in eine beschichtete Glasplatte eingeritzt, die dann als Negativ für fotografische Abzüge dient. Man Ray griff zeit seines Lebens immer wieder auf dieses Verfahren zurück. Seine Cliché-verre-Technik ist durch einen harten, linearen Zeichenstil charakterisiert.

In dieser Zeit stellte Man Ray auch seine ersten Objektskulpturen zusammen. Dazu gehören ein aufgerollter Lampenschirm [*Lampshade*, 1919] und ein Wirrwarr aus Kleiderbügeln [*Obstruction*, 1920]. Beide wurden als Kunstwerke betitelt und präsentiert. Und auch in seiner Arbeit mit der Kamera entfernte er sich immer mehr von herkömmlichen Sujets. Seine Fotografie *Moving sculpture* [1920] zeigt an der Leine hängende, im Wind tanzende Wäsche und *8th Street* [1920] eine zerquetschte Blechdose: ehrfurchtsvoll auf Gelatine-Silberdrucken verewigte prosaische oder weggeworfene Objekte. Diese äußerst provokativen Werke, in denen der Einfluß von Duchamp deutlich wird, setzten sich über konventionelle ästhetische Vorstellungen hinweg und stellten den Schönheitsbegriff des Betrachters in Frage.

Um 1920 setzte sich Man Ray aktiv mit der Fotografie auseinander und begann das kreative Potential dieses Mediums ernsthaft zu erforschen. Seine Bilder aus dieser Zeit sind voller Experimentier- und Entdeckungsfreude. Man Ray bewegte die Kamera während der Belichtung und trug Gel auf die Linse auf, um Bilder jenseits der sichtbaren Welt zu erzeugen. Diese Abzüge wurden aufgezogen, signiert und datiert, um ihren Status als autonome Kunstwerke deutlich zu machen. Im Frühjahr 1920 wurde die Kühnheit seiner Vision belohnt: Auf Einladung des Dadaisten Tristan Tzara reichte er zwei Fotografien zum *Salon Dada: Exposition Internationale* in Paris ein. Die Fotografien zeigen einen Schneebesen und eine Assemblage aus Wäsche-

à laquelle il avait fixé une sonnette démontée. C'était l'une de ses toutes premières tentatives pour impliquer le spectateur dans l'œuvre. Lorsque celui-ci appuyait sur la sonnette, il se rendait compte à son grand dam qu'elle ne fonctionnait pas. Et Man Ray, même s'il s'amusait à se voir traiter de «piètre électricien», espérait cependant que les spectateurs finiraient par passer outre l'évidence sensible et qu'ils chercheraient une signification à l'assemblage.

En 1917, pour sa dernière exposition, Stieglitz offrit à nouveau les cimaises de la Galerie 291 à un accrochage de photographies – plus précisément aux travaux de son protégé, l'Américain Paul Strand, dont les compositions audacieuses frôlaient l'abstraction. Ce type d'expérimentation picturale était encore plus poussé à Londres où un autre Américain, Alvin Langdon Coburn, utilisait l'appareil photo pour créer des images qui ne devait plus rien à la figuration: des «vortographes», comme il les appelait. Contrairement à Paul Strand, dont le travail prenait encore le réel pour point de départ, Alvin Langdon Coburn éliminait de ses œuvres toute référence au monde tel qu'on le connaît. Man Ray, quant à lui, se consacrait cette année-là à ses propres aventures photographiques: il explorait les possibilités créatrices du «cliché verre», procédé de gravure du XIXe siècle qui se caractérisait par le décalque d'une image sur une surface de verre enduite [par exemple sur l'émulsion d'une plaque photographique], laquelle pouvait ensuite servir de négatif au tirage d'épreuves positives. En l'adoptant à son tour, en y revenant à plusieurs reprises pendant sa carrière, Man Ray s'en servit pour épurer et géométriser son coup de crayon.

Il innova aussi, à cette époque, en réalisant un ensemble de sculptures-objets. Parmi celles-ci figuraient notamment un abat-jour en papier déroulé [*Lampshade*, 1919] et un entrelacs de cintres [*Obstruction*, 1920], tous deux intitulés et présentés comme d'authentiques œuvres d'art. Mais surtout, c'est en se servant de plus en plus de l'appareil photo qu'il prit ses distances par

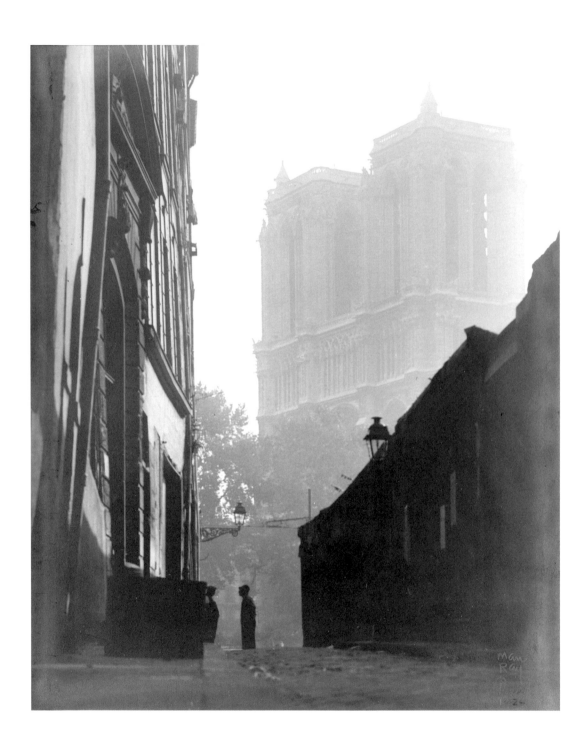

Notre-Dame vue de la rue St-Séverin
1931

when the artist was invited by Dadaist Tristan Tzara to send two photographs to the *Salon Dada: Exposition Internationale* in Paris. The photographs recorded an eggbeater and an assemblage of clothespins with a photographic lamp.

Man Ray was already familiar with the Dada movement in Zurich, Paris, and Berlin from conversations with Duchamp and Francis Picabia, both fringe figures associated with the group. This loosely affiliated band of writers was engaged in a frenzied protest against bourgeois complacency and hypocrisy. They staged Dada performances that featured poetry made of randomly assembled words and sonorously intoned gibberish. Man Ray's inclusion in the exhibition publicly aligned him with this movement and placed his artistic endeavors in an international context for the first time.

Seeking a forum in which to further promote and encourage the art of their time, Man Ray joined Duchamp and collector and artist Katherine Dreier in founding the *Société Anonyme* in 1920. The *Société* organized exhibitions, published books about contemporary artists, and also collected selected works for their permanent collection [now housed at Yale University in Connecticut]. Somewhat to his dismay Man Ray was put in charge of photographing art and artists for postcards and catalogs. But his photographic work continued to bring him acclaim.

Feeling misunderstood in America and knowing that a community of like-minded artists existed on the other side of the Atlantic, Man Ray began to think seriously about visiting Paris. The city was the heart of the international art world in the twenties and his close relationships with Duchamp and Lacroix, from whom he had recently separated, further fueled his desire to make the trip. To finance the voyage, Stieglitz suggested that Man

klammern und einer Fotolampe. Aus Gesprächen mit Duchamp und Francis Picabia war Man Ray bereits mit der Dada-Bewegung vertraut, die – unter anderem mit lautstark vorgetragener absurder Lautpoesie – in Zürich, Paris und Berlin gegen die bürgerliche Selbstgefälligkeit und Heuchelei revoltierte. Mit seiner Teilnahme an der Pariser Ausstellung, die ihn zum ersten Mal in einen internationalen Kontext stellte, schloß sich Man Ray offiziell dieser Bewegung an.

Immer auf der Suche nach einem Forum für die zeitgenössische Kunst, gründete Man Ray zusammen mit Duchamp und der Sammlerin und Künstlerin Katherine Dreier 1920 die *Société Anonyme*. Die *Société* organisierte Ausstellungen, veröffentlichte Bücher über zeitgenössische Künstler und baute eine Sammlung moderner Kunst auf [heute in der Yale University in Connecticut]. Man Ray war es eine eher lästige Pflicht, für die Société Kunstwerke und Künstler für Kataloge und Postkarten fotografieren zu müssen. Nach wie vor jedoch brachte ihm sein fotografisches Werk Anerkennung ein. Da er sich in Amerika mißverstanden fühlte und er wußte, daß es jenseits des Atlantiks eine Gemeinschaft gleichgesinnter Künstler gab, begann Man Ray ernsthaft über eine Reise nach Paris nachzudenken. In den 20er Jahren war Paris das Herz der internationalen Kunstwelt. Seine engen Beziehungen zu Duchamp und Lacroix, von der er sich unlängst getrennt hatte, bestärkten ihn in seinem Plan. Um die Reise zu finanzieren, folgte Man Ray Stieglitz' Rat und wandte sich an Ferdinand Howald, einen Geschäftsmann aus Ohio, der regelmäßig nach New York kam, um Kunst zu kaufen. Howald, der bereits einige Gemälde des Künstlers besaß, ließ sich als Gegenleistung für seine Unterstützung die Zusage geben, sich für seine Sammlung die besten Gemälde aussuchen zu dürfen, die Man Ray in Paris malen würde.

Mit einem Schrankkoffer voller Kunst und ungefähr 100 Francs in der Tasche erreichte der 31jährige Man Ray am 22. Juli 1921 Le Havre. In seiner Autobiographie gibt er vor, am 14. Juli, dem französischen Nationalfeiertag, an Land

rapport aux sujets et aux matériaux traditionnels. Son cliché *Moving sculpture* [Sculpture animée, 1920] représente du linge lavé et étendu qui s'agite dans le vent, tandis que *8th Street* [Huitième rue, 1920] immortalise une boîte de conserve aplatie. Pareille exaltation d'articles prosaïques et d'objets au rebut se retrouve aussi bien dans leur incarnation en trois dimensions [dont une grande partie a cependant été perdue ou détruite] que dans leur respectueuse préservation sous forme d'épreuves aux sels d'argent. Ici et là, la charge provocatrice, fortifiée par les liens amicaux avec Duchamp, bat en brèche les conventions esthétiques et remet en cause les conceptions que l'observateur se fait de la beauté.

À la fin des années 1920, Man Ray était donc plongé dans l'activité photographique, dont il explorait et approfondissait le potentiel de création. Ses images de cette période témoignent amplement de l'excitation de la découverte. Il essaya de faire bouger l'appareil pendant la pose et de brouiller la clarté de l'objectif en y étalant du gel : ainsi obtenait-il des images qui ne reflétaient plus le monde visible. Ou bien, ailleurs et autrement, des images dont le sujet était plus facile à identifier, mais qui cherchaient néanmoins à surprendre, à choquer le spectateur. Montées, signées, datées comme il se doit, toutes ces épreuves prennent le statut d'œuvres d'art à part entière. Au printemps de l'année 1920, Man Ray vit l'audace de sa vision récompensée lorsque le poète dada Tristan Tzara l'invita à envoyer deux de ses photographies au Salon dada : exposition internationale, qui se tenait à Paris. Les photographies montraient respectivement un fouet à œufs et un assemblage de pinces à linge sur une lampe photographique. Man Ray connaissait déjà l'existence du mouvement dada à Zurich, à Paris et à Berlin, grâce à des conversations qu'il avait eues avec Marcel Duchamp et Francis Picabia. Les écrivains qui appartenaient au groupe entendaient protester violemment contre la complaisance et l'hypocrisie bourgeoises. Dans les spectacles qu'ils montaient, ils déclamaient des poèmes composés selon une méthode

Ray seek assistance from Ferdinand Howald, an Ohio businessman who periodically visited New York to purchase art. Howald, who already owned a few paintings by the artist, assented with the guarantee of selecting for his collection the best paintings created by Man Ray on his sojourn.

With funding secure for boat passage, a trunk full of artwork, and about a hundred francs, the thirty-one-year-old Man Ray was on his way, arriving at the port of Le Havre on July 22, 1921. In his autobiography, he claims to have entered Paris on July 14 – French Independence Day – an expression, no doubt, of the liberation and exhilaration of his first night in the City of Light. Met in Paris at the Gare St. Lazare train station by Duchamp, Man Ray was immediately whisked off to the Café Certà to meet his Dada compatriots. His close association with Duchamp helped secure a favorable reception in a climate in which Americans were seldom welcomed into the inner circles. Though unable to follow the conversation fully due to his limited French, Man Ray, in another sense, had finally found a group of artists who spoke his "language". Indeed, the artist was welcomed as a Dada dignitary from abroad, one who had tried to keep its spark alive in the wilderness of New York, where, as he had written to Tzara, "Dada cannot live".

Man Ray was pleased by the positive response but cognizant of not producing any new artwork and of having to rely heavily on others to get along. By the end of the year, his Dadaist friends had arranged a one-man show for him at the Librairie Six, a bookstore run by Philippe and Mick Soupault. The show consisted primarily of work brought from New York – paintings, aerographs, collages, and objects. For this occasion he created his famous *Le Cadeau* [Gift] – a flatiron with tacks glued to the smooth surface of the iron, his first Dada object, made in Paris. The artist documented the transmogrified iron – which moreover disappeared from the exhibit by

gegangen und mit der Eisenbahn nach Paris weitergefahren zu sein – zweifellos wollte er damit seinem Hochgefühl Ausdruck verleihen. An der Gare St. Lazare wurde er von Duchamp begrüßt, der ihn noch am selben Tag ins Café Certà mitnahm, um ihn seinen Dada-Mitstreitern vorzustellen. Amerikanern wurde nur selten Zugang zu den inneren Kreisen der Pariser Kunstszene gewährt, doch seine enge Freundschaft mit Duchamp sicherte ihm einen herzlichen Empfang. Zwar standen ihm seine mangelnden Französischkenntnisse im Wege, doch in einem anderen Sinne hatte er endlich eine Gruppe von Künstlern gefunden, die seine Sprache sprachen. Er wurde sogar als eine Dada-Größe aus dem Ausland willkommen geheißen, der in der New Yorker Wildnis, wo, wie er Tzara geschrieben hatte, »Dada nicht leben« konnte, den Funken am Leben gehalten hatte. Man Ray war über die positive Aufnahme erfreut, doch bald wurde er sich seiner eher bedrückenden Situation bewußt: Seit seiner Ankunft in Paris hatte er nichts Neues mehr hervorgebracht, und finanziell war er auf fremde Hilfe angewiesen. Gegen Ende des Jahres verhalfen ihm seine Dadaistenfreunde zu einer Einzelausstellung in der Librairie Six, einer von Philippe und Mick Soupault geführten Buchhandlung. Hauptsächlich wurden aus New York mitgebrachte Arbeiten gezeigt: Gemälde, Aerografien, Collagen und Objekte. Anläßlich dieser Ausstellung entstand auch sein berühmtes *Le Cadeau* [Das Geschenk], ein auf der Unterseite mit Polsternägeln beklebtes Bügeleisen. Dieses erste in Paris entstandene Dada-Objekt dokumentierte der Künstler mit seiner Kamera. Schon am Abend des Eröffnungstages war das Objekt verschwunden. Zwar wurde kein einziges Werk verkauft, doch für Man Ray markierte diese Ausstellung die Anerkennung seiner Person als Künstler der Pariser Avantgarde.

Um seine finanzielle Lage aufzubessern, beschloß Man Ray, als professioneller Fotograf zu arbeiten. Er bot seine Dienste seinen Künstlerkollegen an und kam mit der Kamera in ihre Ateliers, um ihre Werke zu dokumen-

aléatoire et vociféraient un galimatias incompréhensible. En présentant deux photographies au Salon, Man Ray acceptait de fait la philosophie du mouvement et, pour la première fois, son art s'inscrivait dans un contexte international.

En quête d'une structure qui permettrait de promouvoir et d'encourager davantage l'art de leur époque, Man Ray, Duchamp et l'artiste et collectionneuse Katherine Dreier fondèrent la Société Anonyme en 1920. Cette Société organisait des expositions, publiait des ouvrages sur des artistes contemporains et faisait l'acquisition de certaines œuvres pour sa collection permanente [conservée aujourd'hui à l'Université de Yale, dans le Connecticut]. Man Ray devait photographier des artistes et des œuvres d'art pour les reproduire sur les cartes postales et dans les catalogues. Malgré tout, il continuait à être acclamé pour son œuvre personnelle.

Comme il se sentait incompris en Amérique et qu'il savait qu'il existait, de l'autre côté de l'Atlantique, une communauté d'artistes qui partageaient ses vues, Man Ray se mit à songer sérieusement à entreprendre un voyage à Paris, capitale du monde artistique dans les années 1920. Son amitié avec Marcel Duchamp, sa liaison avec Adon Lacroix [dont il venait pourtant de se séparer] ne firent qu'augmenter son désir. Pour financer son voyage, Stieglitz conseilla à Man Ray de demander l'aide de Ferdinand Howald, homme d'affaires qui habitait dans l'Ohio et se rendait régulièrement à New York pour acheter des œuvres d'art. Ce dernier possédait déjà quelques tableaux de Man Ray ; il consentit à sa demande à condition de pouvoir choisir pour sa collection personnelle les meilleures œuvres que Man Ray réaliserait lors de son séjour.

Une fois les fonds rassemblés pour la traversée, Man Ray s'embarqua pour la France avec une malle pleine d'œuvres d'art et une centaine de francs en poche. Il avait 31 ans. Il débarqua au Havre le 22 juillet 1921, et non pas, comme il le prétend dans son autobiographie, le 14 juillet, jour de la fête

the end of the show – with his camera. No sales resulted from the exhibition but Man Ray portrayed the experience as a rite of passage that marked him as a true artist.

To improve his financial situation, Man Ray decided to work as a professional photographer. He planned to offer this service to fellow artists, which turned out to be an excellent means of meeting them when he arrived at their studios with his camera. During some of these sessions, Man Ray also made the artists' portraits, which positioned him on the dominant side of the camera in the presence of masters such as Picasso, Braque, and Matisse. In this endeavor, Man Ray relied on his network of friends for referrals. The multi-dimensional artist Jean Cocteau first came under the scrutiny of Man Ray's lens in 1922, providing access to his many acquaintances ranging from artists to socialites. Man Ray quickly became indispensable with his camera – developing the photographs at night in his bathroom – which provided him not only with a livelihood and entrée to social functions, but also a means of distinguishing himself artistically. He was even summoned to Marcel Proust's deathbed to photograph the author's illness-ravaged face shortly after his demise. Sylvia Beach, owner of Shakespeare & Company, occasionally hired Man Ray to take publicity pictures of her authors, most notably James Joyce whose controversial novel *Ulysses* she had published. Another fruitful early commission was Man Ray's portrait of the American-born writer and committed collector of contemporary art, Gertrude Stein.

The French couturier Paul Poiret offered Man Ray his first fashion assignments in the early 1920s. Poiret was seeking a new approach to the subject and Man Ray was not one to turn down the opportunity to benefit financially from photographing beautiful women. The models appear as sculptural objects in many of these pictures and some were even photographed next to the castings and carvings of Alberto Giacommeti and Constan-

tieren. Diese Atelierbesuche waren, wie sich zeigen sollte, exzellente Gelegenheiten, die Künstler näher kennenzulernen und oft auch zu porträtieren. Meister wie Picasso, Braque und Matisse standen ihm Modell. Man Ray wurde vom einen zum anderen weiterempfohlen, und schnell machte er sich mit seiner Kamera unentbehrlich. Auch das Multitalent Jean Cocteau, das 1922 zum ersten Mal vor seiner Kamera stand, verschaffte ihm Zugang zu vielen Künstlern und Prominenten aus dem eigenen großen Bekanntenkreis. Die Fotografien, die er nachts in seinem Badezimmer entwickelte, verschafften Man Ray nicht nur ein Einkommen und den Zutritt zur Pariser Gesellschaft, sondern auch die Möglichkeit, sich künstlerisch zu profilieren. Er wurde sogar zu Marcel Prousts Totenbett gerufen, um das Gesicht des Verstorbenen zu fotografieren. Auch Sylvia Beach, die Inhaberin des Buchladens Shakespeare & Company, engagierte ihn gelegentlich für Porträtaufnahmen ihrer Autoren. Einer der bekanntesten war James Joyce, dessen umstrittener Roman *Ulysses* von ihr veröffentlicht wurde. Eine andere wichtige frühe Auftraggeberin war die amerikanische Schriftstellerin und engagierte Sammlerin moderner Kunst, Gertrude Stein.

In den frühen 20er Jahren gab der französische Couturier Paul Poiret Man Ray seine ersten Modeaufträge. Poiret suchte nach neuen Ausdrucksformen für die Modefotografie. Die Gelegenheit, schöne Frauen zu fotografieren und dafür auch noch großzügig honoriert zu werden, ließ ein Mann wie Man Ray sich natürlich nicht entgehen. Auf vielen dieser Bilder sehen die Modelle wie skulpturale Objekte aus, und einige wurden sogar neben Skulpturen und Plastiken von Alberto Giacometti und Constantin Brancusi fotografiert. Manchmal standen ihm enge Freundinnen – Nush Eluard und Adrienne Fidelin – für diese Fotos Modell. In den 30er Jahren waren Man Rays elegante Modefotografien bei populären Magazinen wie *Harper's Bazaar*, *Vogue*, *Vu* und *Vanity Fair* sehr gefragt. Während er anfänglich seine kommerziellen Arbeiten nicht strikt von seinem künstlerischen Schaffen trennte, stand er

nationale. Malgré cette légère distorsion des faits, la date exprime surtout le sentiment de libération et d'exaltation qu'il dut éprouver pendant sa première soirée dans la ville lumière. Duchamp était allé l'attendre à la gare Saint-Lazare et il l'entraîna tout de suite au café Certà pour lui présenter ses compatriotes dada. Grâce à ses liens étroits avec Duchamp, il reçut un accueil chaleureux, alors même que les Américains étaient à l'époque rarement admis dans les cercles intimes. Sa connaissance du français n'était pas suffisante pour lui permettre de suivre toute la conversation, mais il n'en trouva pas moins, en un autre sens, un groupe d'artistes qui parlaient le même «langage» que lui. De fait, il passait pour une sommité du dadaïsme, un être qui avait cherché à alimenter sa flamme dans le désert new-yorkais où, comme il l'avait écrit à Tzara, «Dada ne peut pas vivre». Man Ray était heureux de se voir bien traité, mais il était cependant conscient de ne produire aucune œuvre, de dépendre largement des autres pour se débrouiller dans la vie. Avant la fin de l'année, ses amis dada lui organisèrent une exposition individuelle à la Librairie Six de Philippe et Mick Soupault. Il y présenta essentiellement des œuvres qu'il avait apportées de New York [des toiles, des aérographes, des collages et des objets], mais c'est aussi à cette occasion qu'il réalisa *Le Cadeau*, un fer à repasser avec des clous de tapissier collés sur la semelle. Il photographia le fer à repasser ainsi métamorphosé, avant de se rendre compte à la fin de l'exposition qu'il avait mystérieusement disparu. Il ne vendit aucune œuvre mais cette expérience lui fit l'effet d'être un artiste authentique de l'avant-garde parisienne.

Pour améliorer sa situation financière, Man Ray décida de pratiquer la photographie en professionnel. Il songea à offrir ses services à d'autres artistes, ce qui se révéla un excellent moyen de les rencontrer quand il arrivait dans leur atelier muni de son appareil. Parfois, il en profita même pour tirer le portrait de certains : il se trouvait ainsi en position de domination face à des maîtres comme Picasso, Braque ou Matisse. Pour mener à bien ce projet, il se

tin Brancusi. Several of Man Ray's close friends were occasionally used as models, among them Nush Eluard and Adrienne Fidelin. By the 1930s, Man Ray's stylish pictures were in great demand with popular magazines such as *Harper's Bazaar*, *Vogue*, *Vu*, and *Vanity Fair*. While he did not initially consider his commercial work to be outside the scope of his artistic oeuvre, his reputation as a fashion photographer was something about which he became increasingly ambivalent. Although Man Ray's letters to friends and family at this time reflect frustration over a lack of progress with painting, his photographic work knew no limits.

 While developing prints in the darkroom at the end of 1921 or in the beginning of 1922, Man Ray stumbled across the nineteenth-century photographic practice of making an image without using a camera. By placing an object on light-sensitive paper and exposing it to light, he created a silhouette of whatever was on top of the paper. "I have freed myself from the sticky medium of paint and am working directly with light itself", he wrote excitedly to Howald. Since they are made without a negative, the pictures are one-of-a-kind objects, like a painting or drawing. Man Ray later called these prints "rayographs", claiming credit for the rediscovery of this approach to the medium. Though other artists, notably Christian Schad and László Moholy-Nagy, had also worked with this technique, Man Ray considered himself the true pioneer.

 Rayographs absorbed Man Ray's attention during the first half of 1922. Tzara was so enthusiastic about the work that by December of that year, the two had produced a limited-edition portfolio of twelve Man Ray images titled *Champs délicieux* [Delicious fields] with an introduction by the poet. Ironically, Man Ray had to violate the "uniqueness" of the rayographs by making them reproducible for the portfolio, though to Man Ray a reproduction was always considered as good as an original, perhaps better. These unearthly pictures caught the

später seinem Ruf als Modefotograf immer ambivalenter gegenüber. In den Briefen, die Man Ray in dieser Zeit an Freunde und Angehörige schrieb, beklagte er zwar den Stillstand in seinem malerischen Schaffen, doch in seinem fotografischen Werk konnte davon keine Rede sein.

Gegen Ende des Jahres 1921 oder Anfang 1922 stieß Man Ray in der Dunkelkammer auf ein kameraloses fotografisches Verfahren, das schon im 19. Jahrhundert angewendet worden war: Wird ein Objekt auf lichtempfindliches Papier gelegt und dem Licht ausgesetzt, hinterläßt es auf dem Papier seine Silhouette. »Ich habe mich vom klebrigen Medium der Farbe befreit und arbeite unmittelbar mit dem Licht«, schrieb er begeistert an Howald. Weil es ohne ein Negativ gefertigt wird, stellt ein solches Bild wie ein Gemälde oder eine Zeichnung ein Unikat dar. Man Ray bezeichnete derartige Bilder später als Rayografien und nahm für sich die Wiederentdeckung dieser Technik in Anspruch, obwohl auch andere Künstler – insbesondere Christian Schad und László Moholy-Nagy – sich ihrer bedienten.

In der ersten Hälfte des Jahres 1922 beschäftigte sich Man Ray intensiv mit seinen Rayografien. Tzara war begeistert von diesen Bildern, und als Man Ray im Dezember dieses Jahres unter dem Titel *Champs délicieux* [Köstliche Felder] in limitierter Auflage ein Album mit zwölf Rayografien veröffentlichte, schrieb er die Einführung dazu. Ironischerweise mußte Man Ray die Einzigartigkeit der Rayografien hintertreiben, indem er sie für das Album reproduzierbar machte. Freilich war in seinen Augen eine Reproduktion immer genauso gut wie ein Original, wenn nicht sogar besser. Diese Bilder, die nicht von dieser Welt zu sein schienen, fielen mehreren Zeitschriftenredakteuren ins Auge, und *Vanity Fair* brachte in der Ausgabe vom November 1922 einen ganzseitigen Beitrag über die Rayografien. Auch in weniger weit verbreiteten Publikationen wie *Aventure*, *Der Sturm* und *Broom* erschienen in diesem Jahr Fotografien und Rayografien von Man Ray. Der Titel des Rayografienalbums war ein Verweis auf das 1920 erschienene

faisait recommander par son réseau d'amis. En 1922, Jean Cocteau, artiste polyvalent s'il en fut, posa pour la première fois devant l'objectif de Man Ray et lui permit de rencontrer nombre de ses connaissances dans le milieu artistique et les sphères mondaines. Très vite, on ne put plus se passer de Man Ray et de son appareil : il développait ses photographies la nuit, dans sa salle de bains, et trouvait par ce biais non seulement un moyen de gagner sa vie et d'être invité dans les réceptions, mais encore de se distinguer sur un plan artistique. On l'appela même au chevet de Marcel Proust pour qu'il photographie l'écrivain terrassé par la maladie, juste avant qu'il n'expire. Sylvia Beach, propriétaire de la librairie Shakespeare et Compagnie, louait de temps en temps les services de Man Ray pour qu'il photographie certains écrivains à des fins publicitaires, et notamment James Joyce dont venait de paraître le roman très controversé, *Ulysse*. Dans une perspective tout aussi lucrative, Man Ray se vit également commander le portrait de l'Américaine Gertrude Stein, femme écrivain expatriée à Paris, figure de proue de l'intelligentsia et collectionneuse passionée d'art contemporain.

C'est le couturier français Paul Poiret qui chargea Man Ray de ses premières photographies de mode au début des années 1920. Il cherchait en effet à renouveler l'approche du genre, et Man Ray n'était pas homme à refuser pareille occasion de gagner de l'argent en photographiant de belles femmes. Sur un grand nombre de ces clichés, les mannequins ont l'air de statues, certaines posant même à côté de moulages et de sculptures signées par Alberto Gicometti ou Constantin Brancusi. À l'instar de Nush Éluard et d'Adrienne Fidelin, plusieurs amies proches de Man Ray posèrent de temps en temps pour lui. Au début des années 1930, ses images élégantes étaient très recherchées par des revues comme *Harper's Bazaar*, *Vogue*, *Vu*, qui avaient le vent en poupe. Pourtant, même s'il ne songeait pas, au départ, à tracer une frontière étanche entre ses travaux alimentaires et ses créations artistiques, sa renommée de photographe de mode finit par le gêner aux

imagination of several editors, and Vanity Fair ran a full-page feature on the rayographs in its November 1922 issue. Photographs and rayographs by Man Ray also appeared that year in less mainstream publications including *Aventure, Der Sturm*, and *Broom*.

The title of the portfolio of rayographs was a reference to *Les Champs magnétiques* [Magnetic fields], a 1920 book of writings by Soupault and André Breton that had been created by connecting random thoughts and phrases. A few years later, Breton's 1924 "Manifesto of Surrealism" launched a more systematic exploration of dreams with practices stemming from the Dada movement and inspired by the writings of Sigmund Freud. Surrealism, like Dadaism, began as a literary movement but Breton cited a few visual artists in a footnote to the manifesto, among them Man Ray. Breton particularly favored the artist's photographic work. Man Ray's startling juxtapositions and rayographs transported his images out of the realm of commonplace reality and allowed him to create landscapes of the mind, echoing the "automatic writing" of the Surrealists. These innovations qualified Man Ray as a precursor to Surrealism in Breton's eyes. Though Man Ray was closely associated with both the Dada and Surrealist movements – participating in their events, publishing in their journals, and recording their meetings and members with his camera – he never claimed membership to any group.

A measure of financial success allowed Man Ray to move to the heart of Montparnasse, a quarter frequented by artists, writers, and eccentrics that was also the site of many of Paris's now-famous watering holes, such as Café du Dôme, La Rotonde, and the Jockey Club. There he managed to capture the heart of one of the most celebrated women in Montparnasse. Kiki de Montparnasse [born Alice Prin] was a chanteuse famous for singing ribald songs. She was flamboyant and a bit volatile. Her severely bobbed hair, heavily lined eyelids, and

Buch *Les Champs magnétiques* [Die magnetischen Felder] von André Breton und Philippe Soupault, das sich aus spontan niedergeschriebenen Texten zusammensetzt. Ausgehend von der Dada-Bewegung und inspiriert von den Schriften Sigmund Freuds, postulierte Breton dann 1924 in seinem ersten Manifest des Surrealismus die überragende Bedeutung des Unbewußten und des Traums für die menschliche Existenz. Wie der Dadaismus war auch der Surrealismus ursprünglich eine literarische Bewegung, doch schon in seinem Manifest führte Breton auch bildende Künstler an. Man Ray war einer von ihnen, und Breton hatte eine besondere Vorliebe für dessen fotografische Arbeiten. Mit seinen verblüffenden Kombinationen und seinen Rayografien hatte Man Ray imaginäre Landschaften hervorgebracht, die außerhalb der Realität des Alltags lagen und an die »automatistische Schreibweise« der Surrealisten erinnerten. Diese Innovationen machten Man Ray in Bretons Augen zu einem Vorläufer des Surrealismus. Man Ray war zwar sowohl den Dadaisten als auch den Surrealisten eng verbunden – er nahm an ihren Veranstaltungen teil, publizierte in ihren Zeitschriften, dokumentierte ihre Zusammenkünfte und porträtierte sie mit seiner Kamera –, ließ sich jedoch nie als »Mitglied« von einer dieser Gruppen vereinnahmen.

Seine Einkünfte gestatteten es Man Ray, ins Herz von Montparnasse zu ziehen, in ein vor allem von Künstlern, Schriftstellern und Exzentrikern bewohntes Viertel mit legendären Treffpunkten wie dem Café du Dôme, La Rotonde und dem Jockey Club. In einem dieser Lokale gelang es ihm, das Herz einer der begehrtesten Frauen vom Montparnasse zu erobern. Kiki de Montparnasse [mit bürgerlichem Namen Alice Prin] war eine für ihre frechen Chansons bekannte Sängerin, eine extravagante und etwas sprunghafte junge Frau, die mit ihrem kurz geschnittenen Bubikopf, den dunklen Lidschatten und grellrot geschminkten Lippen unübersehbar war. Sie wurde zum Sujet einiger seiner bekanntesten Fotografien, von denen sich mehrere an die klassischen Akte des Malers Jean Auguste Dominique Ingres anlehnen.

entournures. Bien que sa correspondance de l'époque, avec ses amis et sa famille, témoigne de son insatisfaction face à l'absence de ses progrès en peinture, son œuvre photographique ne connaissait pas de limites.

Un jour où il tirait des épreuves dans sa chambre noire, à la fin de 1921 ou au début des années 1922, Man Ray tomba par hasard sur une pratique photographique remontant au XIXe siècle : la fabrication d'une image sans l'aide d'un appareil. En plaçant un objet sur un papier sensibilisé et en exposant l'ensemble à la lumière, la silhouette de l'objet se découpait avec des contours très nets. «Je me suis libéré de la pâte picturale et je travaille directement avec la lumière», écrivit-il à Howald sur un ton exalté. Faute de négatifs, les images ainsi obtenues constituent des exemplaires uniques. Man Ray devait donner le nom de «rayogrammes» à ces images et s'attribuer la primeur de cette redécouverte. D'autres, pourtant, avaient également employé cette méthode, en particulier Christian Schad et Lázsló Moholy-Nagy, mais il se considérait comme le véritable pionnier en la matière.

Pendant les premiers mois de 1922, Man Ray concentra toute son attention sur ses rayographies. Tristan Tzara manifesta un tel enthousiasme qu'avant la fin de l'année, ils réalisèrent ensemble un recueil à tirage limité intitulé *Champs délicieux*: il réunissait douze images de Man Ray et contenait une préface du poète. Non sans ironie, Man Ray avait dû porter atteinte à «l'unicité» des rayogrammes pour pouvoir les reproduire. Mais il est vrai qu'à ses yeux, une reproduction était toujours aussi bonne qu'un original, peut-être même meilleure … Reste néanmoins que ces images surréelles stimulèrent l'imagination de plusieurs rédacteurs en chef: en novembre 1922, *Vanity Fair* publia un article d'une page sur les rayogrammes ; d'autres photographies et rayographies parurent la même année dans des revues plus spécialisées comme *Aventure, Der Sturm* et *Broom*.

Le titre du recueil renvoyait aux *Champs magnétiques* de Philippe Soupault et d'André Breton, ouvrage de 1920 fondé sur des associations libres de mots

pointy red lipstick smile were instantly recognizable in Paris's bohemian quarter. She became the subject of some of his best-known photographs, several of which emulate the classic nudes of the painter Jean-Auguste-Dominique Ingres. As well as providing him with a willing model, Man Ray's relationship with Kiki also tremendously increased his visibility and status in Paris, as well as helping him improve his French.

As a highly sought-after portraitist, Man Ray was by this time able to charge high fees for sittings. His work was so much in demand that he rented a second studio in a nearby neighborhood where he could paint undisturbed. Financial security also allowed him to hire a succession of studio assistants to tend to clients and help with darkroom work. Nearly all of these assistants went on to establish their own successful careers in photography: Berenice Abbott, Jacques-André Boiffard, Bill Brandt, Lee Miller, and later Naomi Savage.

From the mid-1920s to 1930s, a succession of publications kept Man Ray's work in the public eye. Fellow Dadaist Georges Ribemont-Dessaignes started the trend with his 1924 book on Man Ray, the first monograph devoted to the artist's work. In an essay that same year, Ribemont-Dessaignes called Man Ray a "chemist of mysteries" who creates a new world and "photographs it to prove that it exists." At the end of the 1920s, Man Ray created 1929, a booklet of four graphically sexual images coupled with verse on the four seasons. That summer began quietly for the artist, who was now nearly forty years old. His lengthy affair with Kiki had run its course from sweetness to recriminations. Man Ray was preparing to leave for a holiday with friends in Biarritz when he met a young American woman named Lee Miller, who informed him that she was his new student. Undaunted by his curt explanation that he did not accept students and was leaving for the South of France, Miller replied, "so am I."

Seine Verbindung mit Kiki verhalf ihm darüber hinaus nicht nur zu einer besseren Beherrschung der französischen Sprache, sondern auch zu einem enormen Zugewinn an Präsenz und von Neid begleitetem Ansehen.

Als gefragter Porträtist konnte Man Ray mittlerweile hohe Honorare für Sitzungen verlangen und ein zusätzliches Atelier mieten, um ungestört malen zu können. Er konnte sich jetzt auch Assistenten leisten, die sich um die Kunden kümmerten und ihm in der Dunkelkammer zur Hand gingen. Fast alle seine Assistenten wurden später selbst erfolgreiche Fotografen – Berenice Abbott, Jacques-André Boiffard, Bill Brandt, Lee Miller und in späteren Jahren Naomi Savage.

1924 veröffentlichte der Dadaist Georges Ribemont-Dessaignes die erste Monographie über Man Ray und setzte damit eine bis in die 30er Jahre hinein anhaltende Folge von Publikationen in Gang. In einem im selben Jahr veröffentlichten Aufsatz bezeichnete Ribemont-Dessaignes Man Ray als einen »Chemiker der Mysterien«, der eine neue Welt hervorbringt und sie »zum Beweis ihrer Existenz fotografiert«. 1929 erschien unter dem Titel dieser Jahreszahl ein Buch, das mit vier erotischen, nach den Jahreszeiten benannten Fotografien von Man Ray illustriert war und je ein langes Gedicht von Benjamin Péret und Louis Aragon enthielt. Für den jetzt fast 40 Jahre alten Künstler nahm der Sommer dieses Jahres einen ruhigen Beginn. Seine mehrjährige turbulente Affäre mit Kiki war zu Ende. Am Abend vor seiner Abreise nach Biarritz machte er die Bekanntschaft einer jungen Amerikanerin namens Lee Miller, die ihm mitteilte, daß sie seine neue Schülerin sei. Auf seine knappe Antwort, daß er keine Schüler annehme und nach Südfrankreich fahren wolle, erwiderte sie nur: »ich auch«.

Lee Miller hatte in New York als Mannequin gearbeitet und den Fotografen Edward Steichen und Arnold Genthe Modell gestanden. Bevor sie sich entschloß, eine Karriere als Fotografin zu beginnen, hatte sie einige Jahre an der Art Students' League studiert. Nachdem sie von Freunden im Verlags-

et d'idées. Deux ans plus tard, en 1924, Breton publia son *Premier Manifeste du surréalisme*, où il déclarait vouloir approfondir l'exploration des rêves en reprenant d'une part certaines pratiques du dadaïsme et en s'inspirant d'autre part des écrits de Sigmund Freud. À l'instar du dadaïsme, le surréalisme était à l'origine un mouvement littéraire ; mais dans une note de son manifeste, Breton citait le nom de quelques artistes visuels parmi lesquels Man Ray, dont il appréciait particulièrement l'œuvre photographique. Ses juxtapositions surprenantes, ses rayographies étonnantes se situaient en dehors du réel : elles ressemblaient davantage à des paysages mentaux rappelant « l'écriture automatique » des surréalistes. Aux yeux de Breton, pareilles innovations faisaient de Man Ray un précurseur du surréalisme, mais celui-ci, malgré ses liens étroits avec ce mouvement, comme auparavant avec le mouvement dada, n'a jamais revendiqué d'appartenance à l'un ou à l'autre de ces courants.

Grâce à une rentrée d'argent, Man Ray déménagea pour s'installer au cœur de Montparnasse, quartier fréquenté par des artistes, des écrivains, des marginaux, et comptant une forte concentration de débits de boisson comme le Café du Dôme, La Rotonde et le Jockey Club. Il réussit à gagner le cœur d'une des femmes les plus en vue de Montparnasse : Kiki [Alice Prin de son vrai nom], célèbre chanteuse au répertoire grivois. Elle était exubérante, impossible de ne pas la remarquer dans la Bohème parisienne, avec sa coiffure au bol, ses yeux très maquillés, son sourire pointu et ses lèvres passées au rouge vif ! Elle devint le sujet de photographies qui comptent parmi les plus connues de l'artiste, certaines rivalisant avec les nus classiques du peintre Jean-Auguste-Dominique Ingres. Kiki posait de plus en plus volontiers ; grâce à leur liaison, Man Ray jouissait d'une visibilité accrue, d'un statut plus élevé dans les milieux artistiques parisiens, et il pouvait en outre faire des progrès en français.

Grâce à la cote de ses portraits, Man Ray pouvait se faire grassement payer

Miller had worked as a fashion model in New York, posing for photographers Edward Steichen and Arnold Genthe. She studied for a couple of years at the Art Students' League before deciding to embark on a career in photography. After hearing about Man Ray from friends in the publishing business she left for Paris to find him and soon became his darkroom assistant and receptionist. Lee was an avid pupil who quickly mastered Man Ray's rigorous technical requirements, sometimes working side-by-side with him in the tiny darkroom. During one session, she impulsively switched on the light after a mouse brushed against her foot. The prints developing in the tray took on a surprising appearance, with a halo surrounding each figure. The flash of light had created something called the Sabattier effect, also known as solarization. This was another nineteenth-century discovery in which a negative or print is exposed to light during its development, resulting in a selective reversal of tones. Solarization soon became another signature technique for Man Ray, one that he tended to reserve for his most important photographic subjects. Solarized photographs were especially welcome in Surrealist publications for their otherworldly quality.

In 1931, Man Ray produced the portfolio *Electricité* consisting of ten rayographs on commission as a promotion for the Paris Electric Company [CPDE]. Fittingly, Man Ray created each picture by exposing objects on light-sensitive paper to an electrical light source. The series begins with the picture of a lone light bulb followed by images illustrating the utility of electricity in each room of the house. Man Ray gave his sense of humor full play in the portfolio, resulting in pictures that suggest the use of electricity as a pleasant modern convenience. Instead of making photographic prints for the portfolio, as he had with *Champs délicieux*, he decided to print the images as photogravures, the highest quality method of reproducing large numbers of images.

geschäft von Man Ray gehört hatte, reiste sie nach Paris und wurde bald seine Dunkelkammerassistentin und Empfangsdame. Lee war eine eifrige Schülerin, die Man Rays strenge technische Anforderungen in kurzer Zeit beherrschte und manchmal Seite an Seite mit ihm in der winzigen Dunkelkammer arbeitete. Einmal schaltete sie dabei spontan das Licht ein, als eine Maus ihren Fuß streifte. Die Abzüge, die in den Entwicklerschalen lagen, nahmen ein verblüffendes Erscheinungsbild an: Um alle Figuren bildete sich eine Aureole. Das aufblitzende Licht hatte die auch als Sabattier-Effekt bekannte Solarisation bewirkt. Wird ein Negativ oder Abzug während der Entwicklung dem Licht ausgesetzt, solarisiert es, d.h. es verschieben sich die Tonwerte. Auch diese Entdeckung war schon im 19. Jahrhundert gemacht worden, und Man Ray gelang es nach einer längeren Experimentierphase, den Solarisationsprozeß kontrolliert einzusetzen. Die Solarisation wurde zu einem weiteren unverwechselbaren Kennzeichen seines fotografischen Werks, und er reservierte diese Technik für Sujets, die ihm besonders wichtig waren. Seine solarisierten Fotografien scheinen nicht von dieser Welt zu sein, und vor allem die Surrealisten wußten diese Eigenschaft zu schätzen. 1931 schuf Man Ray im Auftrag der Pariser Elektrizitätsgesellschaft [CPDE] die Mappe *Electricité* mit zehn Rayografien. Für jedes dieser Bilder setzte Man Ray verschiedene Objekte auf lichtempfindlichem Papier einer elektrischen Lichtquelle aus. Die Serie beginnt mit dem Bild einer einsamen Glühbirne, gefolgt von humorvollen Illustrationen der Steigerung der Lebensqualität durch die Nutzung elektrischer Geräte in allen Wohnräumen. Während er sich für *Champs délicieux* mit fotografischen Reproduktionen begnügt hatte, ließ er diese Rayografien als hochwertige Fotogravüren vervielfältigen.

Unterdessen ging auch die dreijährige Beziehung zwischen Man Ray und Lee Miller einem stürmischen Ende entgegen, nicht zuletzt deshalb, weil sie sowohl privat als auch beruflich auf ihre Unabhängigkeit pochte. 1931 lebte

les séances de pose. Les commandes affluaient, à tel point qu'il loua un autre atelier dans un quartier voisin pour pouvoir s'y consacrer à la peinture sans être dérangé. En outre, la sécurité matérielle lui permit d'embaucher une kyrielle de stagiaires pour s'occuper des clients et l'assister à la chambre noire. Presque tous ses assistants firent à leur tour de brillantes carrières dans la photographie : ainsi en alla-t-il de Berenice Abbott, de Jacques-André Boiffard, de Bill Brandt, de Lee Miller et, plus tard, de Naomi Savage.

Entre le milieu des années 1920 et le milieu des années 1930, tout un ensemble de publications plaça l'œuvre de Man Ray en point de mire. C'est Georges Ribemont-Dessaignes, membre du mouvement dada, qui lança la mode en 1924 en publiant la première monographie consacrée à l'artiste. Dans un autre texte paru la même année, il qualifia Man Ray de « chimiste des mystères », créateur d'un nouveau monde qu'il « photographiait pour prouver qu'il existe ». À la fin des années 1920, Man Ray créa *1929*, une plaquette composée de quatre images sexuelles très explicites et de poèmes sur le thème des quatre saisons. L'été 1929 commença paisiblement pour l'artiste. Il avait bientôt quarante ans. Pourtant, sa longue liaison avec Kiki avait dégénéré. Man Ray s'apprêtait à partir en vacances avec des amis à Biarritz. La veille de son départ, il fit la connaissance d'une jeune Américaine qui s'appelait Lee Miller et qui prétendait être sa nouvelle élève. Man Ray lui répondit sèchement qu'il ne prenait pas d'élèves et qu'il partait le lendemain pour le sud de la France, mais Lee Miller, loin de se laisser démonter par sa réponse, riposta du tac au tac : « Moi aussi ».

Lee Miller avait été mannequin à New York. Elle avait posé pour des photographes comme Edward Steichen et Arnold Genthe. Pendant deux ou trois ans, elle avait suivi des cours à l'Art Students' League avant de se lancer dans une carrière photographique. Des amis qui travaillaient dans l'édition lui avaient parlé de Man Ray et elle était partie à sa recherche à Paris. Bientôt, il lui confia des tâches de réceptionniste et l'employa comme assistante à la

Meanwhile, Man Ray's and Miller's three-year association had become stormy, due in large part to her independence in both personal and professional matters. By 1931, she had her own apartment, where she set up a portrait photography studio equipped with a darkroom. Man Ray's early pictures of her idealize her beauty, while later portrayals reflect his bitter fury over her free-spirited approach to their relationship as well as their eventual breakup. In September 1932, Man Ray published a drawing of a metronome with a cut-out photo of Miller's eye attached to the top of the pendulum, titled *Object to be Destroyed*. At year's end, she had left for New York to open a photography business with her brother Eric as well as to exhibit her work at Julien Levy's gallery.

Perhaps surprisingly, given his penchant for trying new techniques, Man Ray gave only cursory attention to color photography. Beginning in the 1930s, he created several images using the carbro process. Making an image with this process required three separate negatives that had to be meticulously aligned to create a successful print. Despite its many commercial applications, Man Ray was dissatisfied with the color quality and did not return to color work until much later in his life. One of his carbro compositions, however, appeared in the December 1933 issue of the Surrealist journal *Minotaure* and another on the cover of his *Photographs by Man Ray 1920 Paris 1934.*

The mid-1930s brought a measure of long-awaited recognition with Man Ray's inclusion in two significant surveys of Surrealist art. His work was shown in the *International Surrealist Exhibition* in London and in *Fantastic Art, Dada, Surrealism* in New York, both in 1936. Continuing his publishing streak, *Sur le réalisme photographique* [On photographic realism] appeared in the journal Cahiers d'art. The artist's *La Photographie n'est*

sie in ihrer eigenen Wohnung, in der sie auch ein Porträtstudio und eine Dunkelkammer eingerichtet hatte. Während Man Ray in seinen frühen Porträts von Lee Miller ihre Schönheit idealisierte, spricht aus den späteren seine verzweifelte Wut über die Vergeblichkeit seines Wunsches, sie an sich zu binden. Im September 1932 veröffentlichte er unter dem Titel *Object to be Destroyed* die Zeichnung eines Metronoms mit einem an der Spitze des Pendels befestigten ausgeschnittenen Foto ihres Auges. Gegen Ende dieses Jahres kehrte sie nach New York zurück, wo sie zusammen mit ihrem Bruder Erik ein Studio eröffnete und ihre Fotografien in Julien Levys Galerie ausstellte.

Trotz seiner Vorliebe für das Experimentieren mit neuen Techniken beschäftigte Man Ray sich nur beiläufig mit der Farbfotografie. Anfang der 30er Jahre schuf er mehrere Bilder mit Hilfe des Carbro-Verfahrens, das damals häufig für Werbefotografien verwendet wurde. Bei diesem Verfahren müssen für einen Abzug drei separate Negative exakt aufeinander abgestimmt werden. Man Ray war allerdings von der Farbqualität nicht überzeugt, und erst sehr viel später kehrte er noch einmal zur Farbfotografie zurück. Eine seiner Carbro-Kompositionen erschien jedoch im Dezember 1933 in der surrealistischen Zeitschrift *Minotaure* und eine andere auf dem Umschlag seines Buchs *Photographs by Man Ray 1920 Paris 1934.*

1936 war Man Ray an zwei bedeutenden und vielbeachteten Ausstellungen surrealistischer Kunst beteiligt: an der *International Surrealist Exhibition* in London und an *Fantastic Art, Dada, Surrealism* in New York. 1935 war in der Zeitschrift *Cahiers d'art* sein Beitrag »Sur le réalisme photographique« [Über den fotografischen Realismus] erschienen, und 1937 wurden unter dem Titel *La Photographie n'est pas l'art* [Die Fotografie ist keine Kunst] zwölf Fotografien mit einem Vorwort von Breton veröffentlicht. Im selben Jahr erschien *Les mains libres* [Die freien Hände], ein Gedichtband von Paul Eluard mit Zeichnungen von Man Ray. In dieser erfolgreichen Zeit erwarb

chambre noire. C'était une élève vive ; elle ne tarda pas à maîtriser ses exigences techniques et travaillait parfois à ses côtés. Au cours d'une séance de développement, elle alluma brusquement la lumière après avoir senti une souris lui frôler le pied. Dans le bain de tirage, les épreuves prirent une drôle d'allure : une auréole vint nimber le contour des objets. L'éclair de lumière avait provoqué un effet Sabattier, autrement dit un effet de solarisation – autre découverte du XIX^e siècle : en exposant à la lumière, pendant la phase de développement, une épreuve positive ou négative, on obtient une inversion partielle des teintes. Man Ray adopta très vite cet effet de solarisation parmi ses traits stylistiques caractéristiques, en le réservant de préférence à ses sujets les plus importants. En raison de leur qualité onirique, les photographies solarisées étaient particulièrement bienvenues dans les publications surréalistes.

En 1931, la Compagnie Parisienne de Distribution d'Électricité [C.P.D.E] commanda à Man Ray l'œuvre *Électricité*. C'est dans cette optique qu'il réalisa un album de dix rayographies en exposant à la lumière électrique, pour chacune d'entre elles, les objets placés sur une feuille de papier sensibilisé. La première de ses rayographies représentait une simple ampoule nue. Suivaient des images illustrant l'utilité de l'électricité dans chaque pièce de la maison. L'artiste déployait tout son sens de l'humour en montrant les avantages du confort moderne. Au lieu des épreuves photographiques qu'il avait utilisées dans *Champs délicieux*, il décida d'imprimer ses images par le procédé de la photogravure, lequel produisait les meilleurs résultats pour des tirages en grand nombre.

Pendant ce temps, Man Ray et Lee Miller connaissaient une liaison orageuse, en grande partie parce que celle-ci voulait conserver son indépendance, tant dans sa vie privée que dans sa vie professionnelle. Dès 1931, elle possédait son propre appartement où elle installa un studio de portrait et une chambre noire. Dans ses premières photographies, Man Ray avait idéalisé sa beauté ;

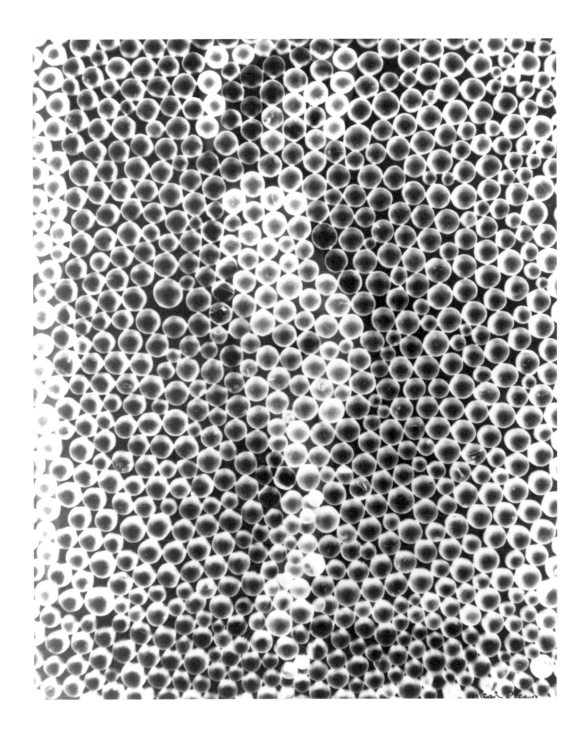

Untitled
1926

pas l'art [Photography is not art] appeared in 1937 with twelve photographs and an introduction by Breton. Also published that year was *Les mains libres* [Free hands], a volume of poems by Paul Eluard with drawings by Man Ray. With his career in full swing, Man Ray decided to purchase a country house outside Paris in Saint-Germain-en-Laye where he could retreat from the city. He also had a new woman in his life, Adrienne [Ady] Fidelin, a young dancer from Guadaloupe. Ady was the model for several of his fashion assignments and appears in a series of nude studies, often adorned with ethnographic artifacts.

Man Ray applied his knowledge of fashion and style to himself as well. Though short of stature, he was a snappy dresser and a wonderful dancer whose charm and sardonic wit found a ready audience among the ladies. His meticulous approach to his appearance was equally evident in the construction of his artistic persona. Man Ray's numerous self-portraits show him to be an artist very aware of manipulating his own image. He presents himself as either the cosmopolitan man-about-town – dapper in his overcoat and hat, perhaps leaning on a walking stick or a new car – or the intense, unsmiling artist, dark eyes blazing confrontationally. Just as he was a man who enjoyed his contradictions, so he was also happy to capitalize on the mystique of the photographic conjurer, the artist conversant with all movements but forging his own path.

Ever intrigued by unusual objects, Man Ray was attracted to a group of three-dimensional mathematical models at the Institut Henri Poincaré in Paris. Fellow Surrealist Max Ernst first called his attention to these plaster realizations of algebraic equations. Man Ray found the shapes so compelling that he photographed them, publishing twelve of the resulting pictures in a 1936 issue of the French journal *Cahiers d'art*. These pictures traveled with Man Ray when he moved to Los Angeles in 1940, where he developed them into a series of

Man Ray ein Landhaus in Saint-Germain-en-Laye bei Paris, wohin er sich zurückziehen konnte, und eine neue Frau trat in sein Leben, Adrienne [Ady] Fidelin, eine junge Tänzerin aus Guadaloupe. Ady stand ihm für verschiedene Modefotografien und, oft mit ethnographischen Artefakten geschmückt, für eine Folge von Aktstudien Modell. Man Rays Gespür für Mode und Stil kam auch ihm selbst zugute. Er war zwar von kleiner Statur, aber er wußte sich zu kleiden und war ein wunderbarer Tänzer, der mit seinem Charme und süffisanten Witz die Damen bezaubern konnte. Die Sorgfalt, die er seinem Erscheinungsbild widmete, tritt auch in seiner Selbstdarstellung als Künstler zutage. Seine zahlreichen Selbstporträts zeigen, daß er ganz bewußt an seinem Image arbeitete. Er präsentierte sich entweder als kosmopolitischer Mann von Welt – elegant in Mantel und Hut, auf einen Spazierstock oder an einen neuen Wagen gelehnt – oder als tiefgründiger Künstler, der mit seinen dunklen Augen und ernstem Blick den Betrachter fixiert. Er schwelgte in seinen Widersprüchen und genoß sein Image als Zauberer mit der Kamera, als Künstler, der – in allen Bewegungen bewandert – unbeirrt seinen eigenen Weg geht.

Zeit seines Lebens war Man Ray von ungewöhnlichen Objekten fasziniert, so auch von einer Gruppe dreidimensionaler mathematischer Modelle im Institut Henri Poincaré in Paris. Sein Freund Max Ernst hatte ihn auf diese Gipsmodelle algebraischer Gleichungen aufmerksam gemacht. Man Ray fand diese Formen so bezwingend, daß er sie fotografierte und zwölf dieser Fotografien 1936 in der Zeitschrift *Cahiers d'art* veröffentlichte. 1940 begleiteten ihn diese Bilder nach Los Angeles und dienten ihm dort 1948 als Grundlage für eine Folge von 20 Gemälden, die als *Shakespearean Equations* [Shakespearesche Gleichungen] bekannt sind. Indem er die mathematische Bedeutung der Vorlagen ignorierte und jedem dieser Bilder den Titel eines Shakespeare-Dramas gab, machte er den Weg für völlig neue Interpretationen frei.

dans ses portraits suivants, il laissa transparaître son amertume et sa colère face à une femme qui revendiquait farouchement sa liberté en le menaçant de séparation. En septembre 1922, il publia une image de métronome sur le balancier duquel il avait fixé avec un trombone une photographie de l'œil de Lee Miller : *Object To Be Destroyed* [Objet à détruire]. À la fin de cette année-là, Lee Miller était repartie à New York, où elle avait ouvert un commerce de photographie avec son frère Erick et où elle exposait ses œuvres à la galerie de Julien Levy.

Étant donné son goût pour l'expérimentation de nouvelles techniques, il semble étonnant que Man Ray n'ait fait qu'un usage très modéré de la photographie en couleurs. À partir des années 1930, il réalisa plusieurs images à l'aide du procédé carbro, qui exige la superposition minutieuse de trois négatifs de séparation pour le tirage d'une épreuve. Malgré ses nombreuses applications commerciales, Man Ray n'était guère satisfait de la qualité des couleurs obtenues et il attendit longtemps pour refaire de la photographie en couleurs. Pourtant, ce sont bel et bien des compositions en couleurs qui parurent, l'une dans le numéro de décembre 1933 de la revue surréaliste *Le Minotaure*, l'autre sur la couverture de son ouvrage *Photographs by Man Ray 1920 Paris 1934*.

Au milieu des années 1930, Man Ray connut enfin la reconnaissance espérée en présentant ses œuvres dans deux expositions fondamentales de l'art surréaliste : l'*International Surrealist Exhibition*, qui eut lieu à Londres en 1936, et *Fantastic Art, Dada, Surrealism*, qui s'ouvrit à New York la même année. Il continua aussi à publier son essai. *Sur le réalisme photographique* parut dans les Cahiers d'art et son recueil de douze photographies préfacé par André Breton, *La Photographie n'est pas un art*, sortit en 1937, la même année que *Les Mains libres*, recueil de poèmes de Paul Éluard illustré de dessins de sa main. Sa carrière battant son plein, Man Ray décida d'acheter une maison de campagne à Saint-Germain-en-Laye pour pouvoir se retirer de Paris à son

twenty oil paintings known as the *Shakespearean Equations* in 1948. Ignoring their mathematical significance, Man Ray opened them up to completely new interpretations by giving each image the title of a different Shakespeare play.

Despite the rumblings of approaching war in Europe and increasing political disarray in France, Man Ray retreated to the Antibes with Ady. But disturbing images of beasts and blood began to appear in his work to refute his attempt at normalcy. After the German invasion of Czechoslovakia, letters from New Jersey expressed mounting concern over the artist's welfare, while his phlegmatic responses assured the family that it was all just a political chess game. Even when France officially entered World War II, Man Ray was consolidating his belongings at the St.-Germain-en-Laye house where he was preparing to stay for the duration of the conflict. By the summer of 1940, however, Man Ray had joined the mass exodus from Paris and was headed toward Spain. After being turned back by the occupying forces, he was reluctantly ready to reclaim his American citizenship. His beloved Ady decided to stay in Paris with her family. What artwork he couldn't easily carry was left with art dealer Maurice Lefevre-Foinet and at the end of July, Man Ray traveled by train to Biarritz to secure a visa from the American Consulate. The composer Virgil Thompson was also there, waiting for a permit to enter Spain, so together the two made the journey to Lisbon where a staggering number of frantic refugees jockeyed for space on any outbound ship.

After two decades in France, Man Ray was leaving behind not only Ady but a successful business, his house, a car, numerous friends, and – even more significantly – much of his life's work. He was also abandoning his celebrity status in Paris. Dispirited by these unwelcome changes and the prospect of returning to the home-

Angesichts der Kriegsgefahr in Europa und der wachsenden politischen Instabilität in Frankreich zog sich Man Ray im Sommer 1937 zusammen mit Ady nach Antibes zurück. Die verstörenden Darstellungen wilder Tiere und blutiger Szenen in den Bildern aus dieser Zeit zeigen jedoch, daß er sich des Ernstes der politischen Lage bewußt war. Nach dem Einmarsch deutscher Truppen in die Tschechoslowakei kam in den Briefen, die er aus New Jersey erhielt, immer stärker die Sorge um sein Wohlergehen zum Ausdruck, während er in seinen phlegmatischen Antwortbriefen an seine Familie beschwichtigend von einem politischen Schachspiel sprach. Als Frankreich offiziell in den Zweiten Weltkrieg eintrat, entschied er sich sogar dazu, sich für die Dauer des Krieges in seinem Haus in Saint-Germain-en-Laye einzurichten, wohin er seine ganze Habe brachte. Im Sommer 1940 jedoch schloß er sich der Massenflucht aus Paris an und machte sich auf den Weg nach Spanien. Nachdem er von den deutschen Besatzungstruppen nach Paris zurückgeschickt worden war, besann er sich widerwillig auf seinen amerikanischen Paß. Seine geliebte Ady beschloß, bei ihrer Familie in Paris zu bleiben. Er ließ den größten Teil seiner Arbeiten bei dem Kunsthändler Maurice Lefèvre-Foinet zurück, und Ende Juli fuhr Man Ray mit dem Zug nach Biarritz, um sich dort im amerikanischen Konsulat ein Visum ausstellen zu lassen. Zusammen mit dem amerikanischen Komponisten Virgil Thomson konnte er die spanische Grenze passieren und sich auf den Weg nach Lissabon machen, wo zahllose verzweifelte Flüchtlinge einen Platz auf einem auslaufenden Schiff zu ergattern hofften.

Nach zwei in Frankreich verbrachten Jahrzehnten ließ Man Ray nicht nur Ady dort zurück, sondern auch ein erfolgreiches Studio, sein Haus, ein Auto, viele Freunde und – wichtiger noch – einen großen Teil seines Lebenswerks und seinen Status als bekannte Persönlichkeit. Die Aussicht auf die Rückkehr in ein Heimatland, in dem er sich nie verstanden oder angemessen gewürdigt gefühlt hatte, konnte seine Stimmung nicht heben. Zu allem Überfluß

gré. Il avait aussi une nouvelle femme dans sa vie : Adrienne Fidelin, dite Ady, jeune danseuse guadeloupéenne. Elle posa pour plusieurs photographies de mode qui avaient été commandées à l'artiste et apparut dans une séries d'études de nu souvent décorées d'objets primitifs.

Man Ray appliquait également à sa propre personne ce qu'il savait de la mode et du style. Il avait beau être de petite taille, il s'habillait avec chic, dansait admirablement et se taillait un beau succès auprès des dames grâce à son charme et à son esprit moqueur. Le soin méticuleux qu'il apportait à sa tenue se retrouve dans la construction de sa personnalité artistique. Ses nombreux autoportraits montrent à quel point il avait conscience de manipuler sa propre image. Dans ses autoportraits photographiques, il se présente tantôt sous les traits d'un homme du monde rompu à la vie cosmopolite [tout fringant avec son pardessus et son chapeau, d'aventure appuyé sur une canne ou sur une nouvelle automobile] ou bien sous les traits de l'artiste buté, renfermé, le regard sombre et vif fixant le spectateur. Tout comme il savourait ses propres contradictions, il prenait plaisir à exploiter la mystique du sorcier photographe, de l'artiste côtoyant tous les mouvements mais frayant sa propre voie.

Toujours perplexe devant les objets insolites, Man Ray fut sensible à un ensemble de constructions mathématiques en trois dimensions qui se trouvaient à l'Institut Henri Poincaré de Paris. Ce fut son acolyte, le peintre surréaliste Max Ernst, qui attira le premier son attention sur ces réalisations en plâtre d'équations algébriques. Incapable de résister, il les photographia sur-le-champ, publia douze de ces images dans un numéro des Cahiers d'art en 1936, puis les apporta dans ses affaires lorsqu'il déménagea à Los Angeles en 1940. Là, en 1948, il en tira une série de vingt peintures à l'huile connues sous le nom de *Shakespearean Equations* [Équations shakespeariennes]. Faisant fi de leur signification mathématique, il les offrit à un jeu d'interprétations inédites en donnant à chacune le titre d'une pièce de Shakespeare.

land where he had never felt appreciated or understood, Man Ray occupied himself with reading during the voyage to America. To make matters worse, his cameras were stolen during the passage. His arrival at the dock in Hoboken did nothing to assuage his fears, as the boat was met by a phalanx of reporters eager to interview fellow Surrealist Salvador Dalí, who was also on the ship. In New Jersey, Man Ray decided to escape his troubles and scout for prospects by crossing the country with Harry Kantor, a family acquaintance embarking on a circuitous business trip that would end in Southern California.

Once they arrived in Hollywood, Man Ray decided it was a good place to weather the war. Its temperate climate, film industry, and growing expatriate population suggested a comfortable substitute for the lively surroundings of Paris. As he noted in a letter to his sister Elsie, he was already accustomed to remaking his life and adapting to new circumstances. Much of his time was spent with the new love of his life, Juliet Browner, a thirty-year-old dancer from New York. Soon Juliet was sharing the artist's studio and became one of the primary subjects of his work. Other close friends included Margaret and Gilbert Nieman and later also Henry Miller.

After living in a number of resident hotels in Hollywood, Man Ray found a home for himself and Juliet on Vine Street, a key Hollywood intersection. The furnished apartment where the couple remained for the next decade included a high-ceilinged room that could be used as a studio and access to a courtyard which became the scene of many photographs. Man Ray also quickly realized the necessity of owning a car in Southern California. He bought a racy "Hollywood Supercharger" and immediately put its speedometer to the test. Because he was classified as a professional photographer, Man Ray was exempt from wartime gasoline rationing, which meant that he and Juliet were free to travel throughout California. His photographs from the forties record their sight-

wurden während der Überfahrt, auf der er sich mit Büchern die Zeit vertrieb, auch noch seine Kameras gestohlen. Und als das Schiff in New York anlegte, kam eine Phalanx von Reportern an Bord, um Salvador Dalí zu interviewen, der sich ebenfalls unter den Passagieren befand. In New Jersey faßte Man Ray den Entschluß, zusammen mit dem Geschäftsreisenden Harry Kantor, einem Bekannten seiner Familie, in dessen Auto quer durch die Vereinigten Staaten nach Südkalifornien zu reisen, um einen neuen Lebensabschnitt einzuleiten.

Als Man Ray in Hollywood eintraf, faßte er den Entschluß, hier den Krieg zu überstehen. Das milde Klima, die Filmindustrie und die vielen Emigranten aus Europa schienen ihm ein angenehmer Ersatz für das Leben in Paris zu sein. Wie er seiner Schwester Elsie schrieb, war es für ihn nichts Ungewohntes, ein neues Leben zu beginnen und sich an neue Umstände anzupassen. Einen großen Teil seiner Zeit verbrachte er mit der neuen Liebe seines Lebens, Juliet Browner, einer 30jährigen Tänzerin aus New York. Sie zogen bald zusammen, und Juliet stand ihm immer wieder Modell. Zu ihren engen Freunden zählten der Schriftsteller Gilbert Neiman und seine Frau Margaret, später auch Henry Miller.

Nachdem er zunächst in mehreren Hotels gelebt hatte, fand Man Ray für sich und Juliet eine Wohnung in der Vine Street, einer Hauptverkehrsstraße von Hollywood. Das möblierte Apartment, in dem das Paar in den folgenden zehn Jahren lebte, hatte einen Raum mit einer hohen Decke, der als Studio genutzt werden konnte, und Zugang zu einem Hof, der zur Kulisse für viele Fotografien wurde. Man Ray erkannte schnell, daß man in Südkalifornien ohne ein Auto kaum auskommen konnte, und kaufte einen rassigen Hollywood Supercharger, den er sofort einem Geschwindigkeitstest unterwarf. Weil er als Berufsfotograf klassifiziert war, war er von der kriegsbedingten Benzinrationierung befreit, so daß er und Juliet nach Lust und Laune durch Kalifornien fahren konnten. Seine Fotografien aus den 40er Jahren dokumen-

Les rumeurs d'une guerre en Europe se rapprochaient ; la situation politique en France était de plus en plus chaotique. Mais malgré tout, Man Ray se retira à Antibes avec Ady. Pourtant, à l'encontre de ses efforts pour faire comme si de rien n'était, des images troublantes de bêtes féroces et de taches de sang apparurent dans ses travaux. Après l'invasion de la Tchécoslovaquie par les Allemands, il reçut des lettres du New Jersey où sa famille se montrait de plus en plus préoccupée par son bien-être, mais il répondait sans s'affoler qu'il ne s'agissait que d'une partie d'échecs politique. Même après que la France fût officiellement entrée dans la Seconde Guerre mondiale, Man Ray continua à rassembler ses possessions dans sa maison de Saint-Germain-en-Laye, où il se préparait à demeurer pendant toute la durée du conflit. Mais dès l'été 1940, il participa à l'exode de masse et quitta Paris en direction de l'Espagne. Après son arrestation par les forces d'occupation, il redemanda à contrecœur sa nationalité américaine. Sa chère Ady décida de rester à Paris avec sa famille. Il laissa les œuvres d'art en dépôt chez le marchand de tableaux Maurice Lefebvre-Foinet et, à la fin du mois de juillet, prit le train pour Biarritz où il alla se procurer un visa auprès du consulat américain. C'est là qu'il rencontra le compositeur Virgil Thompson, qui attendait son permis d'entrée en Espagne. Tous deux firent ensemble le voyage jusqu'à Lisbonne, où un nombre stupéfiant de réfugiés s'agitaient et se bousculaient pour embarquer sur n'importe quel bateau en partance.

Après avoir passé près de vingt ans en France, Man Ray quittait l'Europe en abandonnant non seulement Ady, mais aussi un commerce fructueux, sa maison, une automobile, de nombreux amis et, surtout, une grande partie de son œuvre. Il renonçait aussi à son statut de célébrité à Paris. Pendant la traversée, on lui vola en outre ses appareils photos, ce qui contribua à l'accabler davantage. Et son arrivée à Hoboken, en face de New York, ne fit rien pour dissiper ses craintes : une armée de photographes attendaient le bateau, mais pour interviewer son ami surréaliste Salvador Dalí qui était aussi à bord.

seeing excursions and picnics with friends. Inspired by the lushness of Californian foliage, Man Ray began to take his camera outdoors to make pictures of flowers, the beach, and looming Sequoia trees.

At fifty years of age, Man Ray was a fully formed artist in his prime. But his time in Los Angeles, while pleasant, hardly afforded him the prestige and stimulation to which he had grown accustomed. "Aside from the weather, the atmosphere here is suffocating," he wrote to his sister Elsie in 1941. The uncertain fate of paintings left behind in France was oppressive as was the general wartime atmosphere, further exacerbated on the West Coast by the bombing of Pearl Harbor. Fearful of having lost the work that validated his claim to be an artist, Man Ray began making a second version of some of his earlier paintings. Despite his grumblings about the city's lack of culture and sophistication, he nonetheless found ample venues for exhibiting his work. During the 1940s his art was shown at various Californian Museums and at commercial galleries. Staging these events was no small undertaking since the artist had only a small number of pieces with him in America. His correspondence with Elsie is filled with requests to borrow pictures from her own collection as well as others on the East Coast. Despite this broad exposure, sales were all but non-existent and Man Ray's work was not taken seriously by reviewers. The artist was able to survive by drawing on money saved from his business in Paris and the support of a few devoted patrons. Upon his return to America, Man Ray was appalled to find that his reputation was that of a photographer and not an artist. Though he had never drawn distinctions between the media in which he worked he had begun early in his career to recognize a desire in others to classify him in a narrow category. Eventually finding his declarations of independence falling on deaf ears, Man Ray began to distance himself from his commercial work in photography in hopes of bolstering his hard-won reputation as an artist. His last fashion

tieren seine Ausflüge in die Landschaft und Picknicks mit Freunden. Inspiriert von der üppigen kalifornischen Vegetation, fotografierte er Blumen, den Strand und die gewaltigen Sequoiabäume.

Im Alter von 50 Jahren stand Man Ray auf dem Höhepunkt seiner künstlerischen Entwicklung. Doch so wohl er sich in Los Angeles auch fühlte, das kreative Umfeld, an das er sich in Paris gewöhnt hatte, konnte ihm die Stadt nicht bieten. »Abgesehen vom Wetter ist die Atmosphäre hier erdrückend«, schrieb er 1941 an seine Schwester Elsie. Das ungewisse Schicksal seiner in Frankreich zurückgelassenen Gemälde bedrückte ihn ebenso wie die allgemeine Kriegsatmosphäre, die an der amerikanischen Westküste durch die Bombardierung von Pearl Harbor noch verschärft worden war. Aus Furcht, die Werke, die seinen künstlerischen Rang begründeten, könnten verlorengegangen sein, malte er Zweitversionen einiger seiner früheren Gemälde. Trotz seiner Klagen über die Provinzialität der Stadt mangelte es ihm in den 40er Jahren nicht an Ausstellungen in kalifornischen Museen und kommerziellen Galerien. Zwar konnte er sich über fehlende Präsenz nicht beklagen, doch verkaufen konnte er so gut wie nichts, und die Rezensenten nahmen seine Kunst nicht ernst. Man Ray mußte auf Ersparnisse zurückgreifen und konnte auf einige wenige treue Gönner bauen. Nach seiner Rückkehr nach Amerika hatte er entsetzt entdecken müssen, daß er hier als Fotograf und nicht als Künstler bekannt war. Er selbst hatte zwar nie eine Trennlinie zwischen seinen Medien gezogen, doch andere hatten ihn schon früh in eine beschränkende Kategorie hineindrängen wollen. Als er schließlich erkennen mußte, daß seine Unabhängigkeitserklärungen auf taube Ohren stießen, begann er sich von seinem kommerziellen fotografischen Werk zu distanzieren, um seinen hart erkämpften Ruf als Künstler nicht zu gefährden. Seine letzten Modefotografien erschienen in den frühen 40er Jahren in *Harper's Bazaar*. Trotz finanzieller Schwierigkeiten war er nicht bereit, zu seiner jahrelangen Haupteinnahmequelle zurückzukehren. Seine

Il décida de fuir ses soucis et de partir à l'aventure à l'autre bout du pays. Un ami de la famille, Harry Kantor, entreprenait justement un voyage d'affaires qui devait se terminer, après bien des détours, en Californie du Sud. Il partit avec lui.

Quand ils furent arrivés à Hollywood, Man Ray décida de s'y fixer pour passer la guerre à couvert. Avec son climat tempéré, son industrie cinématographique, son afflux croissant d'expatriés, ce quartier de Los Angeles n'était pas sans lui rappeler l'animation parisienne. Il passa une grande partie de son temps avec son nouvel amour, Juliet Browner, jeune danseuse new-yorkaise de trente ans. Juliet ne tarda pas à partager le studio de l'artiste et celui-ci à la mettre au centre de son œuvre. Parmi ses amis, il comptait les écrivains Margaret et Gilbert Nieman, et plus tard aussi Henry Miller.

Après avoir vécu dans un certain nombre de résidences hôtelières, Man Ray trouva un appartement meublé sur Vine Street, au cœur de Hollywood. Il y emménagea avec Juliet ; ils devaient y rester pendant les dix années qui suivirent. L'appartement comprenait une pièce qui, avec sa hauteur de plafond, pouvait être facilement transformée en studio, et il donnait sur une cour où furent prises de nombreuses photographies. Man Ray se rendit aussi compte qu'il devait absolument posséder une voiture. Il s'acheta un modèle de course bleu métallique [un Hollywood Supercharger, fabriqué par la firme Graham-Page] et se laissa tout de suite griser par la vitesse à laquelle il roulait. En tant que photographe professionnel, il échappait au rationnement d'essence et pouvait donc sillonner la Californie avec Juliet, en toute liberté. Ses photographies des années 1940 montrent leurs excursions touristiques et leurs parties de pique-nique avec des amis. Inspiré par la luxuriance de la végétation californienne, il se mit à sortir avec son appareil pour photographier la flore, la plage et les grands séquoias.

À cinquante ans, c'était un homme dans la fleur de l'âge, un artiste en pleine

assignments were published in *Harper's Bazaar* in the early forties. Despite financial difficulties, he was thus unwilling to resume the work that had kept him afloat for so many years. This backlash against photography was expressed in a number of ways during the artist's stay in Southern California, but none more virulently than in his journal where a free-association section about the color black leads to ruminations about darkroom drudgery linked with the swastika symbol.

His friendship with film director Albert Lewin, one of the few collectors of Man Ray's work in Los Angeles, led to a couple of interesting assignments. Man Ray's chess sets and one of his paintings appeared in Lewin's film *Pandora and the Flying Dutchman* and he also photographed the leading actress Ava Gardner. He later photographed film stars Dolores del Rio, Gypsy Rose Lee, and Randolph Scott, but such portraits were rare. Enhancing the celebrity of others was a role about which the artist had become increasingly bitter.

The mid-1940s were a productive period for Man Ray. His writing and lecturing abilities blossomed and he returned to his fascination with designing chess sets, fabricating a large edition of pieces in anodized aluminum for sale to collectors. After six years together, he and Juliet decided on a whim to marry when friends Max Ernst and Dorothea Tanning came up from Sedona, Arizona to ask the couple to witness their own union. The double wedding was conducted in Beverly Hills on Oct. 24, 1946. At least one newspaper chronicled this "Surrealist wedding."

Duchamp had sent reassuring reports about Man Ray's property in Paris, but the artist did not return there until 1947. This exploratory visit gave Juliet a first look at her husband's adopted homeland, where Man Ray introduced his bride to old friends and returned to his favorite places. After securing some belongings and

Abwehr gegenüber der Fotografie brachte Man Ray während seines Aufenthalts in Südkalifornien auf verschiedene Weise zum Ausdruck, am schärfsten jedoch in seinem Tagebuch, wo er in einem Abschnitt mit freien Assoziationen über die Farbe Schwarz die Plackerei in der Dunkelkammer mit dem Hakenkreuzsymbol in Verbindung bringt.

Einige interessante Aufträge erhielt Man Ray aufgrund seiner Freundschaft mit dem Filmregisseur Albert Lewin, einem der wenigen Sammler seiner Arbeiten in Los Angeles. In Lewins Film *Pandora and the Flying Dutchman* [Pandora und der fliegende Holländer] sind Man Rays Schachfiguren und eines seiner Gemälde zu sehen, und er fotografierte auch die Hauptdarstellerin Ava Gardner. Später porträtierte er auch Filmstars wie Dolores del Rio, Gypsy Rose Lee und Randolph Scott, allerdings nur selten. Mehr und mehr verbitterte es ihn, zur Verbreitung des Ruhms anderer Menschen beizutragen.

Die mittleren 40er Jahre waren eine produktive Zeit für Man Ray. Er veröffentlichte Aufsätze und hielt Vorträge, und er kehrte zu einer alten Leidenschaft zurück und entwarf Schachfiguren, die in einer großen Stückzahl aus eloxiertem Aluminium produziert und an Sammler verkauft wurden. Nachdem sie sechs Jahre zusammengelebt hatten, faßten er und Juliet den spontanen Entschluß, zu heiraten, als Max Ernst und Dorothea Tanning aus Sedona, Arizona, zu ihnen kamen und sie baten, ihre Trauzeugen zu sein. Die Doppelhochzeit wurde am 24. Oktober 1946 in Beverly Hills gefeiert. Eine Zeitung brachte die Neuigkeit unter dem Titel »Surrealistische Hochzeit«.

Man Ray hatte von Duchamp erfahren, daß seine Habe in Paris den Krieg gut überstanden hatte. Erst 1947 kehrte er zum ersten Mal dorthin zurück. Bei dieser Stippvisite lernte Juliet seine Wahlheimat kennen; er stellte sie seinen alten Freunden vor und zeigte ihr seine Lieblingsplätze. Nachdem er sein Haus verkauft, seine Habe sortiert und einen Teil davon zum Transport in die USA verpackt hatte, kehrten er und Juliet nach Amerika zurück, wo sie

possession de ses moyens. Mais même s'il se plaisait à Los Angeles, il n'y retrouvait cependant pas l'ambiance prestigieuse et stimulante à laquelle il avait été habitué. Par crainte d'avoir perdu ce qui justifiait son étiquette d'artiste, Man Ray entreprit de refaire certains de ses tableaux de jeunesse ; et bien qu'il regrettât l'absence de culture et de raffinement à Los Angeles, il finit par trouver suffisamment de lieux pour exposer son œuvre aux musées californiens et dans les galeries commerciales. L'œuvre de Man Ray était largement exposée à la vue mais les ventes étaient quasi inexistantes. Les critiques le prenaient peu au sérieux. C'est grâce aux économies qu'il avait réalisées à Paris, ainsi qu'au soutien indéfectible de quelques mécènes, que l'artiste parvenait à survivre. À son retour en Amérique, Man Ray fut catastrophé de voir qu'il avait une réputation de photographe, non d'artiste. Même s'il n'avait jamais établi de démarcation nette entre les différentes formes d'expression dans lesquelles il travaillait, il avait assez tôt prêté le flanc à ceux qui voulaient l'enfermer dans une seule catégorie étroite. Comprenant enfin que son désir d'indépendance tombait dans l'oreille de sourds, il commença à prendre ses distances par rapport aux travaux photographiques qu'il réalisait dans un but purement alimentaire, espérant ainsi consolider une renommée d'artiste gagnée à la force du poignet. Ses derniers clichés de mode parurent dans *Harper's Bazaar* au début des années quarante. Par la suite, malgré certaines difficultés financières, il répugna à reprendre le type d'activité qui lui avait permis de subvenir à ses besoins pendant tant d'années. Cette brusque répulsion à l'égard de la photographie s'exprima de différentes manières pendant son séjour en Californie du Sud, mais la prise de position la plus virulente se trouve dans le journal intime de l'artiste où, dans un passage consacré à la couleur noire, il en vient à ressasser, au fil de libres associations d'idées, l'ingratitude du travail dans la chambre noire et à évoquer le symbole de la croix gammée.

Grâce à son amitié avec le réalisateur Albert Lewin, l'un des rares collection-

selling his house, Man Ray and Juliet returned to the U.S. with a stop in New Jersey to visit his family. During their stay with Man Ray's sister Elsie, the artist arranged for some of his work remaining in California to be shipped to her to centralize his holdings in the U. S. That year, his volume *Alphabet for Adults* was published. Man Ray also produced a limited-edition album of twenty-seven photographs and one engraving titled *Mr. and Mrs. Woodman* [ill. p. 140–147], featuring the erotic high jinks of two jointed lay figures of the type used by artists.

By the end of 1950 Man Ray was getting restless in California, so he decided to make a change. Though New York was occasionally mentioned as a destination, there could be no doubt that Man Ray would again make his home in Paris. To reduce baggage and secure funds for the journey, Man Ray and Juliet held an open house in December at the Vine Street studio with a giant yard sale. Piles of books both by and about the artist were available for purchase, along with his car and some of his artwork. In the spring the two made their way to the East Coast with traveling companions William Copley and Gloria de Herrera who sailed with them to France in early March. Duchamp, who had taken up residence in New York, came to say goodbye before the ship departed.

The next few months were spent in various hotels. The studio he finally selected, located near the Luxembourg Gardens, was a damp, unheated garage with a glass roof that leaked. But the ceiling was high and the light was good, and Man Ray set about making the place a bit more habitable. He rigged a parachute under the roof and set up a platform for painting. He also surrounded himself with his elaborate collections of masks, found objects, and Man Ray creations. He did not often travel far beyond this private universe, which meant that the studio became a gathering place for old friends and new Man Ray acolytes.

zunächst seine Familie in New Jersey besuchten. Seine aus Frankreich mitgebrachten Werke ließ er bei seiner Schwester Elsie, und auch einige der Arbeiten, die sich in Kalifornien befanden, ließ er zu ihr bringen, um bei ihr sein »amerikanisches Depot« einzurichten. In diesem Jahr veröffentlichte er in limitierter Auflage das Album *Mr. and Mrs. Woodman* [Abb. S. 140–147] mit 27 Fotografien und einer Radierung, die dem Betrachter die erotischen Kapriolen zweier hölzerner Gliederpuppen, wie sie von Künstlern verwendet werden, vorführen. Im Jahr darauf erschien das Album *Alphabet for Adults*. Gegen Ende des Jahres 1950 hielt es Man Ray nicht länger in Kalifornien, und er faßte den Entschluß, wieder einmal einen Ortswechsel vorzunehmen. Zwar wurde New York gelegentlich in Erwägung gezogen, doch an seiner eigentlichen Absicht – nach Paris zurückzukehren – gab es letztlich keine Zweifel. Um Ballast abzuwerfen und die Überfahrt zu finanzieren, veranstalteten Man Ray und Juliet im Dezember in ihrem Apartment in der Vine Street einen »Tag der offenen Tür« mit einer gigantischen Verkaufsaktion auf dem Hof. Stapel von Büchern von und über Man Ray wurden ebenso feilgeboten wie sein Auto und einige seiner Werke. Mit ihren Reisegefährten William Copley und Gloria de Herrera machten sie sich im Frühjahr auf den Weg zur Ostküste, wo sie Anfang März an Bord eines nach Frankreich fahrenden Schiffes gingen. Duchamp, der sich in New York niedergelassen hatte, wartete auf dem Schiff auf sie, um ihnen Lebewohl zu sagen.

Die ersten Monate in Paris verbrachten sie in verschiedenen Hotels. Als dauerhafte Unterkunft fand Man Ray schließlich eine feuchte, unbeheizte Garage mit einem undichten Glasdach in der Nähe des Jardin du Luxembourg, die jedoch eine hohe Decke und gutes Licht hatte. Gleich machte sich Man Ray daran, diesen Ort etwas wohnlicher herzurichten. Er spannte einen Fallschirm unter das Dach und richtete eine Plattform ein, auf der er malen konnte. Außerdem umgab er sich mit seinen umfangreichen Sammlungen von Masken, Objets trouvés und eigenen Schöpfungen. Dieses private

neurs de son œuvre à Los Angeles, il réalisa quelques projets intéressants : Lewin montra ses échiquiers et un de ses tableaux dans *Pandora and the Flying Dutchman* [Pandora et le Hollandais volant], et Ava Gardner, qui tenait le premier rôle dans ce film, posa devant son objectif. Plus tard, il photographia d'autres vedettes de cinéma comme Dolores del Rio, Gypsy Rose Lee ou Randolph Scott. Mais ces portraits étaient rares. C'était avec de plus en plus d'amertume que Man Ray acceptait de mettre en valeur la célébrité d'autrui.

Au milieu des années 1940, il connut une période particulièrement faste. Ses talents d'écrivain et de conférencier prospéraient ; sa fascination pour les échiquiers reprit de plus belle, il en conçut et en fabriqua un grand nombre en aluminium anodisé, pour les vendre à des collectionneurs. Après six ans de vie commune avec Juliet, ils décidèrent sur un coup de tête de se marier lorsque leurs amis Max Ernst et Dorothea Tanning arrivèrent de Sedona, en Arizona, pour leur demander s'ils accepteraient d'être les témoins de leur mariage. Après cette double cérémonie, célébrée à Beverly Hills le 24 octobre 1946, un journal qualifia l'événement de « mariage surréaliste ».

Duchamp avait envoyé à Man Ray des nouvelles rassurantes sur ses possessions parisiennes, mais celui-ci attendit l'année 1947 pour se rendre sur place. Au cours de ce voyage, Juliet vit pour la première fois le pays d'adoption de son mari ; il la présenta à de vieux amis et recommença à fréquenter ses lieux de prédilection. Après avoir mis ses affaires en lieu sûr et vendu sa maison, il repartit pour l'Amérique avec sa femme. Ils s'arrêtèrent dans le New Jersey pour rendre visite à sa famille. Là, ils habitèrent chez sa sœur Elsie et Man Ray se débrouilla pour se faire expédier une partie de son œuvre restée en Californie afin que ses biens soient tous réunis dans un seul endroit aux États-Unis. Cette année-là, Man Ray publia l'ouvrage *Mr. and Mrs. Woodman* [ill. p. 140–147], un album de vingt-sept photographies à tirage limité, ainsi qu'une gravure représentant les ébats érotiques de deux petits mannequins

These were lean times, as the artist continued to shun commercial projects. He also now refused to have his work shown in group exhibitions, feeling wary of how others chose to contextualize it and believing he had earned the right to solo shows. Such convictions hardly paid the rent. Man Ray's health was also beginning to decline with the onset of circulatory and joint problems that would restrict his activities and plague him until the end of his life. Another blow was the loss of Man Ray's loyal and loving sister Elsie, who died suddenly in the mid-1950s.

Though still actively discouraging the inclusion of photographs – except the rayographs – from exhibitions of his work, Man Ray nonetheless maintained his interest in the camera until the end of his life. He was invited by the Polaroid Company in the late 1950s to try a supply of their recently developed black-and-white film. This was an assignment he approached casually, producing a series titled "unconcerned photographs" by randomly pointing the camera and clicking the button. His approach to these nonfigurative pictures is reminiscent of the Surrealist interest in unconscious elements as the basis for art. He also continued regularly to photograph Juliet in both black-and-white and color. As the market for fine-art photography began to grow in the 1970s, Man Ray was still reluctant to sell this body of work to the museums, individuals, and dealers who inquired.

The acclaim and solo exhibitions for which Man Ray had waited so long began to come to him in his seventies. In 1961 he was awarded a gold medal at the Venice Photo Biennale and the following year a selection of his photographic work was shown at the Bibliothèque nationale in Paris. A large career retrospective was organized in Los Angeles in 1966 with an illustrated catalog. Man Ray made a rare trip to the West Coast for the occa-

Universum verließ er nur selten, und es wurde zu einem Treffpunkt für alte Freunde und neue Gefolgsleute.

Es waren magere Zeiten – nach wie vor scheute Man Ray kommerzielle Projekte. Aus Argwohn, in einen unangemessenen Kontext zu geraten, und in der Überzeugung, sich ein Recht auf Einzelausstellungen erworben zu haben, weigerte er sich jetzt auch, an Gruppenausstellungen teilzunehmen. Diese Prinzipientreue war wenig einträglich. Auch Man Rays Gesundheit begann sich zu verschlechtern. Kreislaufprobleme und Gelenkschmerzen traten auf, die ihn in seinen Aktivitäten einschränkten und bis an sein Lebensende plagen sollten. Ein weiterer Schlag war Mitte der 50er Jahre der Verlust seiner geliebten Schwester Elsie, die immer zu ihm gehalten hatte.

Obwohl er weiterhin Fotografien – mit Ausnahme der Rayografien – aus seinen Ausstellungen verbannte, arbeitete er bis zum Ende seines Lebens auch immer wieder mit der Kamera. In den späten 50er Jahren wurde er von der Polaroid Company gebeten, mit einem neu entwickelten Schwarzweiß-film zu experimentieren. Er ging diesen Auftrag unbefangen an und produzierte eine Folge von *Unconcerned Photographs* [Unbeteiligte Fotografien], indem er »wahllos« auf den Auslöser drückte. Diese nichtfigu-rativen Bilder erinnern an das Interesse der Surrealisten an unbewußten Elementen als Basis der Kunst. Weiterhin fotografierte er auch regelmäßig Juliet, sowohl in Schwarzweiß als auch in Farbe. Selbst als der Markt für künstlerisch wertvolle Fotografien in den 70er Jahren zu wachsen begann, war Man Ray noch immer kaum dazu zu bewegen, seine Fotografien an Museen, Sammler oder Händler zu verkaufen.

Die Anerkennung und die Einzelausstellungen, auf die Man Ray so lange gewartet hatte, bekam er schließlich in seinen Siebzigern. 1961 wurde er auf der Biennale von Venedig mit der Goldmedaille für Fotografie ausgezeichnet, und im Jahr darauf wurde eine Auswahl aus seinem fotografischen Werk in der Bibliothèque Nationale in Paris gezeigt. Eine große Retrospektive seines

en bois, semblables à ces bonshommes qu'utilisent les artistes dans leurs études.

À la fin des années 1950, Man Ray commençait à ne plus savoir que faire en Californie. Il envisagea sérieusement de partir. De temps à autre, il évoquait la destination de New York, mais il ne faisait aucun doute que c'était à Paris qu'il allait retourner. Au printemps, ils partirent pour la côte est en compagnie de William Copley et de Gloria de Herrera, puis embarquèrent tous les quatre pour la France au début du mois de mars. Duchamp, qui s'était définitivement établi à New York, vint les saluer sur le quai avant le départ du bateau.

À leur arrivée à Paris, ils passèrent quelques mois à l'hôtel. Finalement Man Ray trouva un studio qui était situé près du Jardin du Luxembourg : c'était un garage humide, sans chauffage, qui avait des fuites dans la verrière. Mais il était haut de plafond et très lumineux. Man Ray procéda à quelques aménagements pour le rendre plus vivable. Sous le toit, il fixa une toile de parachute et installa au-dessus une mezzanine pour ses travaux de peinture. Il apporta également sa riche collection de masques, d'objets trouvés et de créations personnelles. Comme il ne se déplaçait jamais loin de ce petit univers, c'est dans son studio que se rassemblaient ses vieilles connaissances et un flot croissant de disciples.

Pourtant, Man Ray traversait une période de vaches maigres. En effet, il continuait à fuir les propositions commerciales. En outre, il n'acceptait plus de figurer dans des expositions collectives parce qu'il en avait assez de la manière dont on présentait ses œuvres et qu'il pensait avoir suffisamment fait ses preuves pour avoir droit à des expositions individuelles. Ses convictions, cependant, le mettaient dans une situation financière précaire. La santé de Man Ray commençait aussi à décliner : il souffrait de rhumatismes et de troubles circulatoires qui devaient limiter ses activités et s'aggraver jusqu'à la fin de ses jours. Il eut aussi à subir un autre choc lorsque, au milieu des années 1950, sa chère sœur Elsie mourut brusquement.

sion, entertaining an overflowing auditorium with his humorous observations. In 1967, the Awards Committee of the Philadelphia Arts Festival publicly recognized Man Ray for his accomplishments and the honor reflected upon his native city. And his place in the history of modern art was further secured by his inclusion in the landmark exhibition *Dada, Surrealism, and their Heritage* at the Museum of Modern Art in New York in 1968.

With his autobiography *Self Portrait*, published in 1963, he created the "official" version of the myth of Man Ray, the artist, and cannily took the upper hand in defining his life and work. His thorough involvement with this project extended to the design of the book and its distinctive cover. Man Ray traveled to New York to be available for interviews in conjunction with the book release. The trip coincided with the opening of an exhibition of his work at the art museum at Princeton University as well as a show at the Cordier & Ekstrom Gallery in New York, evidence of the growing recognition of his achievements by his native country.

Man Ray's return to Paris had stimulated him to begin a new round of object-making and led him once again to visit Paris flea markets in search of interesting components. During the 1960s the artist created limited edition reproductions of some of his most famous object creations. Throughout his seventies and into his eighties, Man Ray continued to create, though increasingly his time was absorbed by interviews and other activities spurred by the demand for his work, as well as by his own ailments. He also released *Résurrection des mannequins*, a limited edition album of photographs presenting a series of creatively bedecked mannequins from the 1938 *Expositionale du Surréalisme* at the Galerie des Beaux-Arts in Paris, a piece that substantiates Man Ray's presence as both creator and documentarian in the midst of the Surrealist movement.

In August of 1976, Man Ray celebrated his 86th birthday and was awarded the Order of Artistic Merit by

Gesamtwerks, zu der ein illustrierter Katalog erschien, wurde 1966 in Los Angeles veranstaltet. Man Ray nahm aus diesem Anlaß die Mühe auf sich, nach Kalifornien zu reisen und ein überfülltes Auditorium mit seinen humorvollen Bemerkungen zu unterhalten. 1967 würdigte ihn das Preiskomitee des *Philadelphia Arts Festival* als verdienstvollen Sohn der Stadt. Und durch die Teilnahme an der Jahrhundertausstellung *Dada, Surrealism, and their Heritage* im Museum of Modern Art in New York wurde 1968 sein Platz in der Geschichte der modernen Kunst noch stärker gefestigt.

Mit seiner 1963 veröffentlichten Autobiographie *Self Portrait* kreierte er die »offizielle« Version seines eigenen Mythos; er nahm die Darstellung seines Lebens und seines Werkes geschickt in die eigene Hand, ungetrübt von jeder präzisen Datumsangabe. Zur Präsentation des Buches reiste Man Ray nach New York und stellte sich der Presse für Interviews zur Verfügung. Zur selben Zeit wurden Ausstellungen seiner Werke im Kunstmuseum der Princeton University und in der Cordier & Ekstrom Gallery in New York eröffnet – ein Beleg für die wachsende Anerkennung, die er inzwischen in seinem Geburtsland fand.

Nach Paris zurückgekehrt, durchstöberte Man Ray die Flohmärkte der Stadt, um nach interessanten Komponenten für neue Objekte zu suchen. In den 6oer Jahren ließ er Reproduktionen einiger seiner bekanntesten Objektschöpfungen anfertigen. Auch in seinen Siebzigern und bis in die Achtziger hinein blieb er künstlerisch tätig, obwohl seine Zeit mehr und mehr durch Interviews und andere Beschäftigungen im Zusammenhang mit dem großen Interesse an seinem Werk und auch durch seine Gebrechen in Anspruch genommen wurde. 1966 veröffentlichte er *Résurrection des mannequins* [Auferstehung der Mannequins], die limitierte Edition eines Albums mit einer Folge von Fotografien, die 1938 auf der *Exposition Internationale du Surréalisme* in der Galerie des Beaux-Arts in Paris aufgenommen worden waren und – teils von Man Ray selbst – kreativ geschmückte Mannequins

Tout en se montrant farouchement hostile à la présentation de photographies dans des expositions de son œuvre [exception faite de ses rayographies], Man Ray continua à prendre des clichés jusqu'à ses derniers jours. À la fin des années 1950, la firme Polaroïd lui proposa d'essayer sa toute nouvelle pellicule en noir et blanc. Il accepta la proposition et l'honora avec désinvolture, dirigeant son objectif et déclenchant son appareil au hasard. Il en résulta une série d'images qu'il intitula *Unconcerned Photographs* [Photographies insouciantes], dont la méthode de création et le style non figuratif rappelaient l'intérêt des surréalistes pour les éléments de l'inconscient qu'ils plaçaient au fondement de leur art. En outre, Man Ray continua à photographier régulièrement Juliet, aussi bien en noir et blanc qu'en couleurs. Comme le marché de la photographie d'art s'épanouissait dans les années 1970, Man Ray rechignait toujours à vendre ce pan de son œuvre à des musées, à des individus ou à des marchands qui se montraient intéressés. Man Ray avait soixante-dix ans passés lorsque la longue attente de la consécration porta enfin ses fruits : il commença à être reconnu comme artiste et à faire l'objet de grandes rétrospectives. En 1961, il reçut la médaille d'or à la Biennale de photographie de Venise et, l'année suivante, un choix de ses photographies fut exposé à la Bibliothèque Nationale à Paris. En 1966 eut lieu une grande rétrospective de l'ensemble de sa carrière à Los Angeles, accompagnée d'un catalogue illustré. À cette occasion, Man Ray fit le déplacement sur la côte ouest ; il donna une conférence émaillée de remarques humoristiques devant une salle archi-comble. En 1967, le jury du Festival des arts de Philadelphie [Awards Committee of the Philadelphia Arts Festival] lui décerna une récompense officielle pour son œuvre et pour le rayonnement de sa ville natale auquel il avait ainsi contribué. Il conforta sa place dans l'histoire de l'art moderne en participant à l'exposition phare organisée au Museum of Modern Art de New York en 1968 : *Dada, Surrealism, and Their Heritage* [Dada, le surréalisme et leur héritage].

the French government. Despite his rapidly failing health, he insisted on daily work sessions in the studio, even if the only art he had the strength to accomplish was completed in his head. He continued to draw pictures, accepting the wobbling arthritic lines he made as just another tool at his disposal. On the morning of November 18, Man Ray died in his studio with Juliet in attendance and was buried at the Cimetière du Montparnasse.

zeigen. Diese Fotografien belegen seine Doppelrolle als kreativer Künstler und als Dokumentarist innerhalb der surrealistischen Bewegung.

Im August 1976 feierte Man Ray seinen 86. Geburtstag und wurde von der französischen Regierung mit dem Verdienstorden für Künstler ausgezeichnet. Trotz seiner sich rapide verschlechternden Gesundheit wollte er von der täglichen Arbeit im Atelier nicht lassen, auch wenn er nicht mehr die Kraft hatte, das, was vor seinem inneren Auge stand, praktisch umzusetzen. Die zittrigen, arthritischen Linien, die er noch ziehen konnte, akzeptierte er als eine weitere seiner vielen Ausdrucksmöglichkeiten. Im Beisein Juliets starb er am Morgen des 18. November. Er wurde auf dem Cimetière du Montparnasse beigesetzt.

Avec son autobiographie *Self Portrait* [Autoportrait], publiée en 1963, il créa la version «officielle» de son propre mythe. Man Ray se montrait fin stratège : il s'attribuait le droit de définir sa vie et son œuvre en devançant les efforts de quiconque eût voulu l'évaluer. Au moment du lancement du livre, il se rendit à New York pour se faire interviewer. Ce voyage coïncida avec l'inauguration d'une exposition de son œuvre au musée d'art de la Princeton University, ainsi qu'avec une autre exposition à la Cordier & Ekstrom Gallery de New York : autant de preuves que sa reconnaissance allait croissant dans son pays natal.

En revenant s'installer à Paris, Man Ray se remit à fabriquer des objets et à fréquenter les marchés aux puces pour y dénicher des pièces intéressantes. Pendant les années 1960, il reproduisit en nombre limité quelques-unes de ses plus célèbres créations d'objets. Malgré la vieillesse et le manque de temps, accaparé qu'il était par les entretiens, les demandes auxquelles il devait faire face et ses douleurs physiques, rien n'aurait pu l'empêcher de poursuivre son œuvre créatrice. Il publia *Résurrection des mannequins*, recueil de photographies choisies parmi celles qu'il avait prises en 1938 lors de l'Exposition internationale du surréalisme qui s'était tenue à la Galerie des Beaux-Arts à Paris : on y voyait une série de mannequins parés d'atours hautement créatifs. Manière de souligner le rôle qu'avait joué Man Ray au sein du mouvement surréaliste, en double qualité d'artiste et de photographe archiviste.

En août 1976, Man Ray fêta son quatre-vingt-sixième anniversaire et fut décoré de l'Ordre artistique du Mérite par le gouvernement français. Il continuait à dessiner contre vents et marées, tournant à son avantage les tremblements que lui causait l'arthrose et considérant comme un autre outil à sa disposition les lignes qu'il traçait sur le papier d'une main fébrile. Il mourut le matin du 18 novembre dans son studio, en présence de Juliet, et fut enterré au cimetière de Montparnasse.

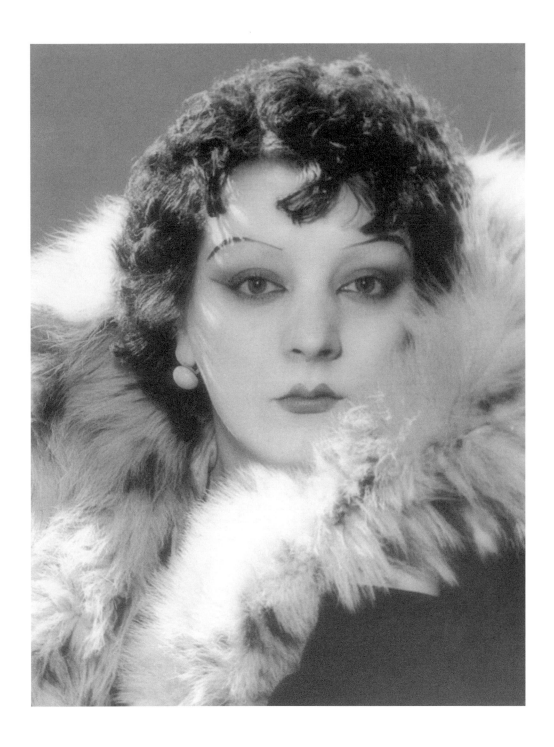

Kiki de Montparnasse
c. 1929

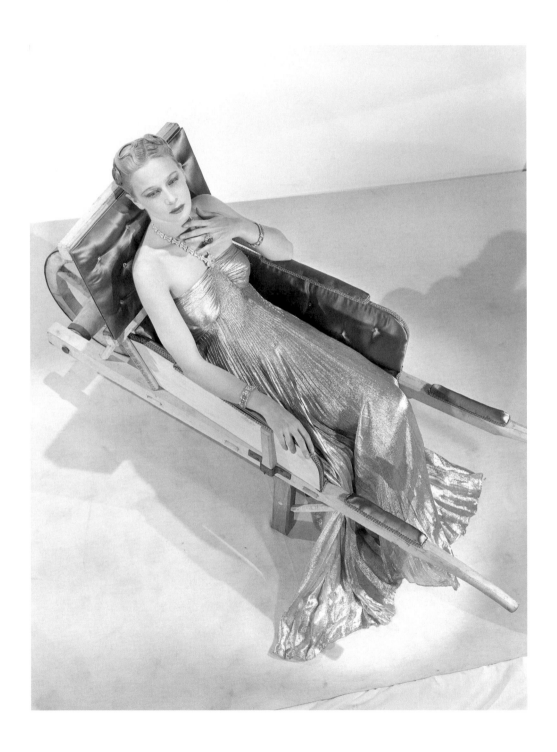

Fashion
1937

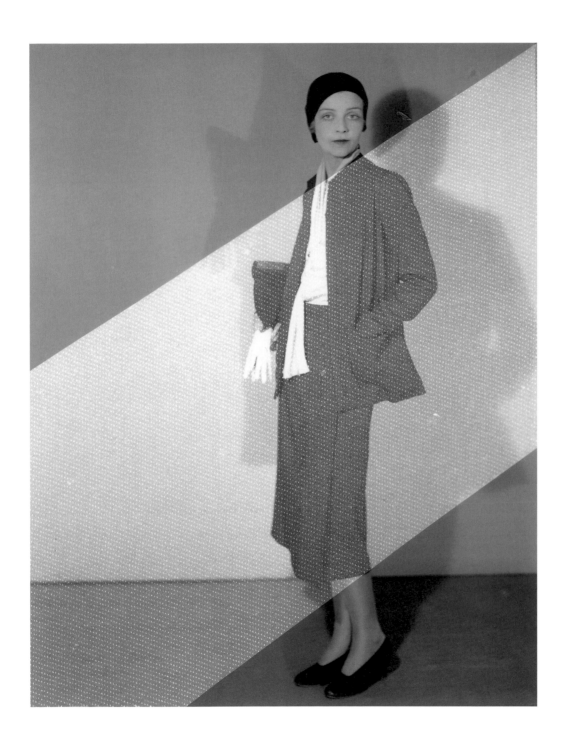

Fashion
c. 1935

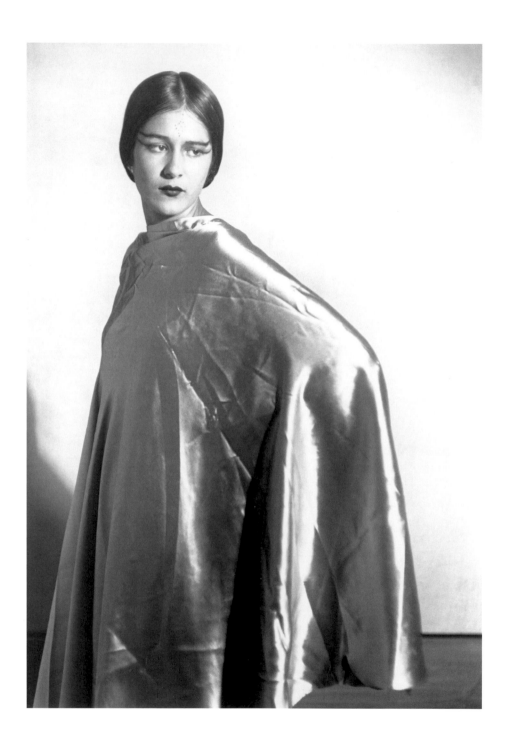

Untitled
c. 1930

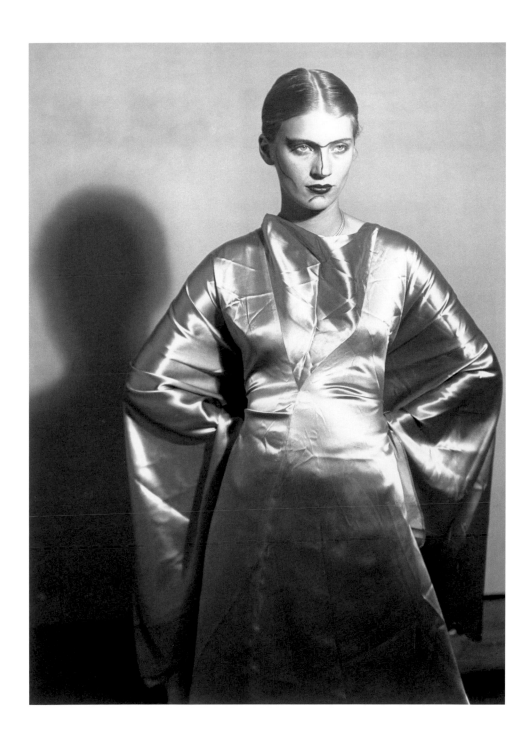

Lee Miller
c. 1930

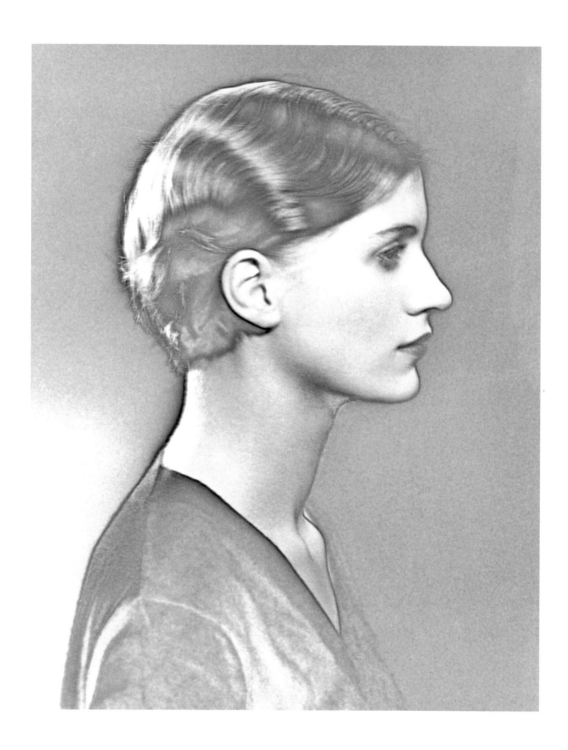

Lee Miller
1929

Es gab immer und gibt immer zwei Beweggründe für alles, was ich tue: die Freiheit und die Freude.

There have always been, and there still are, two themes in everything I do: freedom and pleasure.

Il y a toujours eu, et il y a toujours deux motifs dans tout ce que je fais : la liberté et le plaisir.

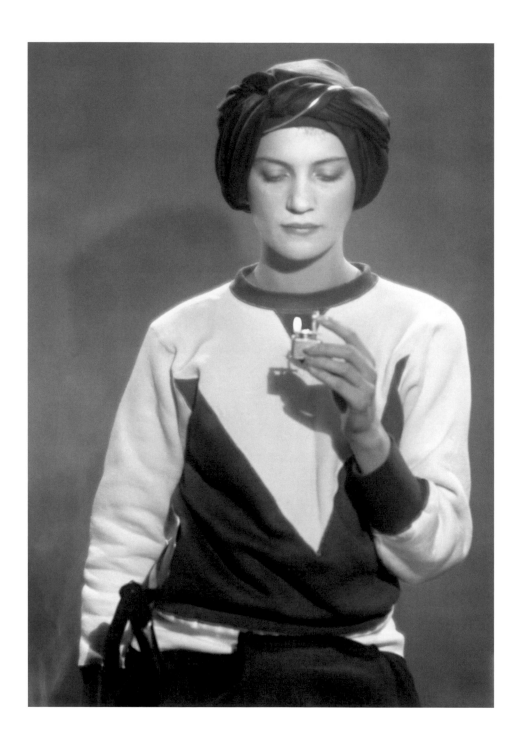

Lee Miller
1930

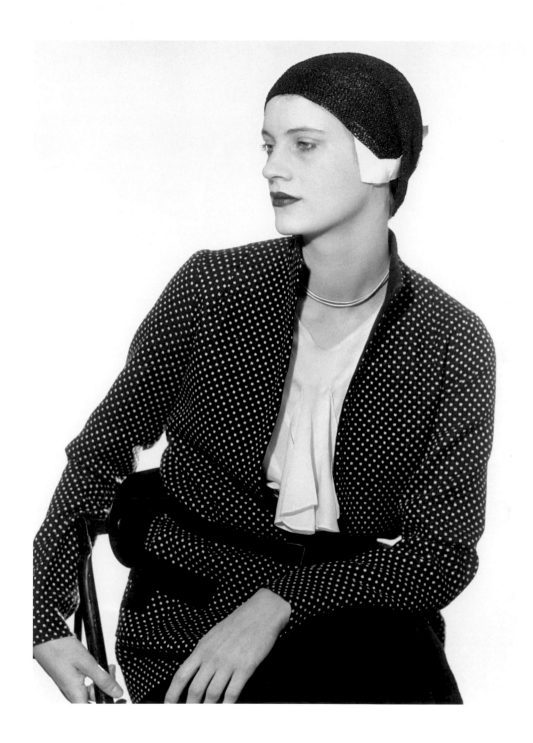

Lee Miller
1930

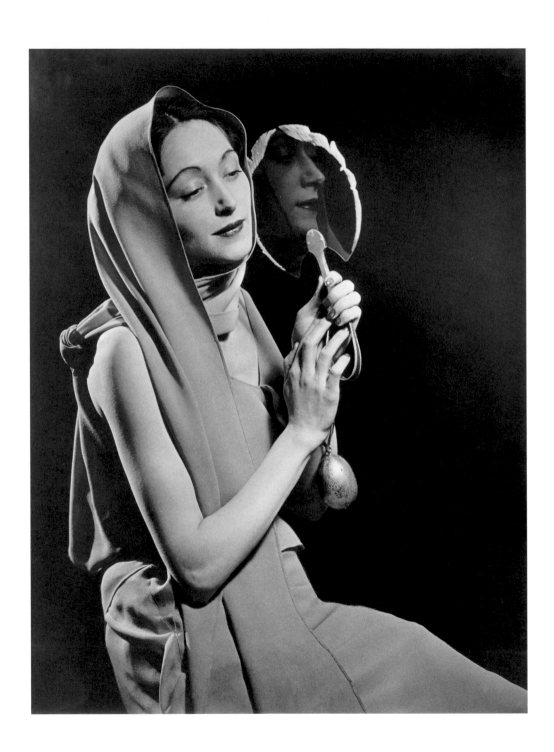

Nusch au miroir
1935

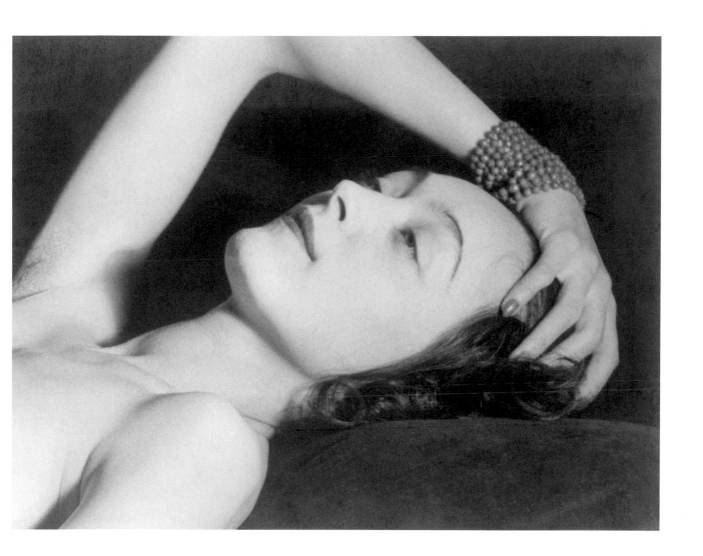

Nusch
1935

Es ist mir nicht gelungen, nicht geboren zu werden. Meine Eltern trennten sich eine Woche nach ihrer Hochzeit und trafen sich erst ein Jahr später zufällig wieder. Damals haben sie beschlossen, mich in die Welt zu setzen. Seitdem ist es nicht zu leugnen, daß ich 1890 in Philadelphia geboren wurde.

I nearly wasn't born. My parents separated a week after their marriage, and didn't meet up again until a year later, quite by chance. That was when they decided to have me. Impossible to deny, ever since, that I was born in Philadelphia in 1890.

J'ai failli ne pas naître. Mes parents se séparèrent une semaine après leur mariage et ne se rencontrèrent de nouveau qu'un an plus tard, par hasard. C'est alors qu'ils se sont décidés à me mettre au monde. Depuis, il est indéniable que je suis né à Philadelphie en 1890.

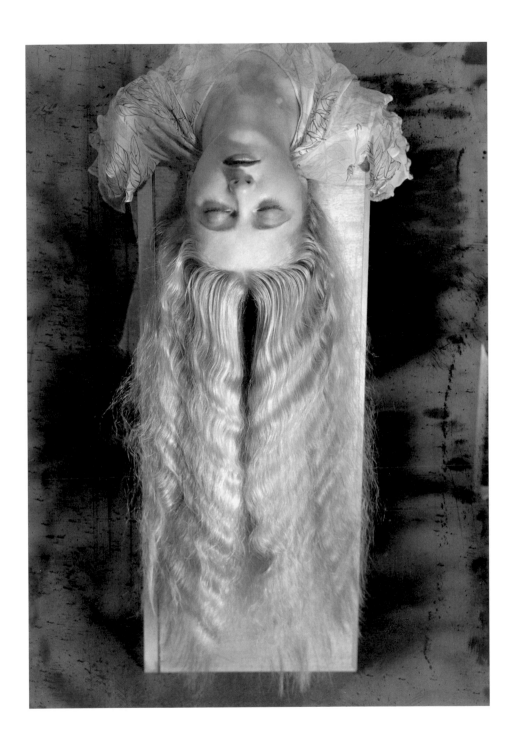

Untitled
1931

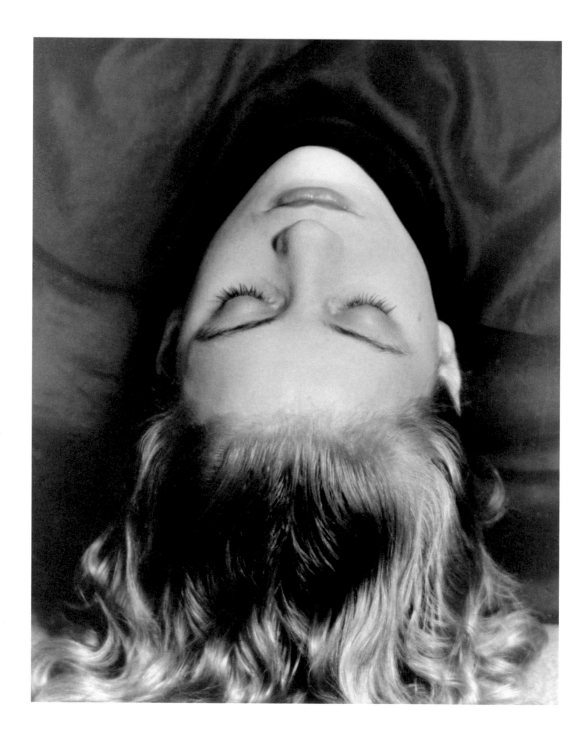

Lee Miller
c. 1930

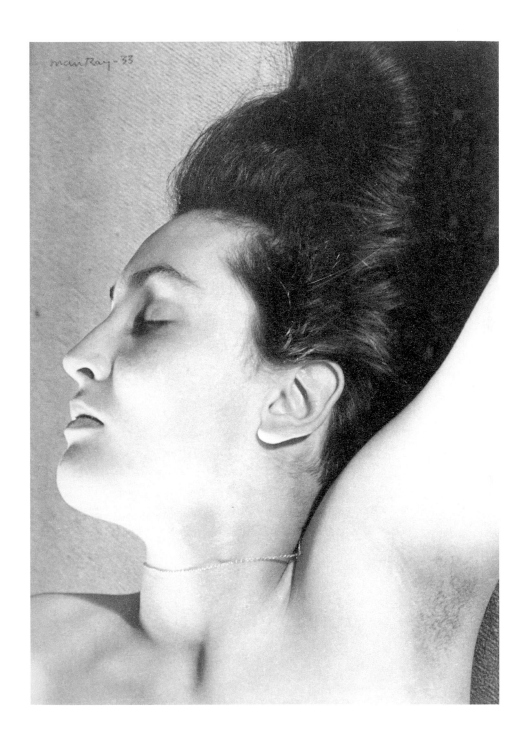

Meret Oppenheim
1933

Wenn ich Fotos machte, wenn ich in der Dunkelkammer war, ließ ich absichtlich alle Regeln außer acht, mischte die unpassendsten Mittel zusammen, verwendete Filme, deren Haltbarkeitsdatum überschritten war, machte die schlimmsten Sachen gegen alle Chemie und gegen das Foto, aber das sieht man nicht.

When I took photos, when I was in the darkroom, I deliberately dodged all the rules, I mixed the most insane products together, I used film way past its use-by date, I committed heinous crimes against chemistry and photography, and you can't see any of it.

Quand je prenais des photos, quand j'étais dans la chambre noire, j'évitais exprès toutes les règles, je mélangeais les produits les plus insensés, j'utilisais des pellicules périmées, je faisais les pires choses contre la chimie et la photo, et ça ne se voit pas.

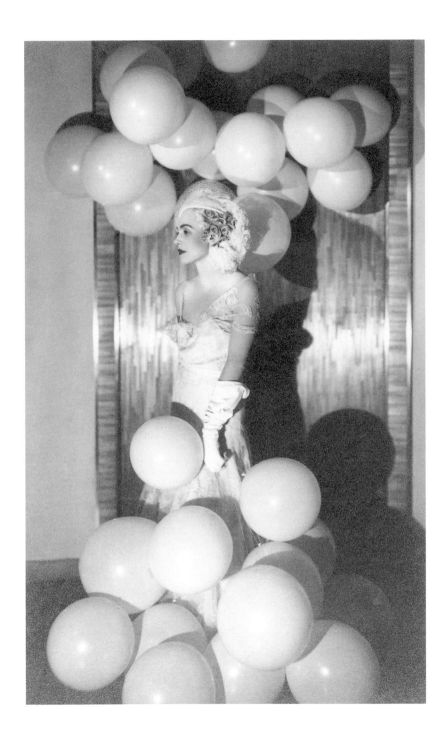

Untitled
1928

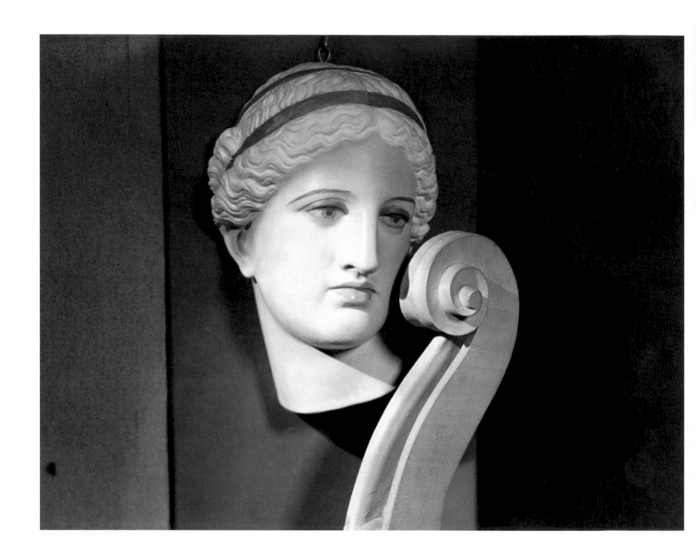

Untitled
c. 1930

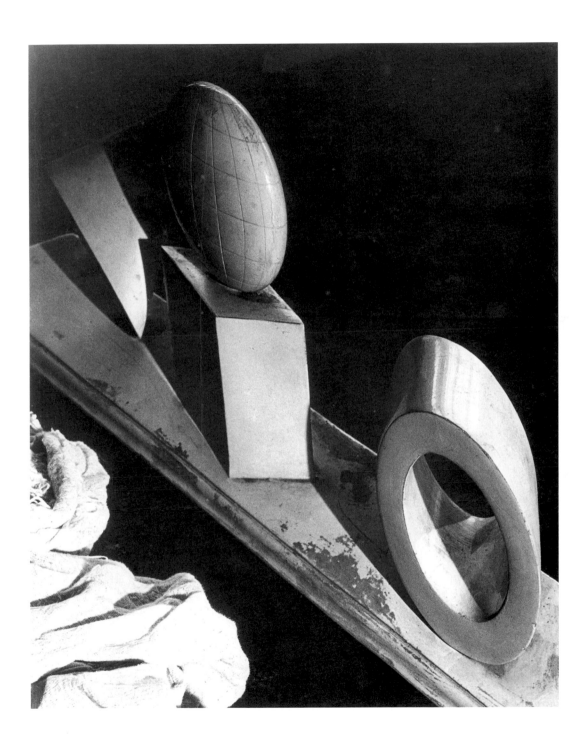

Perspective d'un cube, d'une sphère, d'un cône et d'un cylindre
1934–1936

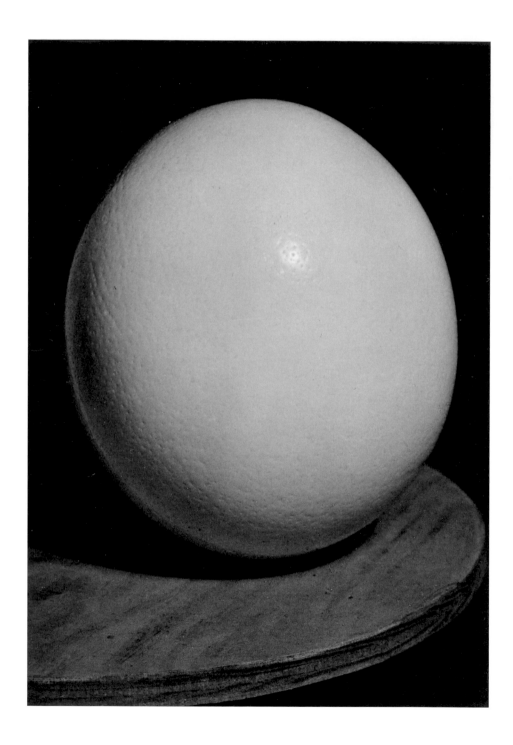

Ostrich Egg
1944

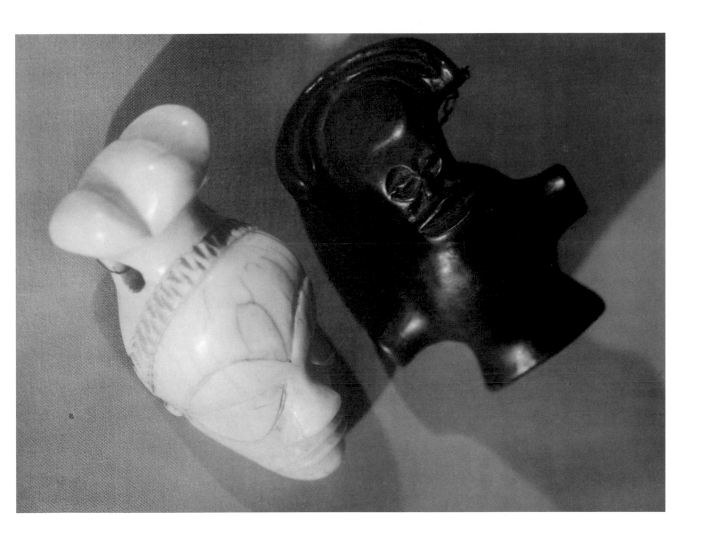

Untitled
c. 1938

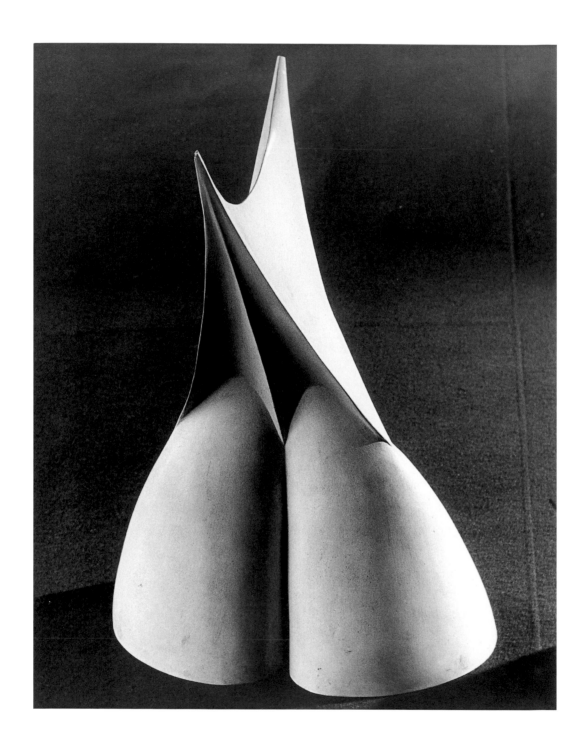

Objet mathématique
1934–36

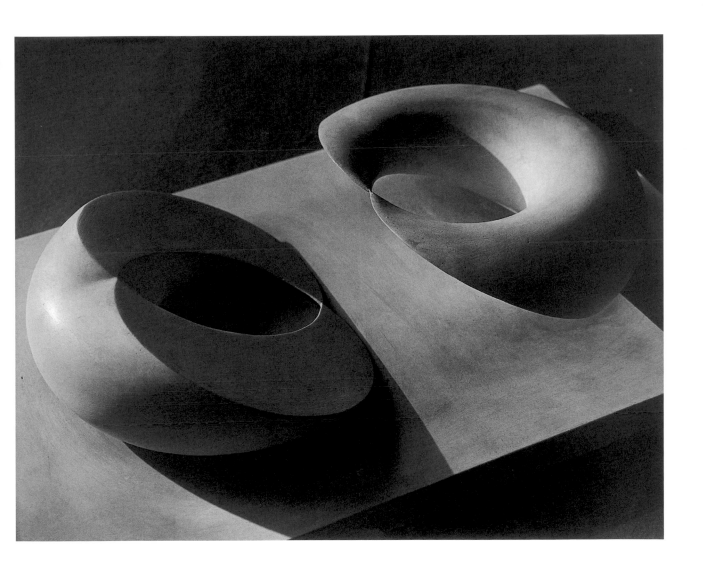

Objet mathématique
1934–36

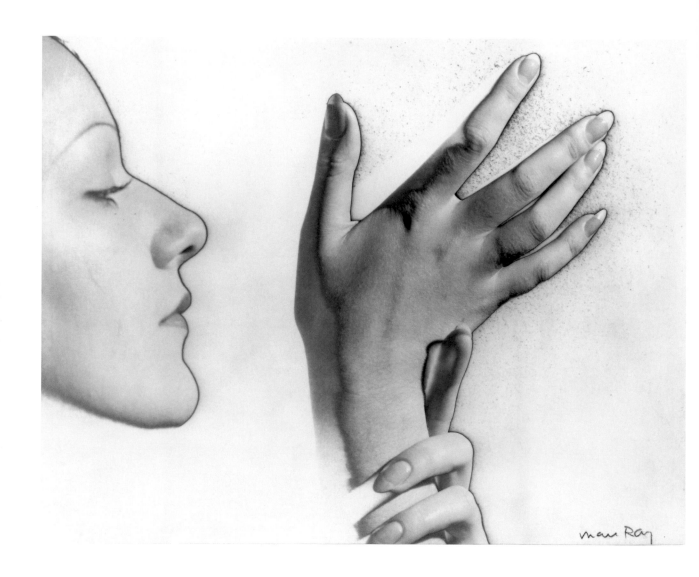

Untitled
1932

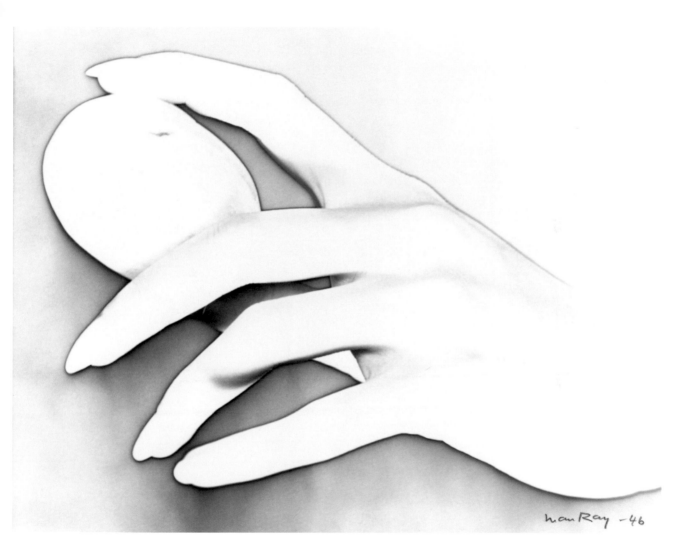

Untitled
1946

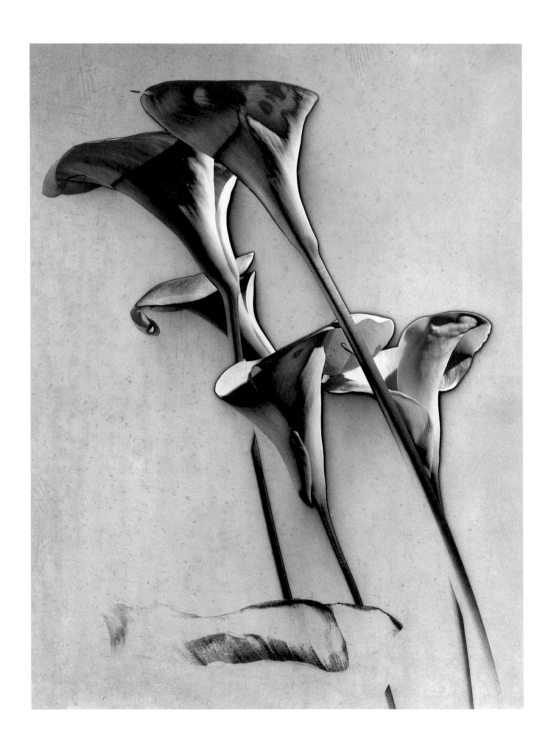

Les Arums
1930

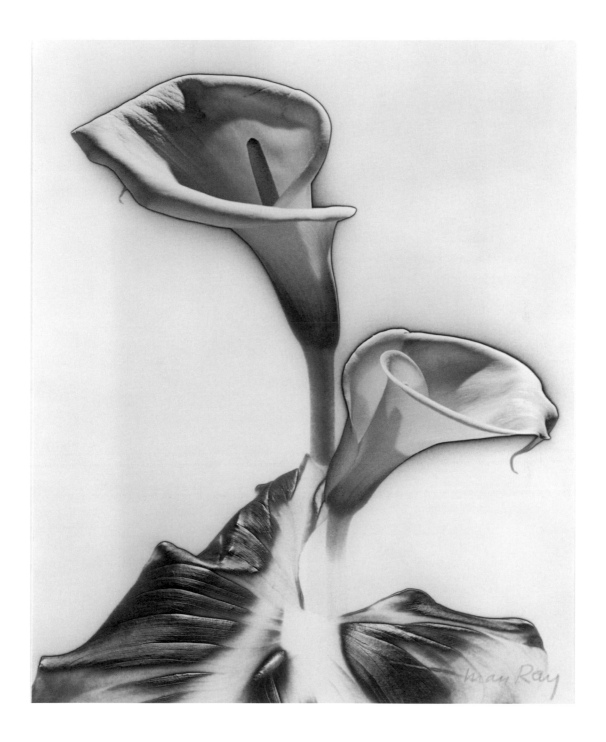

Calla Lilies
1930

Ist es nicht diese ewige Nachahmungsmanie, die den Menschen daran hindert, ein Gott zu sein?

Isn't it this perpetual mania of imitation that prevents man from being a god?

N'est-ce pas cette sempiternelle manie de l'imitation qui empêche les hommes d'égaler les dieux?

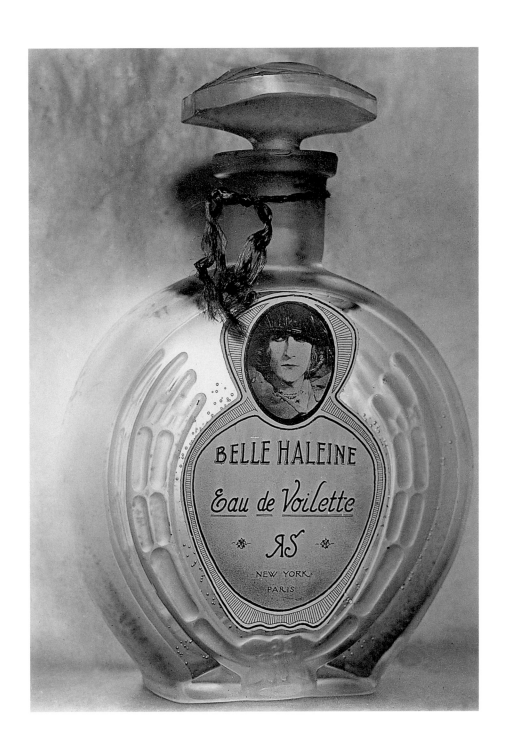

Belle Haleine Eau de Voilette [Marcel Duchamp]
1921

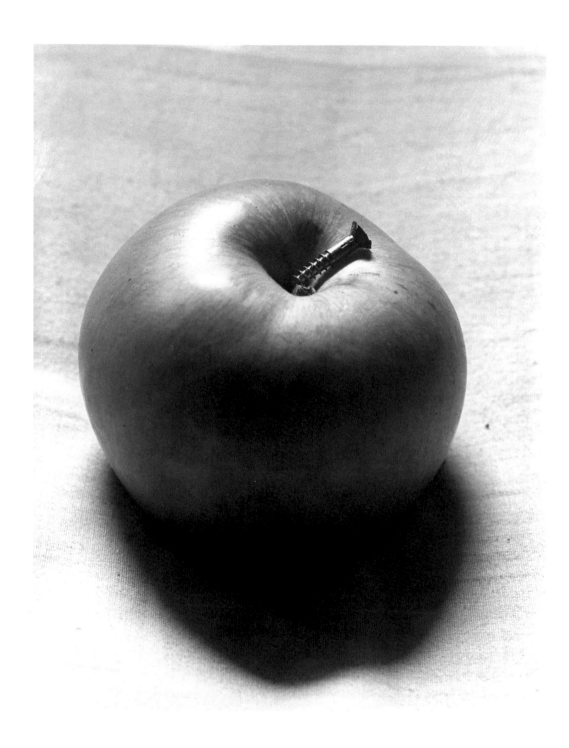

Untitled
1931

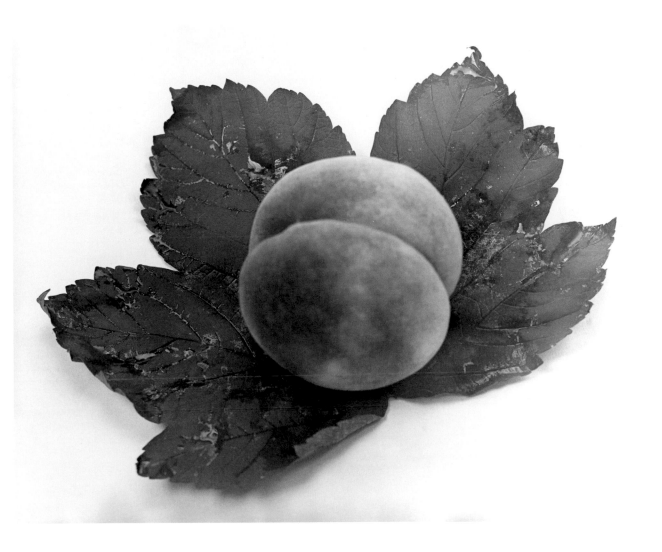

Untitled
1931

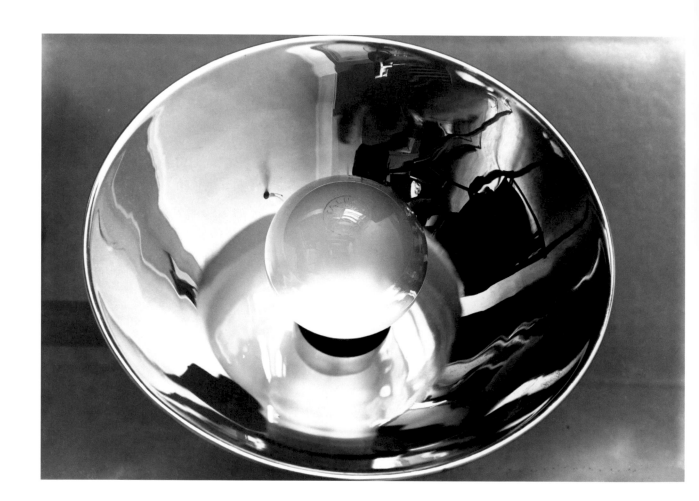

Untitled
1932

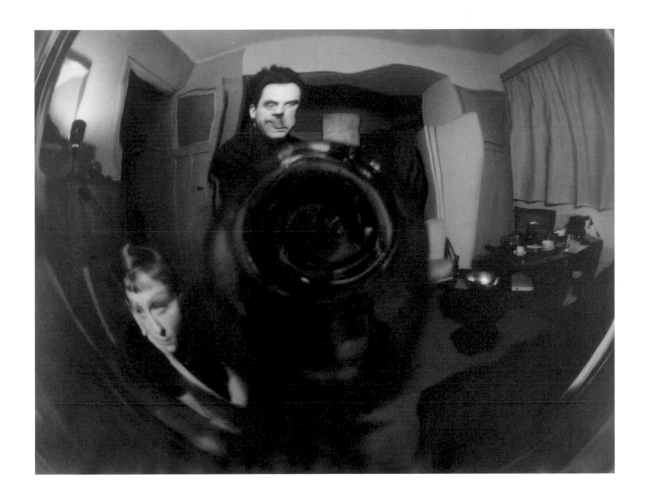

Untitled
1932

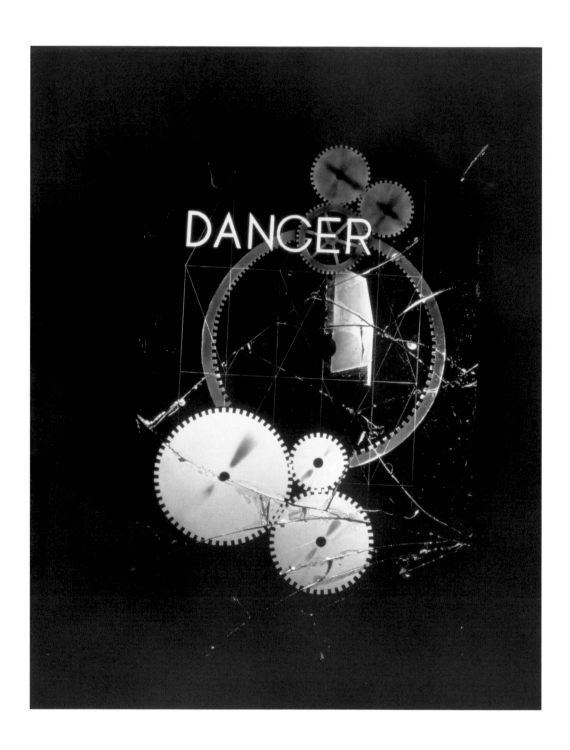

Dancer/Danger
1920

Untitled
c. 1935

Viele Menschen möchten wissen, wie ich bestimmte Effekte erziele. Es genügt, wenn ich dazu sage, daß ich diese Effekte als ganz persönliche Formen betrachte, die durch die Verletzung gemeinhin akzeptierter Prinzipien im Arbeitsprozeß – aber unter strenger Beachtung bekannter Naturphänomene – erreicht werden. Ich will nicht, daß diese Formen sich allgemein verbreiten; dadurch würde nur der Technik wieder einmal zu Lasten des eigentlichen Themas zu große Aufmerksamkeit zuteil.

For those who wish to know how I obtain certain effects, it is sufficient to say that I regard these as very personal forms, obtained by the violation of accepted principles in the process of working, but obeying well known phenomena in nature, forms that I have no desire of seeing universally adopted, which would again give to technique too great an interest, and distract the attention from the value of the subject itself.

À ceux qui voudraient savoir comment je réalise certains effets, je me contenterai de répondre que ces effets sont pour moi des formes très individuelles, auxquelles je parviens en transgressant les principes admis dans le processus de travail, mais non sans respecter des phénomènes bien connus de la nature : ce sont des formes dont je ne souhaite en aucun cas qu'elles soient universellement adoptées car là encore, ce serait accorder trop d'intérêt à la technique et détourner l'attention de la valeur du sujet lui-même.

Élevage de poussière
1920

Enough Rope
1944

Butterflies [Original in Color]
1930–35

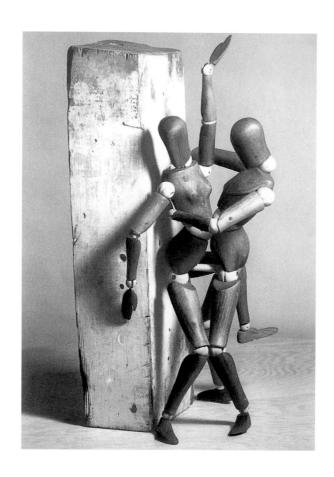

Mr. and Mrs. Woodman
1947

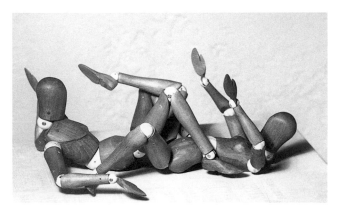

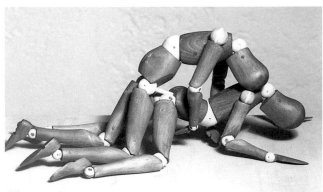

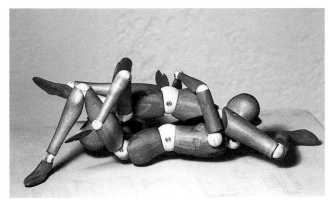

Mr. and Mrs. Woodman
1947

Mr. and Mrs. Woodman
1947

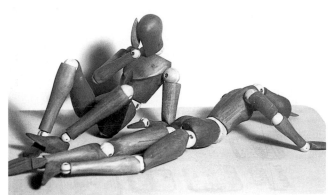

Mr. and Mrs. Woodman
1947

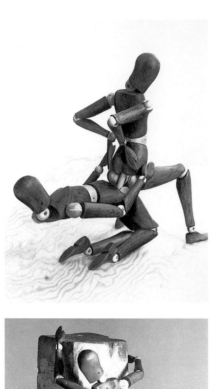
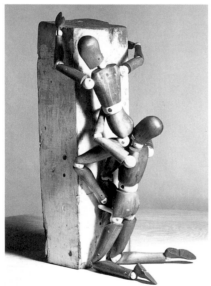

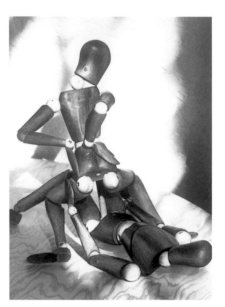

Mr. and Mrs. Woodman
1947

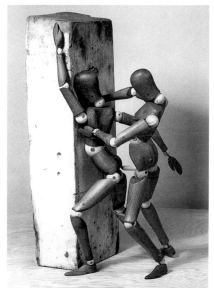

Mr. and Mrs. Woodman
1947

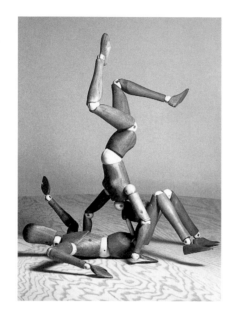
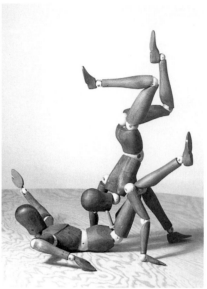
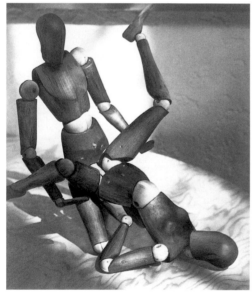
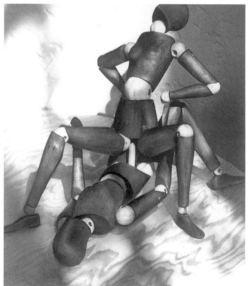

Mr. and Mrs. Woodman
1947

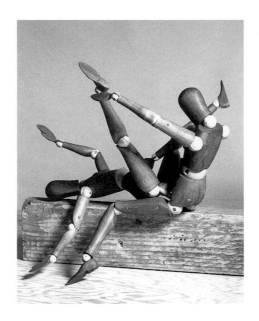

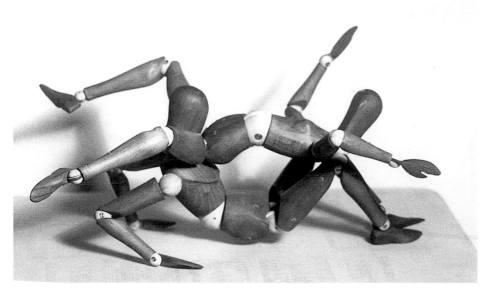

Mr. and Mrs. Woodman
1947

Man Ray
Creator of Surrealist Photography

Man Ray
Der Erfinder der surrealistischen
Fotografie

Man Ray
Créateur de la photographie
surréaliste

Emmanuelle de l'Ecotais

The period Man Ray spent in Paris [1921–1940] proved to be his most interesting, work-wise. It was there that the originality of his art developed, and where it had the greatest repercussions. Paris had become the hub of the art world: the Dada movement, founded in Zurich in 1916, had established a base in the French capital, mainly owing to Tristan Tzara's arrival there. Man Ray, whose art had failed to blossom in the United States, saw Paris as the promised land. His closest friend in America was a Frenchman: none other than Marcel Duchamp. Duchamp took Man Ray around with him, introducing him to everyone who would in due course be instrumental in the development of his work and career.

Thus, the first person to exert a strong influence on Man Ray's work was Marcel Duchamp, and this was some years before Man Ray set off for Paris. They actually met in 1915, in Ridgefield, New Jersey, striking up a friendship immediately, despite the language barrier between them. Duchamp was driven by a desire to achieve "that precision painting and that beauty of indifference" which prompted him to stop painting altogether, so he found in Man Ray and his burgeoning interest in photography, both a friend and a crucial associate. Man Ray himself then strove to develop his painting towards a flattened style, probably as a result of discovering photography. His aerographs [since 1917], which were spray paintings, resulted from the same Duchampian principle that involved classic painting techniques. With his new enthusiasm for photography, Man Ray discovered a convinced supporter in Duchamp. Both men together discovered in photography an ideal means of creative work, satisfying in them that "precision optics" requirement which would give rise, with Duchamp, to different research projects involving optics [*Rotary Glass Plates*, 1920], as well as to certain parts of the *Large Glass* [1915–1923], such as *Draft Pistons* [1914], the photographic production of which was, done at the suggestion of Man Ray.

Man Rays Pariser Schaffensperiode [1921–1940] ist die interessanteste in seinem Gesamtwerk. In Paris entwickelt sich das Originäre seiner Kunst, dort erzielt er die größte Wirkung. Paris ist zu jener Zeit ein wichtiges künstlerisches Zentrum: Die Dada-Bewegung, 1916 in Zürich entstanden, hat in der französischen Hauptstadt Fuß gefaßt, vor allem durch die Ankunft von Tristan Tzara. Man Ray, dessen Kunst in Amerika keine Anerkennung fand, sieht in Paris das gelobte Land. Sein engster Freund in den Vereinigten Staaten ist ein Franzose: Marcel Duchamp. Dieser nimmt ihn in seinen Kreis auf und stellt ihn all jenen vor, die von entscheidender Bedeutung für die Entwicklung seiner Arbeit und seiner Karriere werden sollten.

Der erste Mensch, der eine wichtige Rolle im Werk Man Rays spielen sollte, war also Marcel Duchamp, und zwar noch vor seiner Übersiedlung nach Paris. Ihre erste Begegnung fand 1915 in Ridgefield, New Jersey, statt. Vom ersten Augenblick an haben sie sich gut verstanden, obwohl die Sprache als Hindernis zwischen ihnen stand. Marcel Duchamp, dessen ganzes Streben darauf gerichtet war, »eine Malerei äußerster Präzision und eine Schönheit der Indifferenz« zu erreichen, was ihn schließlich dazu brachte, ganz mit dem Malen aufzuhören, fand in Man Ray und dessen wachsendem Interesse für die Fotografie sowohl einen Freund als auch einen wichtigen Mitarbeiter. Man Ray seinerseits strebte die Weiterentwicklung seiner Malerei in Richtung einer flächenbetonten Zweidimensionalität an, die wahrscheinlich in seiner Entdeckung der Fotografie begründet lag. Bei seinen ab 1917 entstandenen Aerografien, seinen Airbrush-Bildern, ging er nach demselben Prinzip vor wie Duchamp; beide wandten sich ganz von den klassischen Maltechniken ab. In seiner neuen Leidenschaft für die Fotografie fand Man Ray in Marcel Duchamp einen überzeugten Fürsprecher. Besser gesagt, beide Künstler entdeckten in der Fotografie das ideale schöpferische Mittel, das ihre Suche nach »optischer Präzision« befriedigte und bei Duchamp zu einer

La période de Man Ray à Paris [1921–1940] constitue la partie la plus intéressante de son œuvre. C'est là que son art original s'est développé et a eu le maximum de répercussions. Paris est à l'époque un centre artistique très important : le mouvement dada, né en 1916 à Zurich, s'est installé dans la capitale française, notamment grâce à l'arrivée de Tristan Tzara. Man Ray, dont l'art aux États-Unis ne parvient pas à s'épanouir, voit en Paris la terre promise. Son plus proche ami aux États-Unis est français : c'est Marcel Duchamp [1887–1968]. Celui-ci l'entraîne à sa suite, et le présente à tous ceux qui auront une influence capitale sur le développement de son travail et de sa carrière.

La première personne à avoir joué un rôle considérable dans l'œuvre de Man Ray est donc Marcel Duchamp, et ceci bien avant qu'il ne débarque à Paris. En effet, leur rencontre date de 1915, à Ridgefield, dans le New Jersey. Leur entente est immédiate, et ceci même malgré l'obstacle de la langue. Marcel Duchamp, motivé par son désir d'atteindre « cette peinture de précision et cette beauté d'indifférence » qui le poussa à arrêter de peindre rencontra en Man Ray et son intérêt naissant pour la photographie à la fois un ami et un collaborateur important. Man Ray lui-même tâchait alors de faire évoluer sa peinture vers une réalisation en aplat, probablement motivée par la découverte de la photographie. Ses aérographes [depuis 1917], ces peintures vaporisées, procèdent du même principe duchampien d'abandon des techniques picturales classiques. Avec sa nouvelle passion pour la photographie, Man Ray devait trouver en Marcel Duchamp un supporter convaincu. Ou plutôt tous deux découvrirent-ils ensemble dans la photographie un moyen de création idéal, satisfaisant en eux ce besoin « d'optique de précision » qui allait justement donner naissance chez Duchamp à différentes recherches sur l'optique [*Rotative plaques de verre*, 1920], mais également à certaines parties du *Grand Verre* [1915–1923] comme *Les Pistons de courant*

Take, for example, the creation of Rrose Sélavy, by Duchamp. Most probably, the very idea of this imposture sprang to Duchamp's mind because there was a photographer among his circle of friends. What better than a photograph to lend reality to, underpin, and certify the authenticity of a fact, an event, or the existence of a person? In a reciprocal way, it is possible to see in Man Ray's research into shadows [*Integration of Shadows*, 1919, ill. p. 13] and machines [*La femme*, 1920, ill. p. 12] an influence stemming from Duchamp's work on cast shadows and the mechanics of the *Large Glass*.

Marcel Duchamp and Man Ray thus overlap on one point: for an artist, it is the expression of an idea that is of paramount importance, the technique used to do so being not an end in itself, but a means of achieving that end: "… My aim was to turn inwards, rather than outwards," wrote Duchamp. And "… from this viewpoint, I came to think that an artist could use any old thing […] to express what he wanted to say"[2]. Both artists "stood back from the physical act of painting"[3]. Duchamp explained that he wanted "to get back to absolutely dry drawing, to the composition of a dry art", the best example of which was the "mechanical drawing"[4]. And this is precisely what Man Ray did with his aerographs, and with the glass plates and photography.

This perfect mutual understanding would prompt Man Ray to follow his friend to Paris. The miserable failure of the magazine *New York Dada*, which they co-edited in New York, merely confirmed the American's hunch: only the French capital was "ready" to accommodate his deeply Dada spirit.

In Paris, on the evening of 22 July 1921, Duchamp introduced Man Ray to the entire Dada group: André Breton, Jacques Rigaut, Louis Aragon, Paul Eluard and his wife Gala, Théodore Fraenkel, and Philippe Soupault.

differenzierten Beschäftigung mit optischen Gegebenheiten [*Rotierende Glasscheiben*, 1920] führte, aber auch zu einigen Teilen für das *Große Glas* [1915–1923] wie *Die Luftpumpen* [1914], von denen wir wissen, daß die fotografische Realisierung ihm von Man Ray nahegelegt worden war. Nehmen wir zum Beispiel die Kreation von *Rrose Sélavy*: Bestimmt hatte Duchamp die Idee zu dieser Hochstapelei deshalb, weil er einen Fotografen in seiner Nähe hatte. Was kann es Besseres geben als eine Fotografie, um einem Sachverhalt, einem Ereignis oder in diesem Fall einer Person Realität zu verleihen, sie zu verbürgen, ihr einen Authentizitätsnachweis auszustellen? Und umgekehrt, kann man nicht in Man Rays Beschäftigung mit dem Schatten [*Integration of Shadows*, 1919, Abb. S. 13] und den Maschinen [*La femme*, 1920, Abb. S. 12] einen Einfluß von Marcel Duchamps Arbeiten über die geworfenen Schatten und die Mechanik des *Großen Glases* sehen? Und in einem weiteren Punkt haben sich Marcel Duchamp und Man Ray getroffen: Für einen Künstler ist es das wichtigste, eine Idee auszudrücken, die verwendete Technik stellt dabei keinen Selbstzweck dar, sondern ist Mittel, das gesetzte Ziel zu erreichen: »Mein Ziel war es, mich dem Inneren zuzuwenden und weniger dem Äußeren«, sagte Marcel Duchamp. »Unter diesem Blickwinkel kam ich zu dem Schluß, daß ein Künstler egal was benutzen konnte […], um das auszudrücken, was er sagen wollte«.[2] Jedenfalls haben sich beide »vom physischen Akt der Malerei entfernt«.[3] Marcel Duchamp erklärte dazu, er wolle »zu einer absolut *trockenen* Zeichnung zurückkehren, zur Komposition einer *trockenen* Kunst«, wofür die »mechanische Zeichnung […] das beste Beispiel«[4] sei. Und genau das machte Man Ray mit den Aerografien, mit den Clichés-verre und der Fotografie. Dieses vollkommene Einverständnis führte dazu, daß Man Ray seinem Freund nach Paris folgte. Das schmähliche Scheitern der Zeitschrift *New York Dada*, die die beiden in New York ins Leben gerufen hatten, war für den

d'air [1914], dont on sait que la réalisation photographique lui fut suggérée par Man Ray.
Prenons par exemple la création de *Rrose Sélavy* par Marcel Duchamp: l'idée même de cette imposture ne serait-elle pas venue à l'esprit de Duchamp grâce à la présence d'un photographe dans son entourage? Quoi de mieux qu'une photographie pour rendre réel, cautionner, donner un certificat d'authenticité à un fait, un événement ou en l'occurrence à l'existence d'une personne? Réciproquement, ne peut-on voir dans les recherches de Man Ray sur les ombres [*Integration of Shadows*, 1919, ill. p. 13] et les machines [*La femme*, 1920, ill. p. 12] une influence du travail de Marcel Duchamp sur les ombres portées et la mécanique du *Grand Verre*? Marcel Duchamp et Man Ray se rejoignent aussi sur un point: pour un artiste, le plus important est d'exprimer une idée, la technique employée ne constituant pas un but en soi, mais un moyen d'atteindre ce but: «Mon but était de me tourner vers l'intérieur, plutôt que vers l'extérieur», dit Marcel Duchamp. Et il poursuit: «dans cette perspective, j'en vins à penser qu'un artiste pouvait employer n'importe quoi […] pour exprimer ce qu'il voulait dire[2]». Or de fait, tous deux se sont «éloignés de l'acte physique de la peinture[3]». Marcel Duchamp explique qu'il voulait «revenir à un dessin absolument sec, à la composition d'un art sec» dont le «dessin mécanique» était «le meilleur exemple[4]». Et c'est exactement ce que fit Man Ray avec les aérographes, avec les clichés verre et la photographie.
Cette entente parfaite devait conduire Man Ray à suivre son ami à Paris, métropole artistique dans les années 20. L'échec cuisant de la revue *New York Dada* qu'il créèrent à New York ne fut pour l'Américain qu'une confirmation: seule la capitale française était «prête» à accueillir son esprit profondément dada.
C'est le soir du 22 juillet 1921 que Man Ray y rencontre grâce à Marcel

The most surprising thing, for Man Ray, was that there wasn't a single painter among them. They were all poets and writers. None of these artists actually had any influence on Man Ray's work. André Breton, on the other hand, who published the magazine *Littérature*, saw right away how Man Ray could be of use to him. As a photographer, he quickly became the publisher's indispensable right-hand man. And Breton called him up regularly, dispatching him to artists' studios to photograph the works he wanted to reproduce in his magazine. Man Ray was to make the most of this job in two ways: firstly, he used each session to do a portrait photograph of the artist in question; secondly, by way of exchange, he asked André Breton, who wasn't paying him, to reproduce his own works in the magazine. His acknowledged experience as a portraitist [he had won a prize for his portrait of Berenice Abbott at the *Fifteenth Annual Exhibition of Photographs* held in Philadelphia in March 1921], combined with "word-of-mouth" recommendations, was so effective that in no time Man Ray had met all the Parisian personalities of the day. And each one led to other customers: Gertrude Stein introduced him to Pablo Picasso and Georges Braque; Jean Cocteau introduced him to all the affluent aristocrats, who were forever looking for an original portraitist. Little by little, Man Ray's studio even became a place of pilgrimage for foreigners in Paris. In the 1920s, portraits of high-society Parisian ladies were often used as fashion photographs, so that in time Man Ray made contact with the couturier Paul Poiret, and in 1924 started to work regularly for *Vogue*. His success was all the greater because, in tandem, he published his more personal works in *Littérature, Les Feuilles Libres, The Little Review* and even *Vanity Fair*.

What really triggered this success was his discovery of rayography in late 1921 or early 1922. Man Ray

Amerikaner eine eindeutige Bestätigung: Einzig die französische Hauptstadt war »reif«, seinen zutiefst von Dada geprägten Geist anzunehmen.

Es war am Abend des 22. Juli 1921 in Paris, als Man Ray durch Marcel Duchamps Vermittlung die ganze Dada-Gruppe traf: André Breton, Jacques Rigaut, Louis Aragon, Paul Eluard und seine Frau Gala, Théodore Fraenkel und Philippe Soupault. Das erstaunlichste für Man Ray war, daß keiner von ihnen Maler war. Sie waren alle Dichter oder Schriftsteller. Tatsächlich läßt sich keinerlei Einfluß seitens dieser Künstler auf Man Rays Werk feststellen. André Breton jedoch, der die Zeitschrift *Littérature* leitete, erkannte sofort, wie Man Ray ihm nützlich sein könnte. Als Fotograf nämlich wurde er dem Herausgeber schnell unentbehrlich; Breton nahm regelmäßig Kontakt zu ihm auf und schickte ihn zu den Künstlern, um die Arbeiten fotografieren zu lassen, die er in seiner Zeitschrift veröffentlichen wollte. Man Ray profitierte von dieser Aufgabe in zweifacher Hinsicht: Einerseits nutzte er jeden Fototermin, um ein Porträt des betreffenden Künstlers aufzunehmen, andererseits verlangte er als Gegenleistung von André Breton, der ihn nicht bezahlte, seine Fotoarbeiten in der Zeitschrift zu reproduzieren. Seine Erfahrung und der Erfolg auf dem Gebiet der Porträtfotografie [er hatte im März 1921 auf der *Fifteenth Annual Exhibition of Photographs* in Philadelphia einen Preis für das Porträt von Berenice Abbott bekommen] und die Mundpropaganda funktionierten so gut, daß Man Ray innerhalb kürzester Zeit mit sämtlichen Pariser Berühmtheiten jener Epoche zusammentraf und sie alle ihm weitere Kunden zuführten: Gertrude Stein machte ihn mit Pablo Picasso und Georges Braque bekannt; Jean Cocteau führte ihm die ganze Geldaristokratie zu, die auf der Suche nach einem originellen Porträtfotografen war. Nach und nach wurde Man Rays Atelier sogar zur Pilgerstätte für Ausländer, die sich in Paris aufhielten. Da die Porträts der Damen aus der Pariser Gesellschaft in den 20er Jahren häufig als Modefotografien dienten,

Duchamp, tout le groupe dada: André Breton, Jacques Rigaut, Louis Aragon, Paul Éluard et sa femme Gala, Théodore Fraenkel et Philippe Soupault. Surprise pour Man Ray: aucun d'entre eux n'est peintre. Ils sont tous poètes ou écrivains. De fait, il n'existe aucune influence de la part de ces artistes sur l'œuvre de Man Ray. En revanche, André Breton, qui dirige la revue *Littérature*, voit tout de suite comment Man Ray va pouvoir lui être utile. En tant que photographe, il devient vite indispensable à l'éditeur, qui le contacte régulièrement pour l'envoyer chez des artistes photographier les travaux qu'il veut reproduire. Man Ray va tirer parti de cette tâche de deux manières: d'une part il profite de chaque séance pour faire le portrait de l'artiste en question, d'autre part il demande en échange à André Breton, qui ne le paye pas, de reproduire ses propres travaux dans sa revue. Son expérience déjà affirmée dans le portrait [il avait obtenu un prix pour le portrait de Berenice Abbott au *Fifteenth Annual Exhibition of Photographs* de Philadelphie, en mars 1921] et le «bouche à oreille» fonctionnèrent si bien qu'en très peu de temps Man Ray rencontra toutes les personnalités parisiennes du moment, chacune amenant d'autres clients: Gertrude Stein lui présenta Pablo Picasso et Georges Braque; Jean Cocteau toute l'aristocratie aisée en quête d'un portraitiste original. De fil en aiguille, l'atelier de Man Ray devient même le lieu de pèlerinage des étrangers à Paris. Le portrait des dames de la haute société parisienne servant souvent de photographie de mode dans les années 1920, Man Ray entre en contact notamment avec le couturier Paul Poiret qui cherche à renouveler l'approche de ce genre de photographie, puis dès 1924 commence à travailler régulièrement pour *Vogue*. Son succès est d'autant plus grand que parallèlement il publie ses travaux plus personnels dans *Littérature, Les Feuilles Libres, The Little Review* et même *Vanity Fair*. Le déclencheur de ce succès est sans aucun doute sa découverte de la rayographie à la fin de l'année 1921 ou au début de l'année 1922. Puis Man

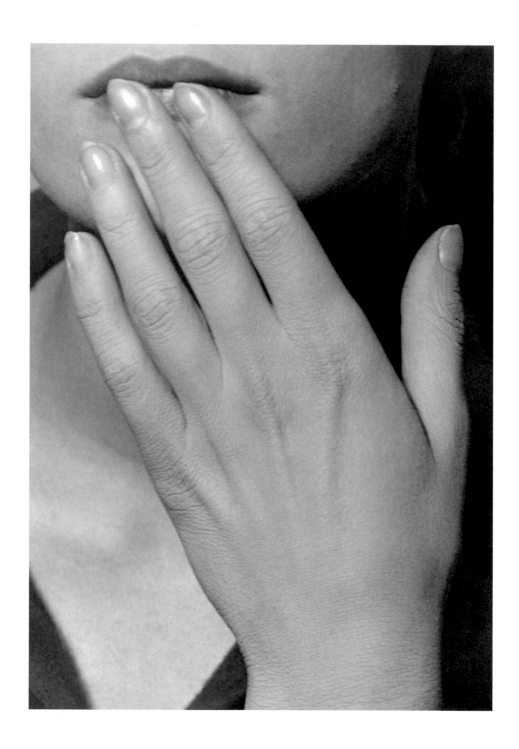

Untitled
1931

became the champion of photographic manipulation, producing effects that, in the eyes of the Parisian public, enhanced creative photography and raised it above photography in its purest form. Running counter to other photographers of the day, who were keen to elevate Modern Man through modern technology, without "doctoring" things, Man Ray used photography like any other medium. He reframed, retouched, negative printed, reversed and inverted pictures[5], and he even took camera-less photographs. In a nutshell, Man Ray invented Surrealist photography.

What is generally known as a "photogram" or "rayograph" is a simple process in which objects are put directly on photographic paper, and then exposed to light for a few seconds. By then developing the paper in a normal way, a reverse image is obtained. Man Ray related how he discovered this procedure during a darkroom session, when some fashion photographs were being developed for Paul Poiret. His explanations, however, were more amusing than they were persuasive. Man Ray harbored a definite wish to hide his creative processes, driven by his deeply held conviction that the important thing was not the technique used, but the final work. Man Ray even said that "a certain contempt for the physical means of expressing an idea is vital for its best possible execution"[6]. So the anecdote about this chance discovery is of little relevance. On the other hand, we do know that Tristan Tzara, then a close friend of Man Ray, had in his possession a collection of "schadographs" produced in about 1918–1919 by Christian Schad [1894–1982]. This latter was part of the Zurich Dada group, and had himself drawn inspiration from the early works of Henry Fox Talbot[7]. Christian Schad used paper which darkened directly: "A surface with very low sensitivity, which could be prepared on sight, in reduced light, and which was

kam Man Ray auch in Kontakt mit dem Couturier Paul Poiret, und ab 1924 begann er regelmäßig für die Zeitschrift *Vogue* zu arbeiten. Sein Erfolg wurde dadurch noch größer, daß er parallel zu diesen Auftragsarbeiten seine persönlicheren Arbeiten in den Zeitschriften *Littérature*, *Les Feuilles Libres*, *The Little Review* und sogar in *Vanity Fair* veröffentlichte.

Der Auslöser für diesen Erfolg war zweifellos seine Erfindung der Rayografie gegen Ende des Jahres 1921 oder Anfang 1922. In der Folge entwickelte sich Man Ray zum Meister der fotografischen Manipulation, vor allem durch die Doppelbelichtung und die Solarisation, zwei Techniken, die die künstlerische Fotografie aufwerteten und die bis dahin in Paris vorherrschende reine Fotografie in den Schatten treten ließen. Im Gegensatz zu anderen Fotografen seiner Zeit, die den modernen Menschen mit Hilfe einer modernen Technik in den Mittelpunkt stellen wollten, ohne mit der Technik »Schindluder zu treiben«, benutzte Man Ray die Fotografie wie jedes andere Medium auch. Er veränderte die Einstellung während der Belichtung, retuschierte und bearbeitete das Negativ[5], arbeitete mit Umkehrentwicklung und seitenverkehrten Bildern; er fotografierte sogar ohne Fotoapparat, kurz gesagt, Man Ray erfand die surrealistische Fotografie.

Was üblicherweise »Fotogramm« oder »Rayografie« genannt wird, ist ein einfaches Verfahren, das darin besteht, Gegenstände direkt auf lichtempfindliches Papier zu legen und sie einige Sekunden lang dem Licht auszusetzen. Entwickelt man das Papier anschließend auf normale Weise, erhält man ein Bild, dessen Hell-Dunkel-Werte vertauscht sind. Man Ray berichtete, daß er dieses Verfahren entdeckt habe, während er in seiner Dunkelkammer Modefotos für Paul Poiret entwickelte. Seine Erklärungen klingen zwar amüsant, sind aber nicht überzeugend. Bei Man Ray ist ganz offensichtlich, daß er seine schöpferischen Prozesse geheimhalten wollte, was seiner Grundüberzeugung entspricht, wonach das Entscheidende nicht die verwendete Technik

Ray se fera le champion des manipulations photographiques, avec notamment la surimpression et la solarisation, toutes deux valorisant la photographie créative aux dépens de la photographie pure qui prévalait alors à Paris. Contrairement aux photographes de son temps, qui veulent mettre en valeur l'Homme Moderne au moyen d'une technique moderne, sans la «trafiquer», Man Ray utilise la photographie comme n'importe quel autre médium. Il recadre, retouche[5], imprime en négatif, renverse ou inverse les images ; il photographie même sans appareil, bref Man Ray invente la photographie surréaliste.

Ce qu'on appelle généralement «photogramme» ou «rayographie» est un procédé simple qui consiste à poser directement sur du papier sensible des objets et à les exposer à la lumière pendant quelques secondes. En développant ensuite normalement le papier, on obtient une image dont les valeurs sont inversées. Man Ray raconta qu'il avait découvert ce procédé lors d'une séance de développement en chambre noire de photographies de mode pour Paul Poiret. Mais ses explications, bien qu'amusantes, ne sont pas convaincantes. Il existe chez Man Ray une volonté évidente de cacher ses processus de création, motivée par une de ses profondes convictions selon laquelle l'important n'est pas la technique employée, mais l'œuvre finale. Man Ray disait même qu' «un certain mépris pour le moyen physique d'exprimer une idée est indispensable pour la réaliser au mieux[6]». L'anecdote concernant cette découverte soi-disant due au hasard est donc sans importance. En revanche, on sait que Tristan Tzara, alors un proche ami de Man Ray, possédait une collection de schadographies réalisées vers 1918–1919 par Christian Schad [1894–1982]. Ce dernier faisait partie du groupe dada de Zurich, et s'était lui-même inspiré des premiers travaux de Henry Fox Talbot[7]. Christian Schad utilisait du papier à noircissement direct : «Un support très peu sensible, que l'on pouvait préparer à vue, en lumière atténuée, et qui était

then exposed to the sun. The advantage of this procedure was that it required no darkroom"[8]. Man Ray, for his part, produced rayographs in a darkroom: "It's only after having been developed and then fixed that the print could be looked at in full daylight. The main reason for this choice was probably based on the possibility of altering, as required, the intensity and direction of the light"[9]. What is more, Christian Schad only placed paper cutouts and flat objects on the sensitive paper. In so doing, he produced pictures very much akin to Cubist collages. For his part, Man Ray used all manner of three-dimensional objects, and glass items in particular; the shadows cast by them, and their translucent nature, made it possible to obtain different values in the resulting blacks and whites. The fact that there were Christian Schad prints in the collection of a close friend of Man Ray may lead us to suppose that he did not "discover" this technique by chance, the way he explained it, but that he drew on Christian Schad's research to create a new form of expression.

Man Ray's laboratory experiments are in keeping with his earlier research. In the pictures he produced in New York, Man Ray had shown his concern for expressing the life of objects, their independence, and their capacity to mean something more than they would when seen as simple products, manufactured for a specific purpose. *La femme* [1920, ill. p. 12] is an eggbeater whose significance is transformed by way of the titles. There are other versions with the title *Man* [1918] or *L'Homme* .The rayograph proceeded along the same lines. The aim here was to give things another appearance. The objects placed by Man Ray on sensitive photographic paper were often recognizable, though transformed and transported into a foreign world. It was precisely this relationship and this dialectic between the known and the unknown that helped to open up the mind to another reality.

ist, sondern das Werk, das am Ende herauskommt. Man Ray sagte sogar, daß »eine gewisse Verachtung für das physikalische Mittel zum Ausdruck einer Idee unabdingbar ist, um diese auf bestmögliche Weise umzusetzen«.[6] Die Anekdote, in der er seine Erfindung dem Zufall zuschreibt, ist also nicht sehr stichhaltig. Hingegen wissen wir, daß Tristan Tzara, der damals eng mit Man Ray befreundet war, eine Sammlung von Schadografien besaß, die Christian Schad [1894–1982] 1918/19 angefertigt hatte. Schad gehörte zur Gruppe der Dadaisten in Zürich und hatte sich durch die frühen Arbeiten von Henry Fox Talbot[7] anregen lassen. Für seine Schadografien benutzte er direkt schwärzendes Papier: »ein wenig empfindliches Material, das man bei Sicht, in gedämpftem Licht, präparieren konnte, um es anschließend dem Sonnenlicht auszusetzen. Der Vorteil dieses Verfahrens bestand darin, daß man keine Dunkelkammer brauchte.«[8] Man Ray hingegen fertigte seine Rayografien in der Dunkelkammer an: »Erst nachdem der Abzug entwickelt und fixiert war, konnte er bei Tageslicht betrachtet werden. Der Hauptgrund für diese Vorgehensweise lag wahrscheinlich darin, daß so die Möglichkeit bestand, die Intensität oder den Einfall des Lichts bewußt zu modifizieren.«[9] Hinzu kommt, daß Schad auf das lichtempfindliche Papier ausschließlich Scherenschnitte und flache Gegenstände legte und so Bilder erzeugte, die kubischen Collagen ähnelten. Man Ray hingegen verwendete alle Arten von dreidimensionalen Gegenständen und vor allem Glasobjekte, deren Schatten oder Lichtdurchlässigkeit es ermöglichten, unterschiedliche Helligkeitswerte auf den schwarzen und weißen Flächen zu erzielen. Seine Kenntnis der Arbeiten von Schad läßt also darauf schließen, daß er die neue Technik nicht durch Zufall »entdeckt« hat, sondern daß diese Schadografien ihn dazu angeregt haben, eine neue Ausdrucksform für sich zu kreieren.

Man Rays Experimente im Fotolabor sind vergleichbar mit seinen Arbeiten aus früheren Zeiten: In seinen Bildern aus der New Yorker Zeit hatte er sein

ensuite exposé au soleil. L'avantage de ce procédé était de ne pas nécessiter de chambre noire[8].» Man Ray, lui, allait réaliser ses rayographies en chambre noire : «Ce n'est qu'après avoir été développée puis fixée que l'épreuve pouvait être observée au grand jour. La principale raison de ce choix reposait vraisemblablement sur la possibilité de modifier à volonté l'intensité ou la direction de la lumière[9].» En outre, Christian Schad ne posait sur le papier sensible que des papiers découpés ou des objets plats, et réalisait ainsi des images proches des collages cubistes. Man Ray de son côté utilisa toutes sortes d'objets en trois dimensions et notamment des objets en verre, dont les ombres portées ou la translucidité permettaient d'obtenir des valeurs différentes dans les noirs et les blancs. La présence d'épreuves de Christian Schad dans la collection d'un ami proche de Man Ray peut donc laisser supposer qu'il ne «découvrit» pas cette technique par hasard comme il l'expliqua, mais qu'il s'inspira des recherches de Christian Schad pour créer un nouveau mode d'expression.

Les expériences de Man Ray en laboratoire sont compatibles avec ses recherches antérieures et ses expériences : Man Ray avait montré, dans ses images faites à New York, son souci d'exprimer de manière «sensible», donc au moyen de la photographie, la vie des objets, leur indépendance, leur capacité à signifier autre chose que ce pour quoi ils avaient été fabriqués : *La femme* [1920, ill. p. 12] est un batteur à œufs dont la signification est transformée par le biais des titres. Il y a d'autres versions avec le titre *Man* [1918] ou *L'Homme*. La rayographie procède du même principe. Il s'agit là de donner une autre apparence aux choses. Les objets posés par Man Ray sur le papier sensible sont souvent reconnaissables, tout en étant transformés, transportés dans un monde étranger. C'est précisément ce rapport, cette dialectique entre le connu et l'inconnu qui permet d'ouvrir l'esprit à une autre réalité.

In the eyes of the great majority of people, rayographs were the first photographic prints to attain an artistic value equivalent to that of painting. As Man Ray explained in his *Self Portrait*, he "was trying to do with photography what painters were doing, but with light and chemicals, instead of pigment, and without the optical help of the camera"[10]. The rayograph showed that, contrary to received wisdom, the photograph was not simply a reproductive and documentary tool, but something creative and inventive, something that could give rise to imagery emerging from the artist's imagination, inspiration, and thinking.

The words occurring most frequently in articles of the day to describe Man Ray and his rayographs are "poet", "poetry" and "poetic", since these pictures are, technically speaking, the outcome of actual writing on photographic paper. An impression of movement is obtained by exposing the objects several times over to different light sources. Man Ray wrote with a light bulb just as poets write with pens. White light replaced black ink. Man Ray became the supreme poet, writing with light.

Early in 1922, Tristan Tzara regarded Man Ray's rayographs as purest Dada works. The title of his album, *Champs délicieux* [Delicious Fields], was signally inspired by the title of the piece by André Breton and Philippe Soupault, *Les Champs magnétiques* [Magnetic fields, 1920]. However, since this piece was regarded *a posteriori* by André Breton himself as the first Surrealist text, the rayographs are, by analogy, often considered to be the first Surrealist photographic works. The fact remains that the rayographs were not Surrealist works – Surrealism did not come into being until 1924. They are simply works showing a Dada spirit, based on the principle of the "destructive projection" of "all formal art", to borrow an expression used by Georges Ribemont-Dessaignes.

Anliegen zum Ausdruck gebracht, auf »lichtempfindliche« Weise, also mit dem Mittel der Fotografie, das Eigenleben der Gegenstände vorzuführen, ihre Unabhängigkeit, ihre Fähigkeit, etwas anderes zu bedeuten als das, wofür sie gemacht worden waren: *La femme* [1920, Abb. S. 12] ist ein Quirl oder Schneebesen, dessen Bedeutung durch die Indirektheit und Vieldeutigkeit der Titel transformiert wird. Es existieren andere Versionen mit dem Titel *Man* [1918] oder *L'Homme*. Die Rayografie geht nach demselben Prinzip vor. Es handelt sich darum, den Dingen eine andere Erscheinungsform zu geben. Die Gegenstände, die Man Ray auf das lichtempfindliche Papier gelegt hat, sind häufig erkennbar, jedoch völlig transformiert und dadurch in eine fremde Welt transponiert. Durch diese neue Beziehung, diese Dialektik zwischen Bekanntem und Unbekanntem, wird es möglich, den Geist für eine neue Realität zu öffnen.

Die Rayografien waren die ersten fotografischen Arbeiten, die, obgleich in wesentlich höherer Anzahl entstanden, den gleichen Rang einnahmen wie seine Malerei. Wie Man Ray in seinem *Self Portrait* schreibt, versuchte er, »mit der Photographie etwas ähnliches wie die Maler, aber nicht mit Farbe, sondern mit Licht und Chemikalien und ohne die optische Hilfe der Kamera«.[10] Die Rayografie stellte unter Beweis, daß die Fotografie, entgegen der herrschenden Vorstellung, nicht nur reproduzierend und dokumentarisch war, sondern ebenfalls kreativ und innovativ, und daß sie Bilder hervorbringen konnte, die der Phantasie, der Inspiration und der Gedankenarbeit des Künstlers entsprungen waren.

Die Begriffe, die man in Artikeln aus jener Zeit über Man Ray und seine Rayografien am häufigsten findet, sind »Poet«, »Poesie« und »poetisch«. Technisch gesehen sind diese Bilder tatsächlich das Ergebnis einer Schrift auf lichtempfindlichem Papier. Der Eindruck von Bewegung entsteht dadurch, daß die Gegenstände mehrfach unterschiedlichen Lichtquellen ausgesetzt

Les rayographies furent les premières épreuves photographiques à acquérir auprès du plus grand nombre une valeur équivalente à celle de la peinture. Comme il l'explique dans son *Autoportrait,* Man Ray essayait « de faire en photographie ce que faisaient les peintres, avec cette différence [qu'il utilisait] de la lumière et des produits chimiques au lieu de couleurs et cela sans le secours de l'appareil photo[10] ». La rayographie prouvait que la photographie, contrairement aux idées reçues, n'était pas simplement reproductrice, documentaire, mais également créatrice, inventive, et qu'elle pouvait donner naissance à des images nées de l'imagination, de l'inspiration et de la réflexion de l'artiste.

Les mots que l'on retrouve le plus souvent dans les articles de l'époque pour qualifier Man Ray ou ses rayographies sont « poète », « poésie », « poétique ». Parce que du point de vue technique, ces images sont le résultat d'une véritable écriture sur le papier sensible. Une impression de mouvement est obtenue en exposant plusieurs fois les objets à des sources lumineuses différentes. Man Ray écrit avec une ampoule comme le poète écrit avec un stylo. La lumière blanche a remplacé l'encre noire. Man Ray devient le poète par excellence, qui écrit avec la lumière.

Au début de l'année 1922, les rayographies de Man Ray sont considérées comme des œuvres du plus pur dada. Le titre de son album de douze rayographies *Champs délicieux* était fortement inspiré du titre du texte d'André Breton et Philippe Soupault, *Les champs magnétiques* [1920]. Mais celui-ci ayant été considéré a posteriori par André Breton lui-même comme le premier texte surréaliste, les rayographies, par analogie, sont souvent considérées comme les premières œuvres photographiques surréalistes. Or les rayographies ne sont pas des œuvres surréalistes – on soulignera d'ailleurs que le surréalisme naquit en 1924 –, mais des œuvres d'esprit dada, fondées sur le principe de « projection destructive » de « tout art formel », pour repren-

Objects are projected into an unknown world, and shown to us by way of a new art: rayography. The creation of this art was a means of ousting the classical arts, and its manner of expression made it possible to counteract the existing realist and abstract styles. In painting, specifically, abstract representation was not seen as an acceptable possibility for the Dadaists, because as long as the classical means of creation continued to exist, Dada would not. Using a new procedure, Man Ray managed to present a new vision of ordinary objects. Once set and arranged in relation to one another, their association helped to create a "plastic poetry": something novel and unknown yet distinctive, something visible and almost palpable, that emerged from Man Ray's writing with light and the photographic medium. The rayographs were not abstract, since they were the recording, through contact, of real objects. There was no room for the subconscious here, because the arrangement of the objects was carefully worked out. And it was no dream world that was represented, but a reality – a different reality, of course, but an actual one.

The parallel with Breton and Soupault's automatic writing in *Les champs magnétiques* thus referred solely to the technical process of the work. André Breton observed in 1921: "The automatic writing that appeared at the end of the 19th century was nothing less than thought photography"[11]. It arose more from an idea than from a dream, or the subconscious or dark forces, as was explained later. The link between *Champs délicieux* and *Les Champs magnétiques* must therefore be considered in the light of the impact enjoyed by the piece written by André Breton and Philippe Soupault in 1920 – an impact that was felt at the height of the Dada period. Other techniques further established Man Ray's success and linked him with the Surrealist movement: double exposure

worden sind. Man Ray schreibt mit einer Glühbirne, wie der Dichter mit einem Stift schreibt. Das weiße Licht ist an die Stelle der schwarzen Tinte getreten. Man Ray wird zum Inbegriff eines Dichters, der mit Licht schreibt. Zu Beginn des Jahres 1922 wurden Man Rays Rayografien von Tristan Tzara als vollkommene Dada-Schöpfungen angesehen. Der Titel seines Albums *Champs délicieux* [Köstliche Felder] mit zwölf Rayografien lehnt sich deutlich an den Titel eines Textes von André Breton und Philippe Soupault an, *Les Champs magnétiques* [Die magnetischen Felder] aus dem Jahre 1920. Dieser wurde im nachhinein von André Breton selbst als der erste surrealistische Text bezeichnet, und entsprechend werden die Rayografien häufig als die ersten surrealistischen Fotografien angesehen. Doch die Rayografien sind keine surrealistischen Werke – der Surrealismus entstand erst im Jahr 1924 –, sondern Arbeiten aus dem Geist von Dada, die auf dem Prinzip der »destruktiven Projektion aller formalen Kunst« basierten, um eine Formulierung von Georges Ribemont-Dessaignes zu benutzen. Die Gegenstände werden in ein unbekanntes Universum projiziert und uns über den Umweg einer neuen Kunst, der Rayografie, vorgeführt. Durch die Erfindung dieser neuen Kunst wird es möglich, die klassische Kunst zu verdrängen, und die neue Form macht es möglich, bis dahin existierende abstrakte oder realistische Darstellungsformen zu verdrängen. Vor allem in der Malerei wurde die abstrakte Darstellung von den Dadaisten nicht als akzeptable Möglichkeit angesehen; zwar bestanden die klassischen künstlerischen Ausdrucksmittel auch weiterhin, Dada aber gehörte nicht dazu. Man Ray gelang es, mittels eines neuen Verfahrens Gegenständen, vor allem Gebrauchsgegenständen, eine neue Sichtweise zu verleihen. Sie waren sorgfältig angeordnet, so daß sie zueinander in Beziehung treten konnten, und durch diese neue Zuordnung entstand eine »plastische Poesie«. Nicht nur ein Traumbild, wie man es später unter dem Einfluß des Surrealismus zu nennen pflegte, sondern das Bild einer

dre une expression de Georges Ribemont-Dessaignes. Les objets sont projetés dans un univers inconnu, et nous sont montrés par le biais d'un art nouveau: la rayographie. La création de cet art permet d'évincer les arts classiques, et son mode de représentation permet d'évincer les modes réalistes ou abstraits qui existaient jusque-là. En peinture notamment, la représentation abstraite n'était pas envisagée comme une possibilité acceptable pour les dadaïstes ; car tant que subsisteraient les moyens classiques de création, Dada ne serait pas. Man Ray parvenait à donner, au moyen d'un nouveau procédé, une vision nouvelle d'objets pourtant usuels. Agencés, disposés les uns en fonction des autres, leur association permettait de créer une «poésie plastique». Non pas une image de rêve, comme on le dira plus tard sous l'influence du surréalisme, mais l'image d'une autre réalité, nouvelle, inconnue et toutefois distincte, visible et presque palpable, grâce à l'écriture de la lumière, grâce au médium photographique. Les rayographies n'étaient pas abstraites, puisqu'elles étaient l'enregistrement par contact d'objets réels. L'inconscient n'a pas sa place ici, car l'agencement des objets est raisonné, et ce n'est pas le monde du rêve qui est représenté, mais bien une réalité, différente certes de celle que nous connaissons, mais tout aussi effective.

Le parallèle avec l'écriture automatique de Breton et Soupault dans *Les Champs magnétiques* renvoyait donc uniquement au procédé technique de l'œuvre. André Breton disait en 1921 : «L'écriture automatique apparue à la fin du XIXᵉ siècle est une véritable photographie de la pensée[11].» Il s'agissait donc ici de l'idée, et non pas du rêve, de l'inconscient ou des forces obscures comme cela fut expliqué a posteriori. Le rapport entre *Champs délicieux* et *Les Champs magnétiques* doit donc être considéré en fonction de l'impact qu'avait eu le texte d'André Breton et de Philippe Soupault en 1920, impact qui s'inscrivait alors en pleine période dada.

and solarization. What is commonly known as double exposure is the overlaying of two negatives [in the enlarger or even at the moment of the shot]. This technique makes it possible to retranscribe a movement or relief, and juxtapose two elements in such a way as to give them a specific sense, as may happen with a portrait [*Tristan Tzara*, 1921]. Man Ray used this technique extensively, but it was through solarization that he came to establish himself as one of the most important photographers in Paris.

Solarization is technically defined as the partial reversal of values on a photograph, accompanied by a characteristic edging. This technique, obtained by switching on the light just when the development is taking place, was hitherto regarded as a laboratory accident. Man Ray mastered this process in 1929 and applied it to many portraits, nudes and fashion photographs. It was an immediate success, because it achieved a striking and most surprising effect for those days: a kind of materialization of the aura. This, where the occult sciences are concerned, can only be seen, in principle, by the initiated. Unlike the Surrealists, Man Ray had little interest in spiritualism, yet he was regarded as a Surrealist photographer partly because of this practice. What is more, it was not because of Surrealism that Man Ray developed his photographic art, but rather because of Man Ray that the Surrealist movement developed its photographic activity: While being part of the Dada movement, Man Ray was actually developing a poetic vision of objects, one of the favorite themes of Surrealism. Still in a Dadaist spirit, he broached the photographic medium like a creative art that was removed from reality, a tool offering complete freedom of production, whose documentary status itself became a source of playfulness [*Rrose Sélavy*, 1921]. With an instrument supposed to faithfully reproduce nature, he was photographing fantastical landscapes as early

anderen, neuen Realität, einer unbekannten, aber dennoch wahrnehmbaren, einer sichtbaren und fast greifbaren, dank der Lichtschrift, dank des fotografischen Mediums. Die Rayografien sind nicht abstrakt, denn sie sind durch Kontakt mit realen Gegenständen entstandene Aufnahmen. Das Unbewußte hat hier nichts zu suchen, denn die Anordnung der Gegenstände ist genau überlegt. Hier wird keine Traumwelt dargestellt, sondern eine Realität, zwar eine andere, aber eine vorhandene.

Die Parallele zum automatistischen Schreiben von Breton und Soupault in *Les Champs magnétiques* bezieht sich also einzig auf das technische Verfahren des Werkes. André Breton schrieb 1921: »Das automatistische Schreiben, das gegen Ende des 19. Jahrhunderts aufkam, ist im Grunde eine Fotografie des Denkens.«[11] Hierbei geht es also um die Idee und nicht um den Traum, das Unbewußte oder dunkle Kräfte, wie es im nachhinein interpretiert worden ist. Die Beziehung zwischen den *Champs délicieux* und *Les Champs magnétiques* muß zweifellos darin gesehen werden, welchen Einfluß der Text von André Breton und Philippe Soupault 1920 ausübte, ein Einfluß, der in der Hochzeit von Dada wirksam war.

Es gab noch andere Techniken, die Man Rays Erfolg ausmachten und ihn mit der surrealistischen Bewegung verbanden: die Doppelbelichtung und die Solarisation. Doppelbelichtung ist das Übereinanderlegen zweier Negative [im Vergrößerer oder bei der Aufnahme selbst]. Diese Technik ermöglicht die Übertragung einer Bewegung, eines Reliefs, oder das Nebeneinander zweier Elemente in der Weise, daß ihnen eine spezielle Bedeutung verliehen wird, wie dies bei einem Porträt der Fall sein kann [*Tristan Tzara*, 1921]. Man Ray benutzte diese Technik häufig, aber in erster Linie war es die Solarisation, durch die er sich in Paris einen Namen als bedeutender Fotograf machte. Die Solarisation ist technisch gesehen eine teilweise Umkehrung der Hell-Dunkel-Werte auf einer Fotografie, dazu gehört auch die charakteristische

D'autres techniques firent le succès de Man Ray et le lièrent au mouvement surréaliste: la surimpression et la solarisation. Ce qu'on appelle la surimpression est la superposition de deux négatifs [dans l'agrandisseur ou même au moment de la prise de vue]. Cette technique permet de retranscrire un mouvement, un relief ou de juxtaposer deux éléments de manière à leur donner une signification particulière, comme cela peut être le cas dans un portrait [*Tristan Tzara*, 1921]. Man Ray utilisa beaucoup cette technique, mais c'est davantage grâce à la solarisation qu'il s'imposa comme un des plus grands photographes à Paris.

Techniquement la solarisation se définit comme l'inversion partielle des valeurs sur une photographie, accompagnée d'un liséré caractéristique. Obtenue en allumant la lumière au moment du développement, elle était jusque-là considérée comme un accident de laboratoire. Man Ray maîtrise ce procédé dès 1929, et l'applique à un grand nombre de portraits, de nus et de photographies de mode. Son succès est immédiat, car il obtient ainsi un effet saisissant et très étonnant pour l'époque: une sorte de matérialisation de l'aura. Celle-ci, pour les sciences occultes, n'est en principe visible que par les seuls initiés. Man Ray, contrairement aux surréalistes, ne fut pas un adepte du spiritisme, pourtant il fut considéré comme un photographe surréaliste en partie en raison de cette pratique. En outre, ce n'est pas grâce au surréalisme que Man Ray développa son art photographique, comme on l'a souvent dit, mais bien plutôt grâce à Man Ray que le surréalisme se développa en photographie: en effet, alors qu'il s'inscrivait dans la mouvance Dada, Man Ray donnait déjà une vision poétique des objets, un des thèmes de prédilection du surréalisme. Dada encore, il abordait le médium photographique comme un art créatif détaché de la réalité, un outil permettant toute liberté de réalisation, dont le statut documentaire lui-même devenait source de jeu [*Rrose Sélavy*, 1921]. Avec un instrument censé reproduire fidèlement la

as 1920, e. g. "Here is the estate of Rrose Sélavy … "11, later known as *Elevage de poussière* [Dust Breeding, ill. p. 137]. Finally, in 1920 Man Ray produced pictures displaying blatant eroticism and transformation. Rosalind Krauss[13] singles out the picture *Head, New York* as an important example of what Georges Bataille and, in his wake, the Surrealist photographers would later call "l'informe", or shapelessness. However, it should be emphasized that the date of this picture was 1920, and that it took four more years for Surrealism to come into being.

Man Ray was unique in being the only photographer to make the shift from Dada to Surrealism, as well as the first photographer to work closely with the Surrealist movement, an isolated position he held for almost five years. The first Surrealist magazine, *La Révolution Surréaliste* published virtually only Man Ray pictures. The handful of other photographs used were for the most part pictures found in bric-à-brac shops or even in popular and scientific magazines, and were therefore anonymous.

The desire to produce art "automatically" was predominant in Bretonian thinking. As an instant form of creation, photography became the ideal medium as far as painting was concerned, which called for a period of gestation, allowing reasoning to block direct access to the subconscious. But well ahead of the Surrealists, Man

Umrandung. Sie entsteht, wenn im Augenblick der Entwicklung eine Lichtquelle eingeschaltet wird; diese Technik wurde bis dahin als Laborunfall angesehen. Man Ray wandte dieses Verfahren seit 1929 an und stellte eine Vielzahl von Porträts, Aktaufnahmen und Modefotografien in dieser Technik her. Er hatte damit sofort Erfolg, denn er erzielte mit dieser Neuerung faszinierende Effekte, die für jene Zeit sehr erstaunlich waren: eine Art Materialisierung der Aura. Diese ist nach den okkulten Wissenschaften im Prinzip nur Eingeweihten sichtbar. Im Gegensatz zu den Surrealisten war Man Ray kein Anhänger des Spiritismus, gleichwohl wurde er, teils wegen dieser Praxis, als surrealistischer Fotograf angesehen. Im übrigen ist es nicht dem Surrealismus zu verdanken, daß Man Ray seine Fotokunst entwickelte, wie häufig behauptet wird, sondern vielmehr war es Man Ray, durch den sich der Surrealismus in der Fotografie entwickelte: Schon als er sich der Dada-Bewegung verschrieb, verlieh Man Ray den Gegenständen eine poetische Sicht, und dies wurde zu einem der Lieblingsthemen des Surrealismus. Als Dadaist betrachtete er das Medium Fotografie als eine kreative Kunst, die von der Realität abgelöst ist, ein Werkzeug, das alle Freiheit der Ausführung für ihn bereithielt und dessen dokumentarische Funktion ihm Anlaß zum Spielen gab [*Rrose Sélavy*, 1921]. Mit einem Instrument, das eigentlich dazu gedacht war, die Natur getreu abzubilden, fotografierte er ab 1920 fantasmagorische Landschaften [»Dies ist die Domäne von Rrose Sélavy … «12, auch *Élevage de poussière* (Staubzucht, Abb. S. 137), genannt]. Ab 1920 schuf Man Ray Bilder, bei denen die Erotik und die Transformation offensichtlich waren. Rosalind Krauss[13] hebt die Bedeutung des Bildes *Head, New York* für eine künstlerische Richtung hervor, die später von Georges Bataille und nach ihm von den surrealistischen Fotografen »Informel« genannt wurde. Es muß aber darauf hingewiesen werden, daß das Entstehungsdatum dieses Bildes im Jahre 1920 liegt und der Surrealismus sich erst vier Jahre später formierte.

nature, il photographia dès 1920 des paysages fantasmagoriques [« Voici le domaine de Rrose Sélavy … »12, dit *Élevage de poussière*, ill. p. 137]. Enfin, dès 1920, Man Ray produisait des images où l'érotisme et la transformation étaient patents. Car si Rosalind Krauss[13] relève l'importance de l'image *Head, New York* dans ce que plus tard Georges Bataille et après lui les photographes surréalistes appelèrent « l'informe », il faut souligner ici que la date de cette image est 1920. Or, ne l'oublions pas, le surréalisme ne naquit que quatre ans plus tard.

En réalité, Man Ray fut d'une part le seul photographe qui soit passé de Dada au surréalisme, d'autre part le premier photographe à être proche du mouvement surréaliste, au point d'être le seul dans cette position pendant près de cinq ans: la première revue surréaliste, *La Révolution Surréaliste*, ne publie pratiquement que des images de Man Ray. Les quelques autres photographies utilisées sont pour la plupart des images trouvées chez les brocanteurs ou même dans des revues populaires ou scientifiques, donc anonymes.

La volonté d'une réalisation « automatique » de l'art préside à la pensée bretonienne. La photographie, forme instantanée de création, devient le médium idéal face à la peinture qui nécessite un temps de gestation, laissant le raisonnement entraver l'accès direct à l'inconscient. Mais Man Ray, bien avant les surréalistes, avait compris la puissance de création de la photographie. Son essence documentaire, son apparent attachement au réel avait dès le début inspiré une conscience déjà aiguë de « l'irréalité contenue dans la réalité même ».

Les techniques que Man Ray utilisa à Paris connurent un succès immédiat. Le photogramme et la solarisation se répandirent en France puis dans toute l'Europe comme une traînée de poudre. Le rôle des artistes français dans cette réussite fut équivalent à celui d'un galeriste ou d'un éditeur – ce qu'ils étaient d'ailleurs, pour la plupart : grâce à eux, Man Ray publia ses travaux dans de

Ray had understood the creative power of photography. From the outset, its documentary essence and its apparent commitment to the real had given rise to an already acute awareness of the "unreality contained in reality itself".

The techniques applied by Man Ray in Paris enjoyed instant success. The use of photograms and solarization spread throughout France and then Europe like wildfire. The part played by French artists in this success story was akin to that of a gallery owners or publishers, which, incidentally, most of them were. Thanks to them, Man Ray had his works published in many magazines put out by the Dada and Surrealist movements [*Littérature, Mécano, Merz, La Révolution Surréaliste, Le Surréalisme au service de la Révolution, Minotaure*, etc.]. Even though his work was definitely brought about by a Dada spirit, Man Ray did not consider himself a "Dadaist". Thus, Man Ray cannot be pigeonholed in any specific category of artists, or in any particular movement. He remains unclassifiable.

Man Ray war einerseits der einzige Fotograf, der von Dada zum Surrealismus übergegangen ist, andererseits war er der erste Fotograf, welcher der surrealistischen Bewegung nahestand, er war sogar der einzige, der dieser Position fast fünf Jahre lang treu blieb. Die erste surrealistische Zeitschrift, *La Révolution Surréaliste*, veröffentlichte praktisch ausschließlich Bilder von Man Ray. Die wenigen anderen reproduzierten Fotos sind meist Fundstücke aus Trödelläden, oder sie stammten aus Illustrierten und wissenschaftlichen Zeitschriften, waren also anonym.

Die Idee der »automatistischen« Realisierung der Kunst beherrschte das Denken André Bretons und seiner Anhänger. Die Fotografie als Form der Augenblickskreation wurde zum idealen Medium im Gegensatz zur Malerei, die eine Entstehungszeit erfordert, zumal der direkte Zugang zum Unbewußten durch das Nachdenken in Fesseln gelegt wird. Man Ray aber hatte schon lange vor den Surrealisten das kreative Potential der Fotografie erkannt. Ihr dokumentarisches Wesen, ihre Anbindung an die Realität hatten ihm schon früh bewußt gemacht, daß die »Irrealität in der Realität selbst enthalten ist«. Die Techniken, die Man Ray in Paris entwickelte, verzeichneten unmittelbare Erfolge. Das Fotogramm und die Solarisation fanden zuerst in Paris und dann in ganz Europa schnelle Verbreitung. Dabei spielten französische Künstler etwa die Rolle eines Galeristen oder eines Verlegers – was sie übrigens meistens auch waren. Ihnen hatte es Man Ray zu verdanken, daß er seine Arbeiten in vielen Zeitschriften der dadaistischen und surrealistischen Bewegung veröffentlichen konnte [*Littérature, Mécano, Merz, La Révolution Surréaliste, Le Surréalisme au service de la Révolution, Minotaure* etc.]. Obwohl sein Werk ganz sicher aus dem Geist von Dada entstanden ist, betrachtete Man Ray sich nicht als Dadaisten. Insofern gehört er nicht in eine spezielle Kategorie von Künstlern, noch ist er einer Bewegung zuzuordnen. Man Ray ist nicht klassifizierbar.

nombreuses revues des mouvements dada et surréaliste [*Littérature, Mécano, Merz, La Révolution Surréaliste, Le Surréalisme au service de la Révolution, Minotaure*, etc.]. Man Ray lui-même ne se considérait pas comme « dadaïste », bien que son œuvre, très certainement, ait été générée par un esprit dada. Il n'entre donc pas dans une catégorie particulière d'artistes, ni même dans un mouvement. Man Ray est inclassable.

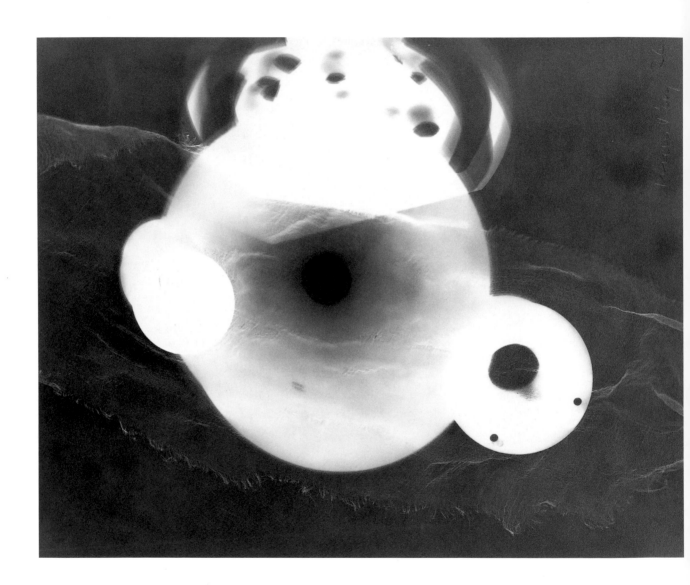

Rayograph
1926

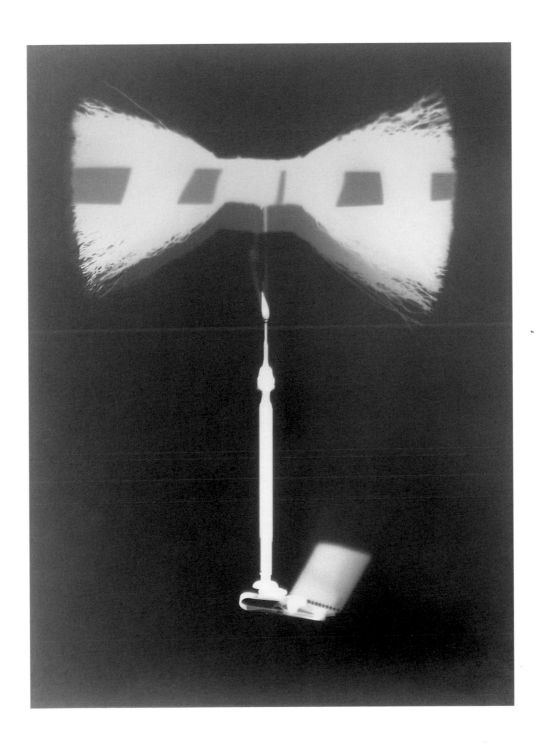

Rayograph
1921–22

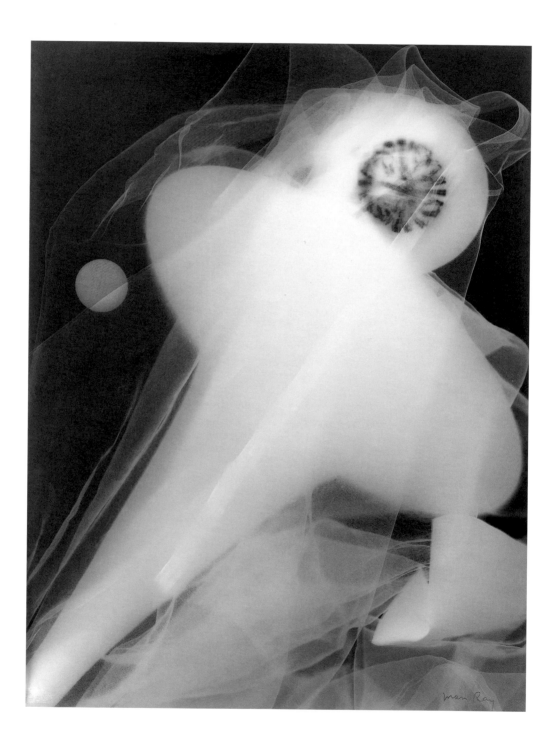

Rayograph
1925

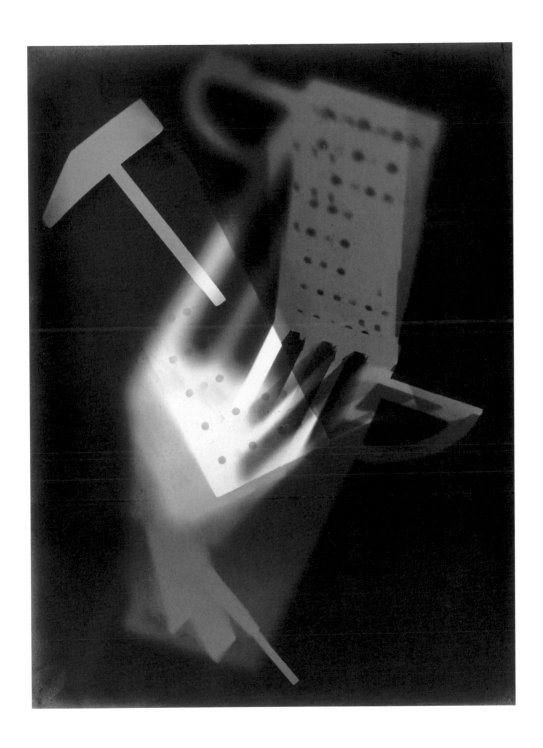

Rayograph
c. 1928

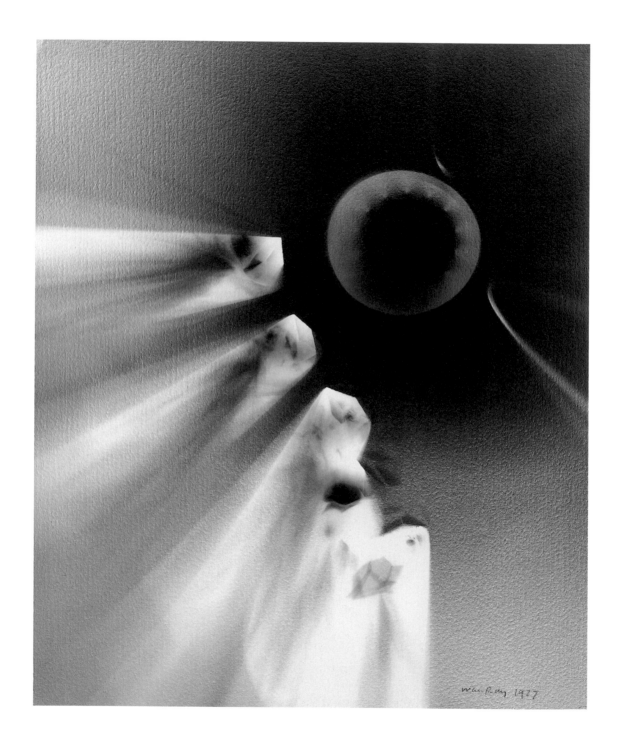

Rayograph
1927

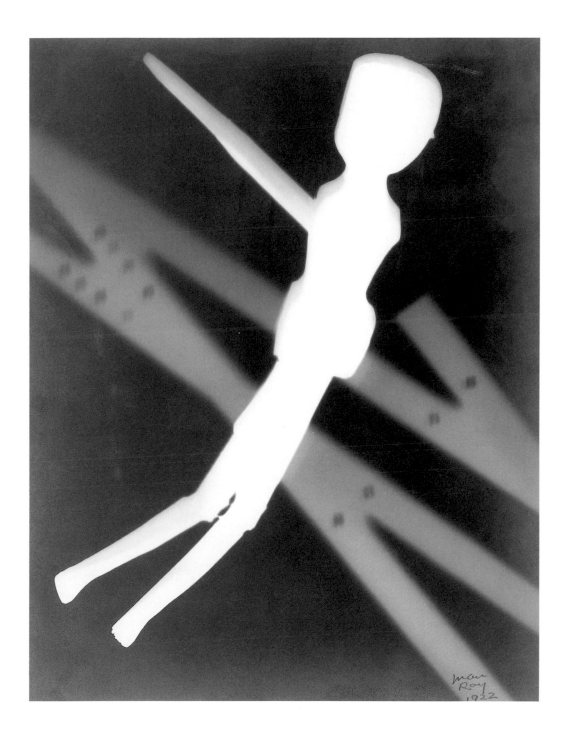

Rayograph
1922

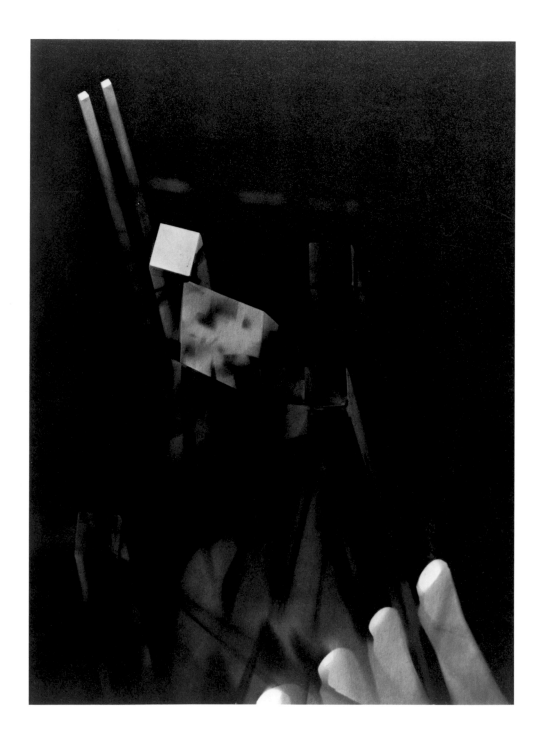

Rayograph
1922

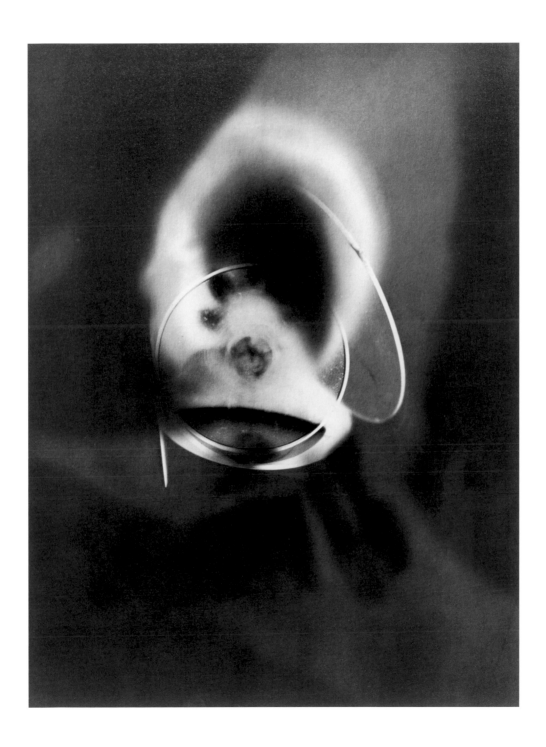

Rayograph
1922-23

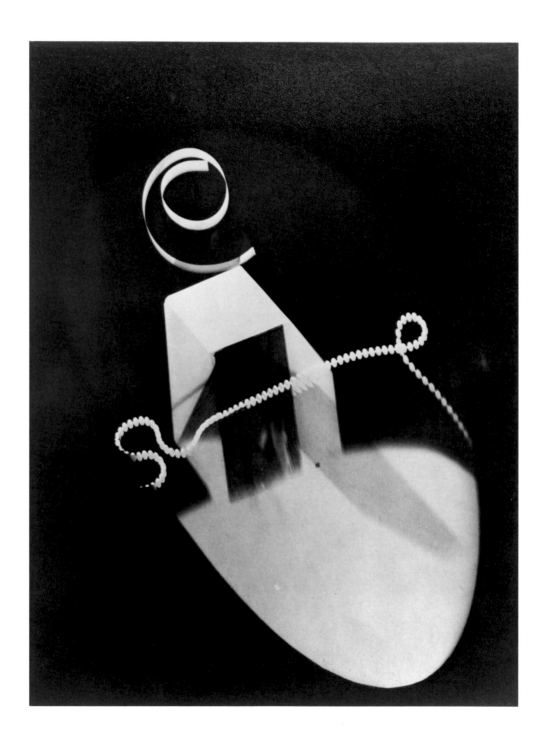

Rayograph
c. 1927

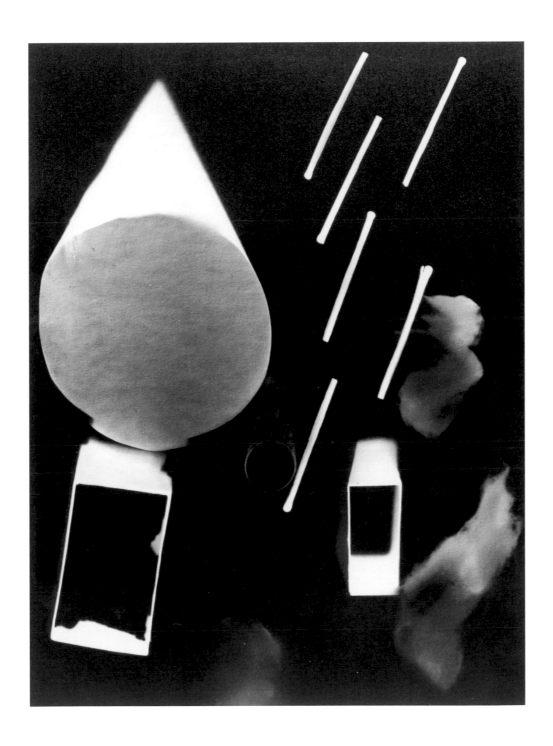

Rayograph
1925

Alles kann durch das Licht verändert, deformiert oder eliminiert werden.
Es ist genauso geschmeidig wie der Pinsel.

Everything can be transformed, deformed, and obliterated by light.
Its flexibility is precisely the same as the suppleness of the brush.

Tout peut être transformé, déformé, éliminé par la lumière. Sa souplesse est la
même que celle du pinceau, exactement.

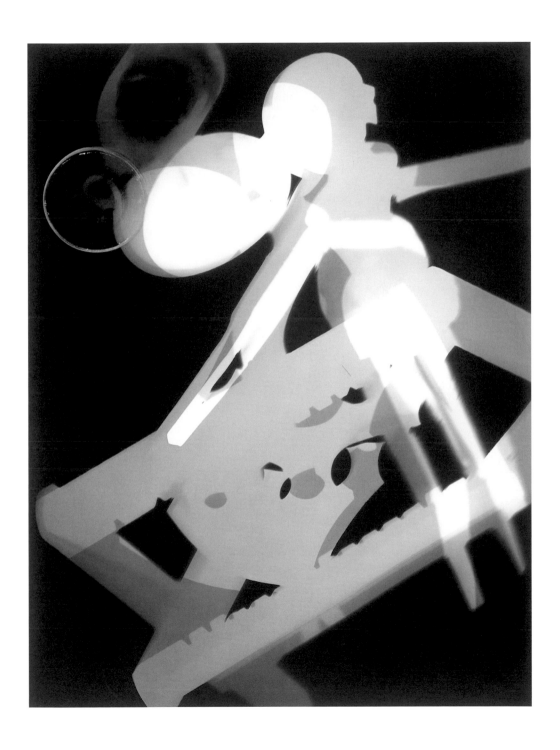

Rayograph
1925

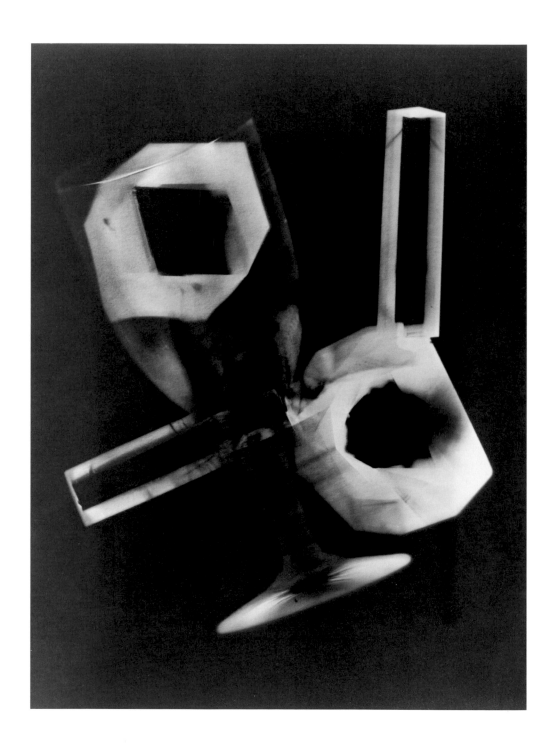

Rayograph
1925

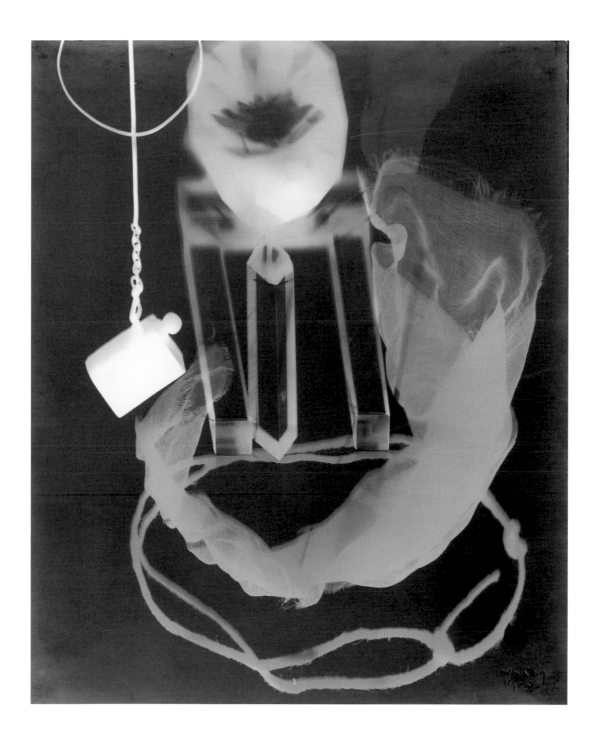

Rayograph
1923

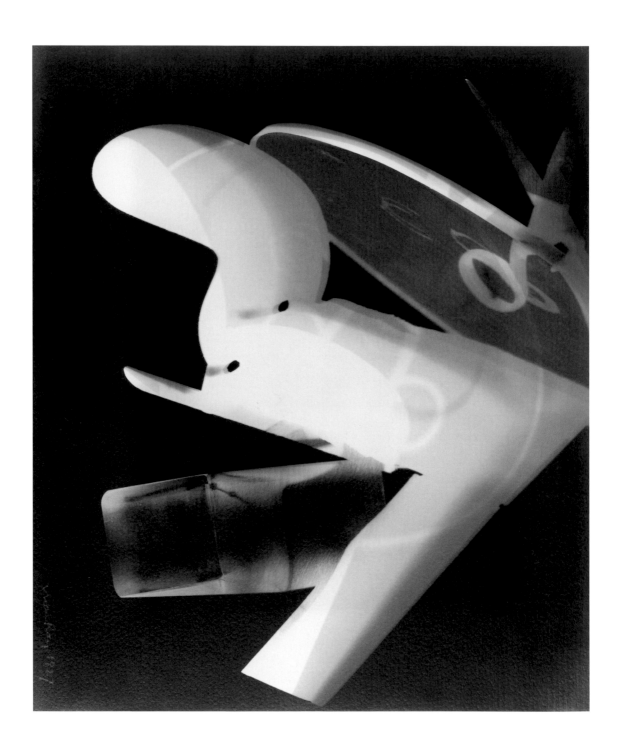

Rayograph
1927

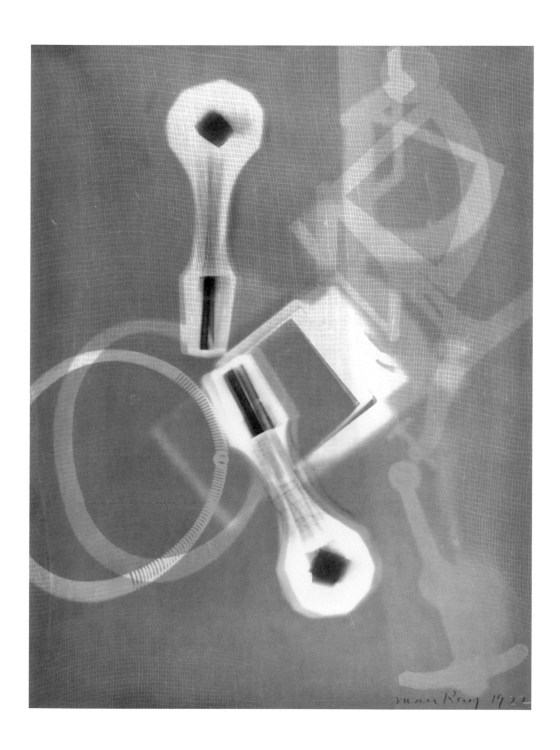

Rayograph
1922

Wie die unberührte Asche eines von Flammen verzehrten Objekts sind diese Bilder durch Licht und Chemikalien fixierte oxydierte Rückstände einer Erfahrung, eines Abenteuers, nicht eines Experiments. Sie gehen auf Neugier, auf Inspiration zurück, und diese Worte geben nicht vor, irgendeine Information vermitteln zu wollen.

Like the undisturbed ashes of an object consumed by flames these images are oxidized residues fixed by light and chemical elements of an experience, an adventure, not an experiment. They are the result of curiosity, inspiration, and these words do not pretend to convey any information.

Telles les cendres inertes d'un objet consumé par le feu, ces images forment des résidus oxydés dus à l'action de la lumière et des éléments chimiques, des vestiges d'une expérience vécue, d'une aventure, mais non pas d'une expérimentation. Elles ont pour origine la curiosité, l'inspiration – deux termes qui ne prétendent pas transmettre davantage de renseignements.

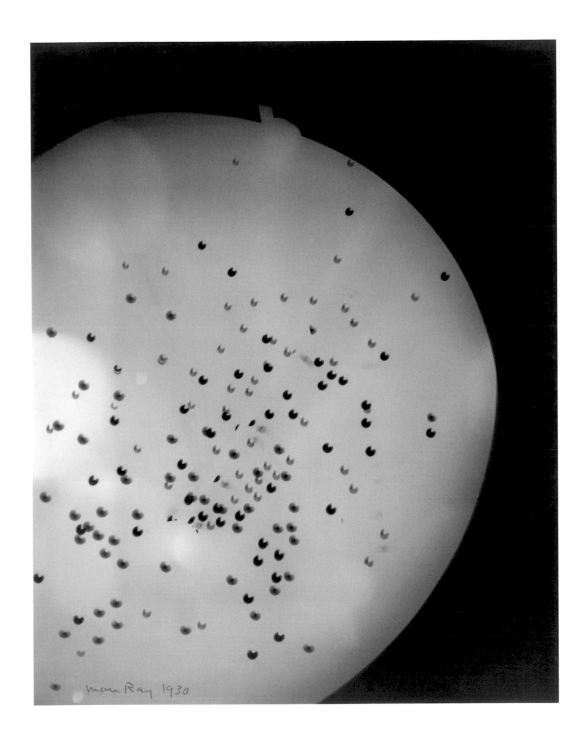

Rayograph
1930

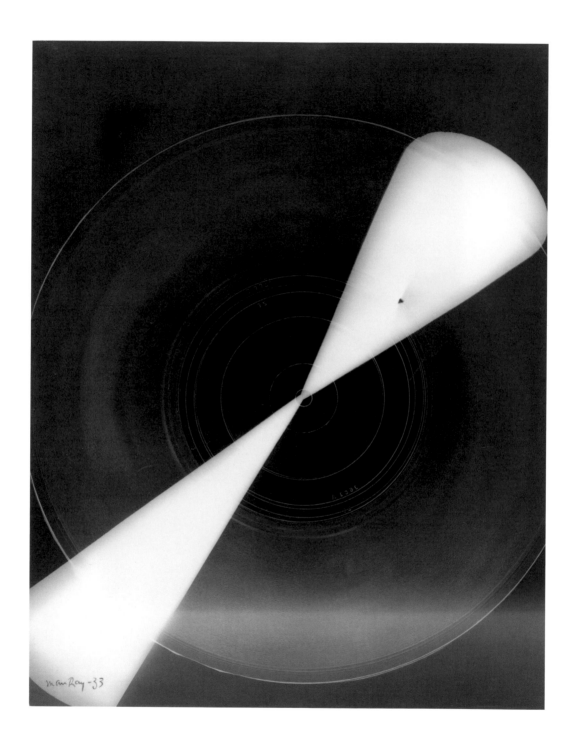

Rayograph
1933

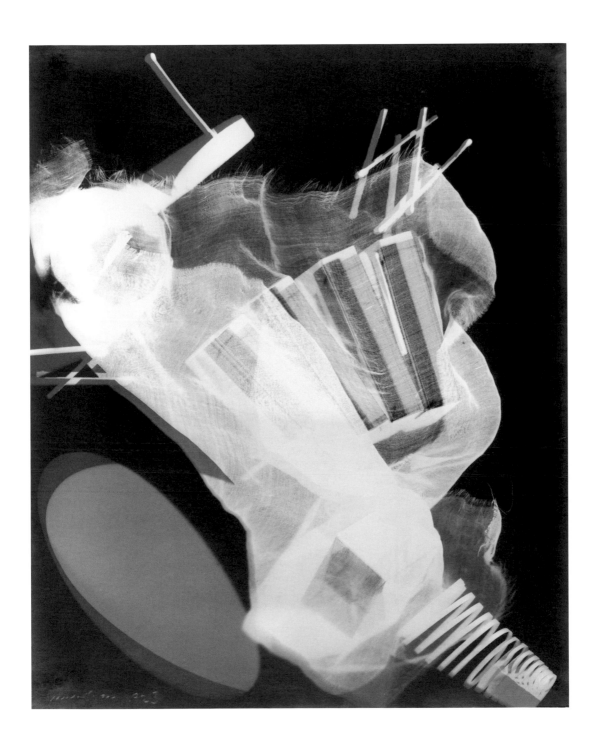

Rayograph
1922

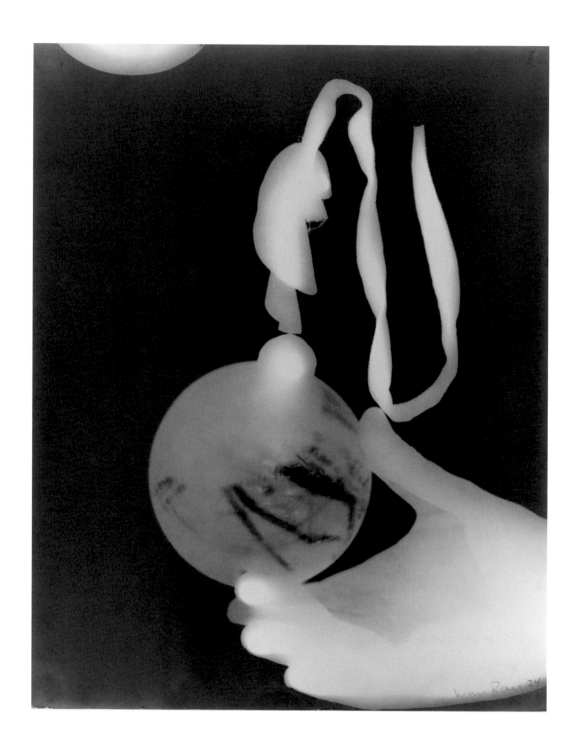

Rayograph
1924

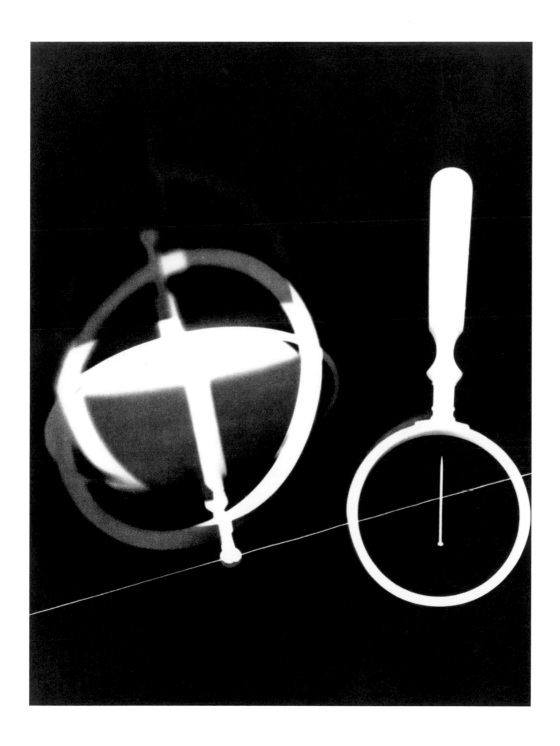

Rayograph
1922

Ist die Fotografie eine Kunst? Man muß nicht herausfinden, ob sie eine Kunst ist. Kunst ist überholt. Wir brauchen etwas anderes. Man muß sich nur anschauen, wie das Licht arbeitet. Das Licht ist schöpferisch. Ich setze mich vor mein empfindliches Blatt Papier und denke nach.

Is photography an art? There's no point trying to find out if it's an art. Art is a thing of the past. We need something else. You've got to watch light at work. It's light that creates. I sit down in front of my sheet of photographic paper and I think.

La photographie est-elle un art ? Il n'y a pas à chercher si c'est un art. L'art est dépassé. Il faut autre chose. Il faut regarder travailler la lumière. C'est la lumière qui crée. Je m'assieds devant ma feuille de papier sensible et je pense.

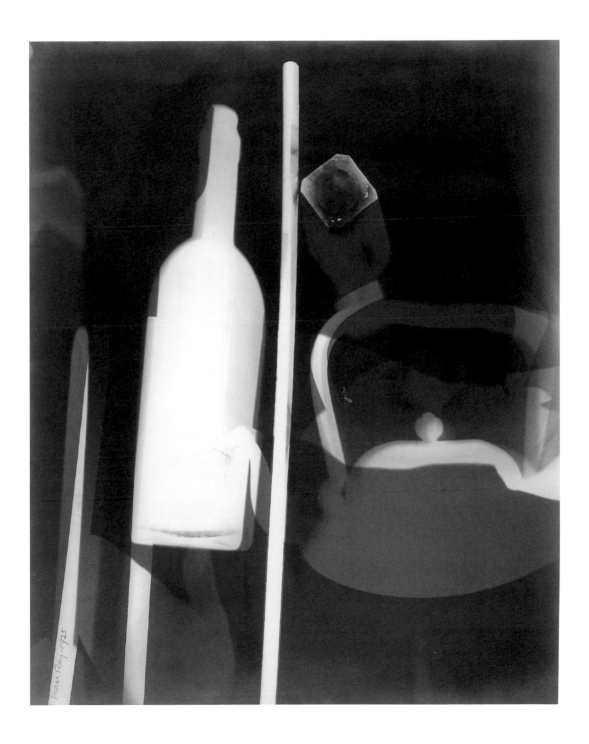

Rayograph
1925

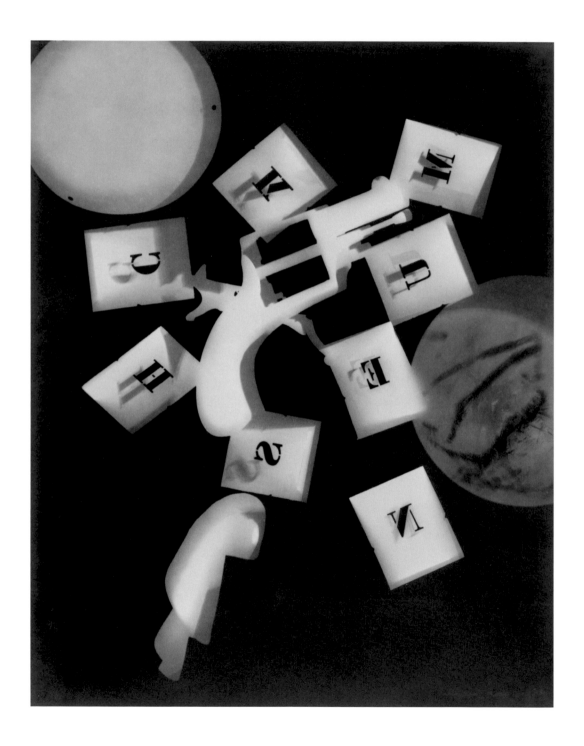

Rayograph
1924

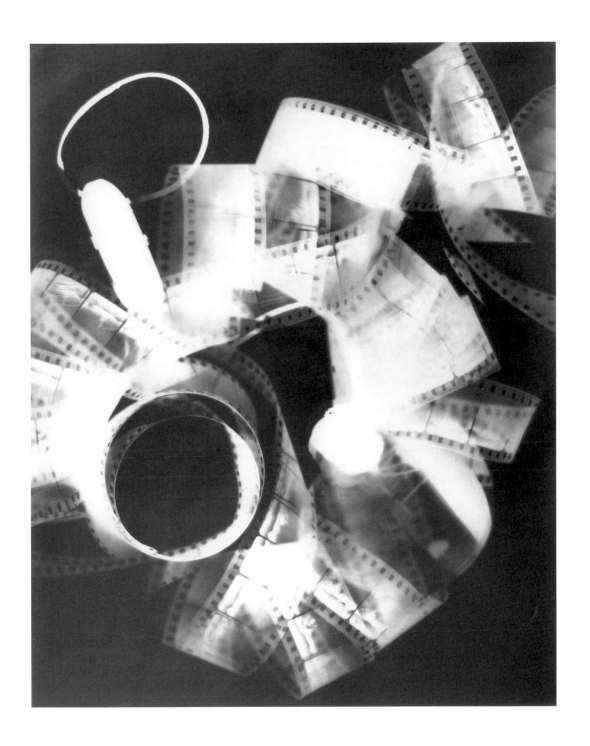

Rayograph
1930

Für mich gibt es keinen Unterschied zwischen Traum und Wirklichkeit. Ich weiß nie, ob das, was ich mache, ein Produkt des Traums oder des Wachseins ist.

For me there's no difference between dream and reality. I never know if what I'm doing is done when I'm dreaming or when I'm awake.

Pour moi, il n'y a pas de différence entre le rêve et la réalité. Je ne sais jamais si ce que je fais est le produit du rêve ou de l'éveil.

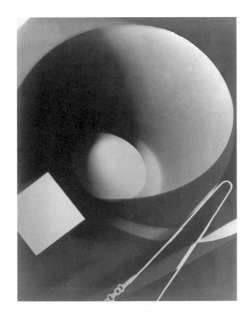
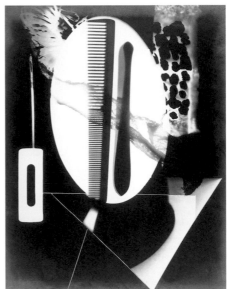
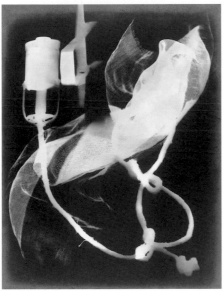
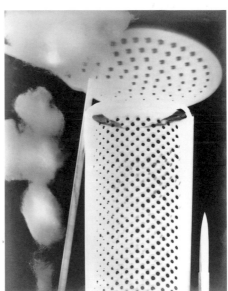

Champs délicieux
1922

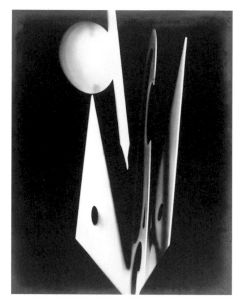

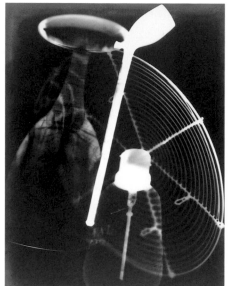

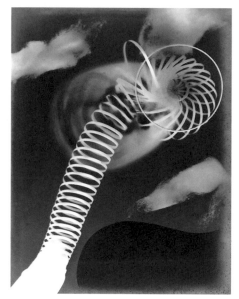

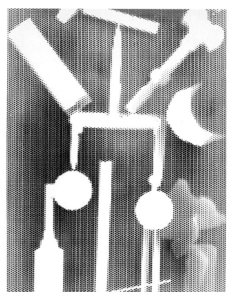

Champs délicieux
1922

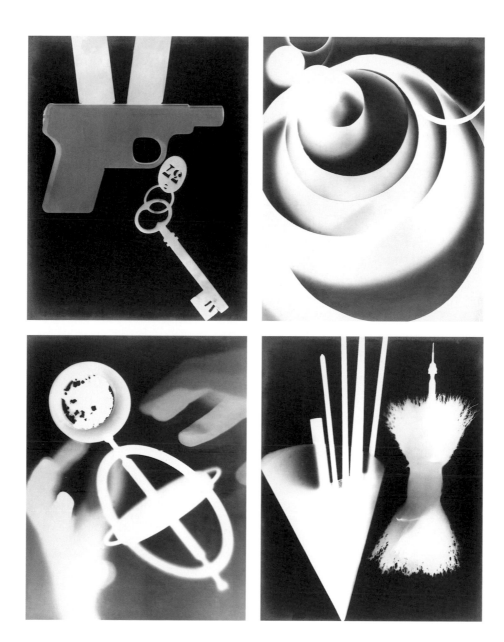

Champs délicieux
1922

Marcel Duchamp
1916

Jean Cocteau
1925

Constantin Brancusi
1933

Ich bleibe dabei: Die Fotografie ist keine Kunst.

I maintain that photography is not artistic.

Je persiste à croire que la photographie n'est pas de l'art.

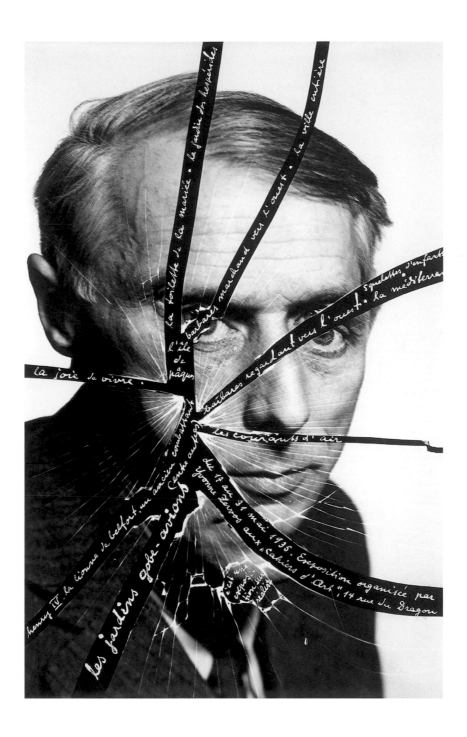

Max Ernst
c. 1934

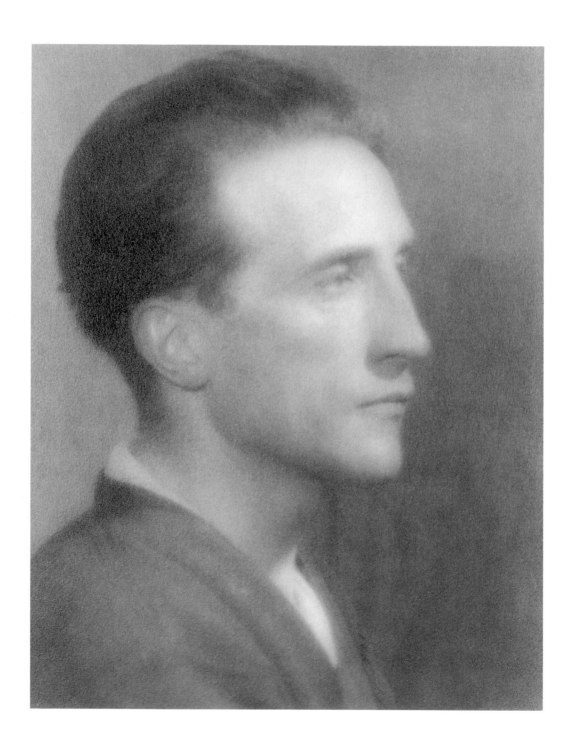

Marcel Duchamp
1920

James Joyce
1922

*Erst beim Fotografieren meiner Gemälde habe ich entdeckt, was in ihnen steckte,
und das kam erst bei der Schwarzweißreproduktion heraus. Eines Tages habe
ich das Gemälde zerstört und das Foto behalten. Seitdem überzeuge ich mich
immer wieder aufs neue, daß die Malerei ein veraltetes Ausdrucksmittel ist und
von der Fotografie entthront werden wird, sobald die visuelle Erziehung des
Publikums vollzogen ist.*

*It was when I photographed my canvases that I discovered the value they
acquired from black-and-white reproduction. One day I just destroyed the
picture and kept the proof. Ever since, I've been trying to convince myself
that painting is an outmoded type of expression, and that photography will
usurp it when the public has finally been visually educated.*

*C'est en photographiant mes toiles que j'ai découvert la valeur qu'elles pre-
naient à la reproduction en noir et blanc. Un jour est venu où j'ai détruit le
tableau et gardé l'épreuve. Depuis je n'ai cessé de me persuader que la peinture
est un moyen d'expression désuet et que la photographie la détrônera quand
l'éducation visuelle du public sera faite.*

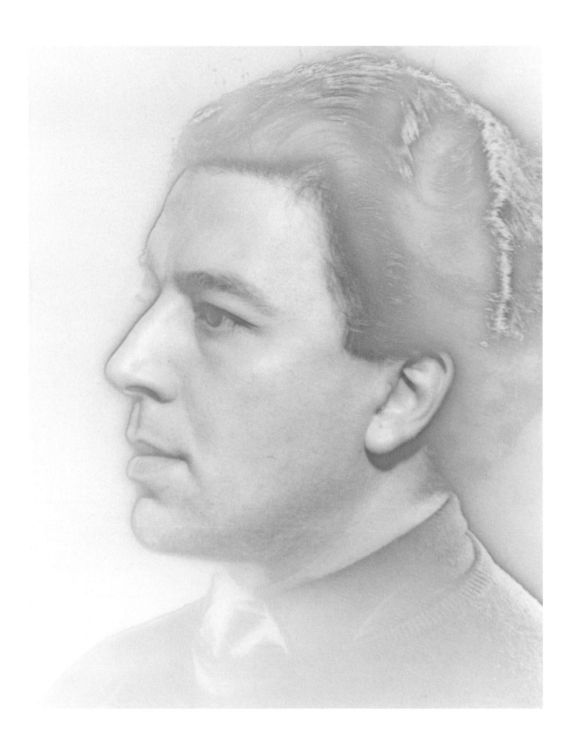

André Breton
c. 1930

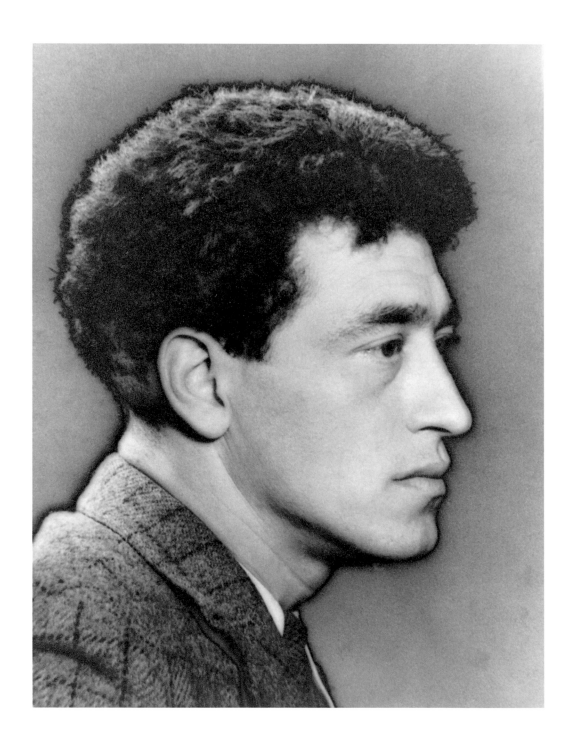

Alberto Giacometti
c. 1934

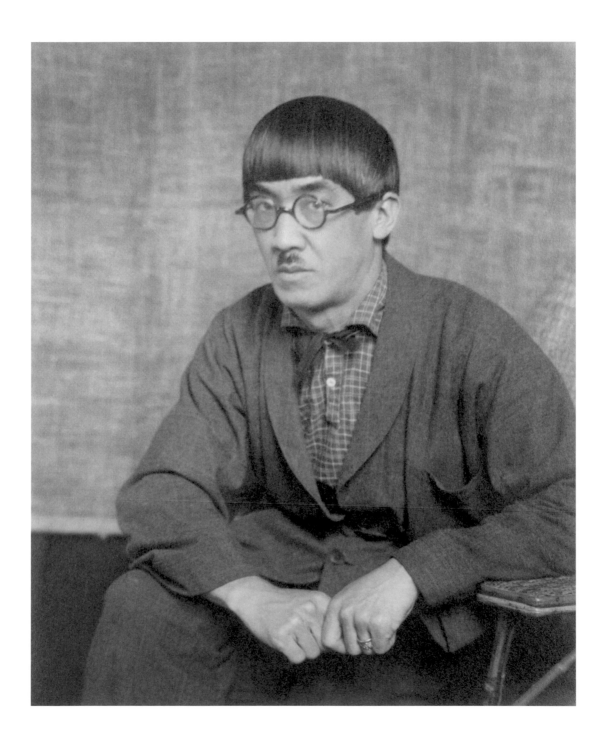

Tsugouharu Foujita
1922

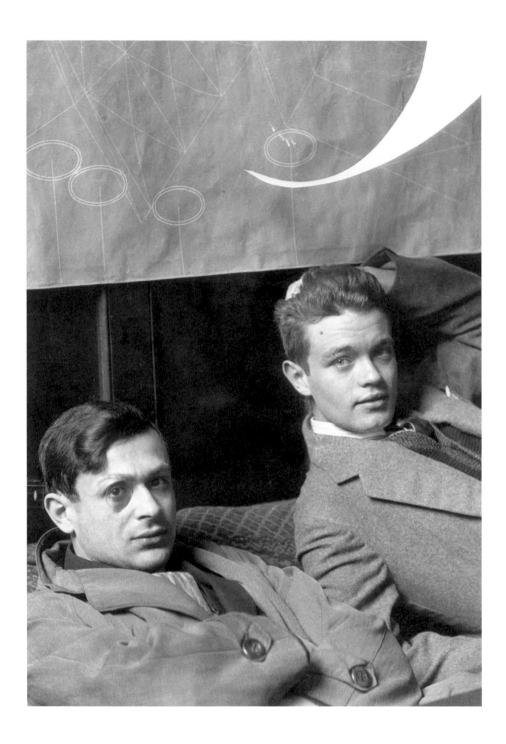

Tristan Tzara, René Crevel
1928

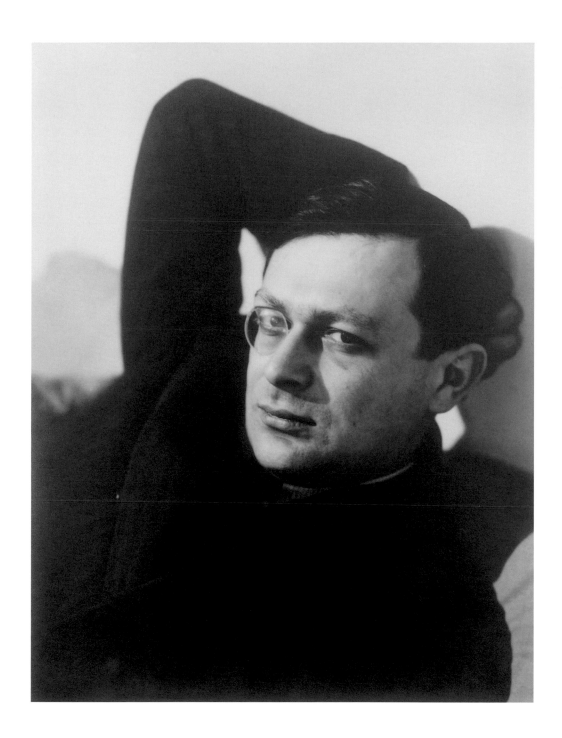

Tristan Tzara
1934

Ich kenne nur eines: die Möglichkeit, mich auf die eine oder andere Weise auszudrücken. Die Fotografie gibt mir diese Möglichkeit; sie ist ein sehr viel einfacheres und schnelleres Medium als die Malerei.

I know just one thing: how I express myself, in one way or another. Photography offers me the means, more simply and faster than painting.

Je ne connais qu'une chose : le moyen de m'exprimer d'une manière ou d'une autre. La photographie m'en donne le moyen, un moyen bien plus simple et bien plus rapide que la peinture.

Marcel Duchamp
1921

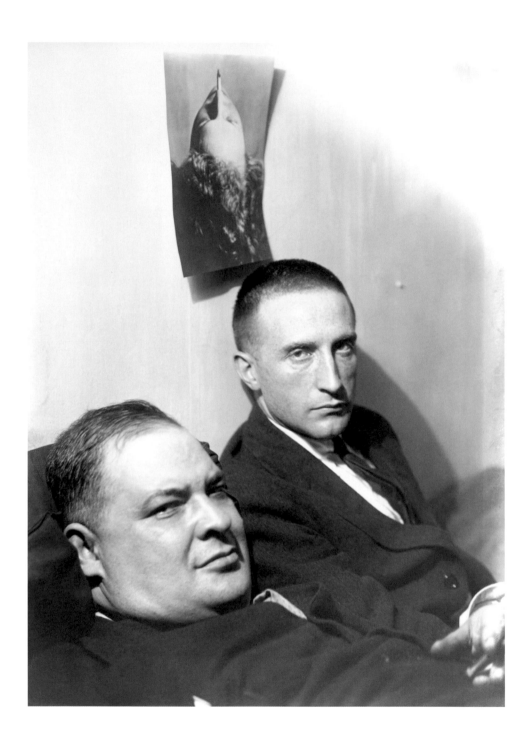

Joseph Stella, Marcel Duchamp
1920

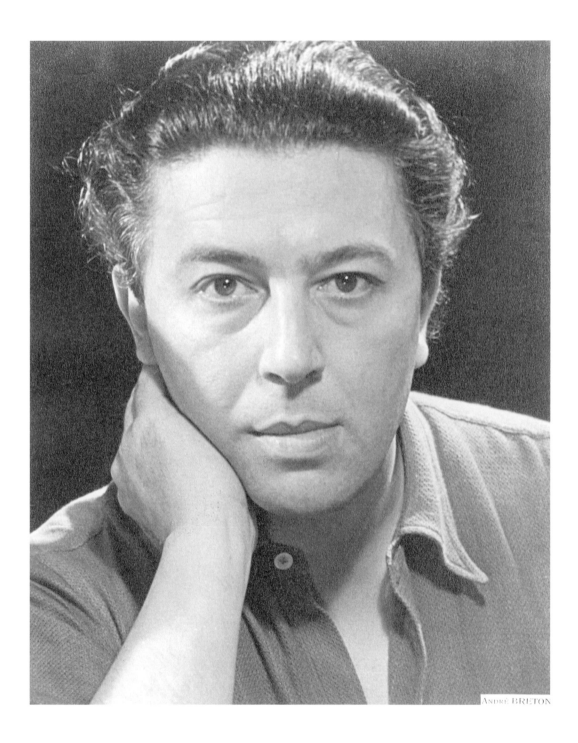

André Breton
c. 1930

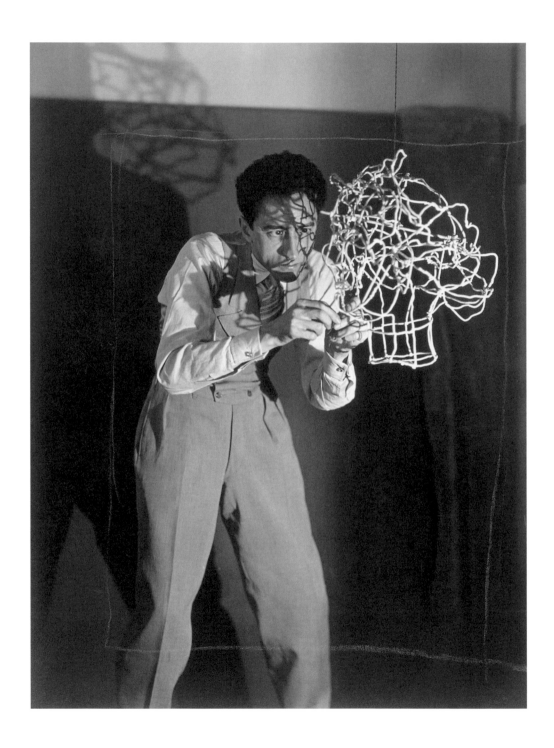

Jean Cocteau, sculpting his own Head in Wire
c. 1925

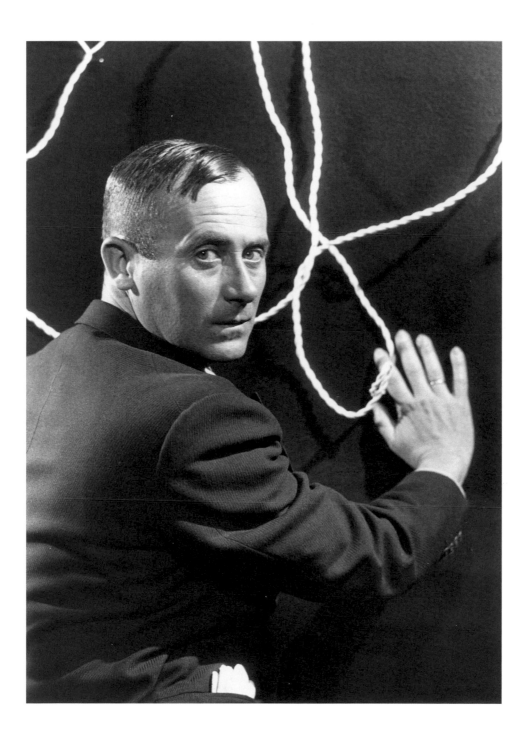

Joan Miró
c. 1930

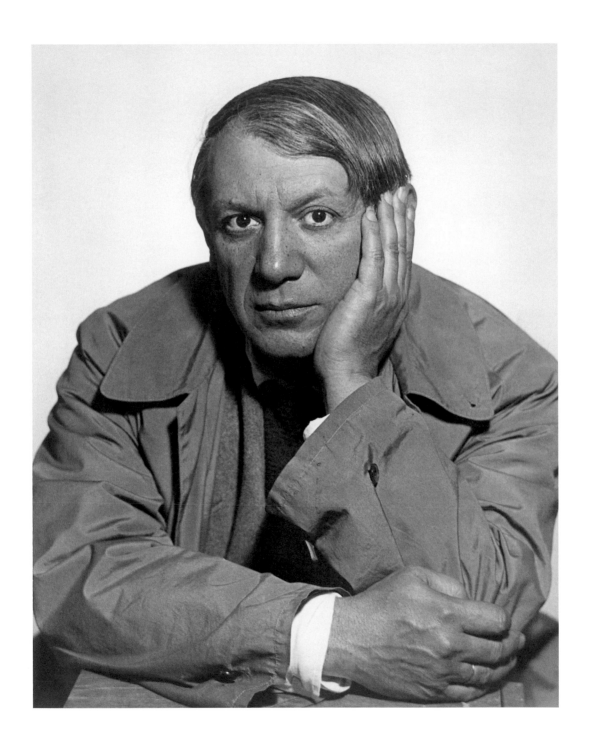

Pablo Picasso
1932

Biography
Biographie
Biographie

1890
Emmanuel Radnitzky born in Philadelphia on August 27.

1897
Family moves to Brooklyn.

1908
Graduates from high school. Offered scholarship to study architecture but decides to become an artist. Works in New York as a draftsman and graphic designer.

1910
Enrolls in life drawing classes at the National Academy of Design, New York. Visits the gallery of Alfred Stieglitz [1864–1946].

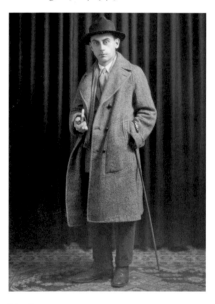

Man Ray
1920

1890
Emmanuel Radnitzky wird am 27. August Philadelphia geboren.

1897
Die Familie zieht nach Brooklyn.

1908
Er beendet die High-School. Ein Stipendium für ein Architekturstudium lehnt er ab, um Künstler zu werden.
Er arbeitet in New York als Zeichner und Grafiker.

1910
Er belegt Aktzeichenklassen an der National Academy of Design, New York. Er besucht die Galerie von Alfred Stieglitz [1864–1946].

1911
Er belegt Anatomiezeichenkurse an der Art Students' League in New York.

1912
Er studiert am Ferrer Center, New York. Er beginnt mit »Man Ray« zu signieren.

1913
Er besucht die *Armory Show* in New York. Er zieht in die Künstlerkolonie in Ridgefield, New Jersey, und lernt die belgische Schriftstellerin Adon Lacroix [1886–1980] kennen.

1914
Er heiratet Adon Lacroix. Um diese Zeit kauft er seine erste Kamera, um seine Gemälde zu fotografieren.

1915
Er lernt den Sammler Walter Arensberg [1878–1954] kennen, der ihn mit Marcel Duchamp [1887–1968] bekanntmacht. Erste Einzelausstellung

1890
Naissance d'Emmanuel Radnitzky à Philadelphie le 27 août.

1897
Déménagement de la famille à Brooklyn.

1908
Man Ray termine ses études secondaires. Il se voit offrir une bourse pour poursuivre des études d'architecture mais décide de devenir artiste. Travaille à New York comme dessinateur et graphiste.

1910
Suit des cours de dessin d'après nature à la National Academy of Design de New York. Fréquente la galerie d'Alfred Stieglitz [1864–1946].

1911
Suit des cours d'anatomie à l'Art Students' League de New York.

1912
Études au Ferrer Center à New York. Commence à signer ses œuvres sous le nom de «Man Ray».

1913
Voit l'*Armory Show* à New York. S'installe dans la petite colonie d'artistes de Ridgefield, dans le New Jersey. Rencontre la femme écrivain belge Adon Lacroix [1886–1980].

1914
Mariage avec Adon Lacroix. À cette époque, achète son premier appareil pour photographier ses peintures.

1915
Rencontre le collectionneur Walter Arensberg [1878–1954], qui lui présente Marcel Duchamp

1911

Attends anatomy classes at the Art Students' League, New York.

1912

Studies at the Ferrer Center, New York. Begins to sign work as "Man Ray".

1913

Visits Armory Show in New York. Moves to artists' colony in Ridgefield, New Jersey. Meets Belgian writer Adon Lacroix [1886–1980].

1914

Marries Adon Lacroix. About this time, acquires first camera to photograph his artworks.

1915

Meets the collector Walter Arensberg [1878–1954], who introduces him to Marcel Duchamp [1887–1968]. First one-man exhibition at the Daniel Gallery, New York. Moves back to New York.

1916

With Arensberg and Duchamp, founds the *Society of Independent Artists*. Second one-man exhibition at the Daniel Gallery.

1917

Society of Independent Artists exhibition held in New York. Creates aerographs, pictures made with an airbrush. The American photographer Alvin Langdon Coburn [1882–1966] begins making vortographs in London.

1919

Third one-man exhibition at the Daniel Gallery features aerographs. Separates from Lacroix.

1920

Joins with Duchamp and Katherine Dreier

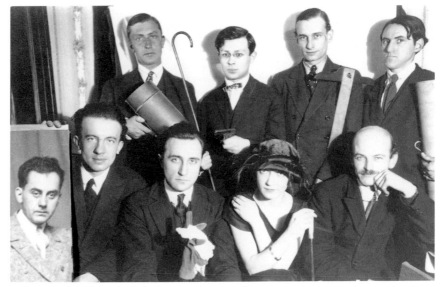

Dada group. Above, l. to r.: Paul Chadourne, Tristan Tzara, Philippe Soupault, Serge Chadourne. Below, l. to r.: Man Ray, Paul Eluard, Jacques Rigaut, Mick Soupault, Georges Riebemont-Dessaignes 1922

in der Daniel Gallery, New York. Er zieht zurück nach New York.

1916

Zusammen mit Arensberg und Duchamp gründet er die *Society of Independent Artists*. Zweite Einzelausstellung in der Daniel Gallery.

1917

Ausstellung der *Society of Independent Artists* in New York. Mit Hilfe einer Spritzpistole fertigt er Aerografien. Der amerikanische Fotograf Alvin Langdon Coburn [1882–1966] fertigt in London die ersten Vortografien.

[1887–1968]. Première exposition individuelle à la Daniel Gallery à New York. Retourne vivre à New York.

1916

Fondation de la *Society of Independent Artists* [Société des artistes indépendants] avec Arensberg et Duchamp. Seconde exposition individuelle à la Daniel Gallery.

1917

Exposition de la *Society of Independent Artists* à New York. Man Ray réalise des aérographes, c'est-à-dire des peintures au pistolet. Le photographe américain Alvin Langdon Coburn [1882–1966] commence à créer des «vortographes» à Londres.

[1877–1952] to establish the *Société Anonyme*, the first museum devoted to modern art. Begins freelance work for *Harper's Bazaar*, an association that continues until 1942. Exhibition of his photographs at the *Salon Dada: Exposition Internationale* in Paris.

1921

With Duchamp, publishes the sole issue of *New York Dada*. Duchamp leaves for Paris in June; Man Ray is able to follow in July. Duchamp introduces him to the Paris Dadaists, whom he photographs. Has a one-man show at Librairie Six. Meets and photographs Kiki [Alice Prin, 1901–53], who soon moves in with him.

1922

Decides to support himself by becoming a portrait photographer; begins to receive attention for his pictures of cultural luminaries. Tries his hand at fashion photography for designer Paul Poiret [1879–1944]. Makes first rayographs [cameraless photographs]. Full-page feature on rayographs in November issue of *Vanity Fair*. Publication of *Champs délicieux* [The delicious fields], a limited edition album of twelve rayographs with a preface by the Dada leader Tristan Tzara [1896–1963].

1923

Abbott becomes his darkroom assistant until 1926.

Paul Outerbridge: Man Ray
1926

1919

In der dritten Einzelausstellung in der Daniel Gallery werden Aerografien gezeigt. Man Ray trennt sich von Adon Lacroix.

1920

Zusammen mit Duchamp und Katherine Dreier [1877–1952] gründet er die Société *Anonyme*, um das erste amerikanische Museum für moderne Kunst aufzubauen. Beginn der Tätigkeit als freischaffender Fotograf für *Harper's Bazaar*, die er bis 1942 fortsetzt. Im *Salon Dada: Exposition Internationale* in Paris stellt er Fotografien aus.

1921

Zusammen mit Duchamp veröffentlicht er die einzige Ausgabe der Zeitschrift *New York Dada*. Duchamp reist im Juni nach Paris ab; Man Ray folgt ihm im Juli nach. Duchamp führt ihn in den Kreis der Pariser Dadaisten ein, die er fotografiert. Einzelausstellung in der Librairie Six. Er lernt Kiki [Alice Prin, 1901–1953] kennen, die er fotografiert und die bald zu ihm zieht.

1922

Er verdient seinen Lebensunterhalt als Porträtfotograf und gewinnt Anerkennung für seine Aufnahmen von Künstlern und prominenten Persönlichkeiten. Der Couturier Paul Poiret [1879–1944] engagiert ihn als Modefotografen. Die ersten Rayografien [ohne Kamera gefertigte Fotografien] entstehen. Ganzseitiger Beitrag über Rayografien in der Novemberausgabe von *Vanity Fair*. Er veröffentlicht *Champs délicieux* [Die köstlichen Felder], ein Album mit zwölf Rayografien und einem Vorwort von Tristan Tzara [1896–1963].

1923

Berenice Abbott wird seine Dunkelkammerassistentin [bis 1926]. In der Märzausgabe von Broom, für die er das Titelblatt gestaltet, und in der Dada-Zeitschrift *Littérature* veröffentlicht er Rayografien.

1924

André Breton [1896–1966] publiziert sein erstes Manifest des Surrealismus. *Le violon d'Ingres* wird in *Littérature* veröffentlicht. Modefotografien in französischen und amerikanischen Ausgaben von *Vogue*.

1925

Er nimmt an der ersten Ausstellung surrealistischer Kunst in der Galerie Pierre, Paris, teil.

1919

Troisième exposition individuelle à la Daniel Gallery, comprenant notamment des aérographes. Man Ray se sépare d'Adon Lacroix.

1920

Fonde avec Duchamp et Katherine Dreier [1877–1952] la *Société Anonyme*, premier musée entièrement consacré à l'art moderne. Commence à travailler en indépendant pour la revue *Harper's Bazaar*: cette collaboration durera jusqu'en 1942. Exposition de ses photographies au *Salon Dada: Exposition Internationale*, qui se tient à Paris.

1921

Il publie avec Duchamp le seul numéro de la revue *New York Dada*. Duchamp part pour Paris en juin; Man Ray le suit en juillet. Il est présenté par Duchamp aux dadaïstes parisiens qu'il prend en photo. Exposition individuelle à la Librairie Six. Rencontre Kiki [de son vrai nom Alice Prin, 1901–1953]. Il la photographie et ils se mettent bientôt en ménage.

1922

Man Ray décide de gagner sa vie en se spécialisant dans la photographie de portrait ; il commence à attirer l'attention par ses clichés de sommités. Il s'essaie à la photographie de mode pour le couturier Paul Poiret [1879–1944] et réalise ses premières rayographies [photographies sans appareil]. Article d'une page sur les rayographies dans le numéro de novembre de *Vanity Fair*. Publication des Champs délicieux, album de douze rayographies, préfacé par Tristan Tzara [1896–1963].

1923

Berenice Abbott devient son assistante jusqu'en 1926 et travaille pour lui dans la chambre noire. Publication de rayogrammes dans le numéro de mars de *Broom*, dont il conçoit la couverture, et dans la revue dada *Littérature*.

1924

Parution du premier Manifeste du surréalisme d'André Breton [1896–1966]. Parution de *Le Violon d'Ingres* dans la revue *Littérature*. Parution de photographies de mode dans les éditions française et américaine de *Vogue*.

1925

Participation à la première exposition d'art surréaliste à la Galerie Pierre à Paris.

Publishes rayographs in the March issue of *Broom*, for which he designs the cover, and in the Dada journal *Littérature*.

1924

André Breton [1896–1966] publishes Manifesto of Surrealism. *Le Violon d'Ingres* published in *Littérature*. Fashion photographs appear in French and American editions of *Vogue*.

1925

Participates in the first exhibition of Surrealist art at the Galerie Pierre, Paris.

1926

One-man exhibition at the Galerie Surréaliste. *Société Anonyme* exhibition at the Brooklyn Museum.

1926

Einzelausstellung in der Galerie Surréaliste. Teilnahme an der von der *Société Anonyme* organisierten Ausstellung im Brooklyn Museum, New York.

1927

Zu einer Ausstellung seiner Werke in der Daniel Gallery reist er nach New York.

1929

Er lernt Lee Miller [1907–1977] kennen, die seine Assistentin und Geliebte wird [bis 1932]. Einzelausstellung im Chicago Arts Club.

1930

Der Dadaist Georges Ribemont-Dessaignes

1926

Exposition individuelle à la Galerie Surréaliste. Participation à l'exposition de la *Société Anonyme* au musée de Brooklyn.

1927

Man Ray se rend à New York pour une exposition de son œuvre à la Daniel Gallery.

1929

Rencontre Lee Miller [1907–1977], qui sera son assistante et sa maîtresse jusqu'en 1932. Exposition individuelle au Chicago Arts Club.

1930

Publication à Paris d'une monographie sur Man Ray, signée par l'écrivain dadaïste Georges Ribemont-Dessaignes [1884–1974].

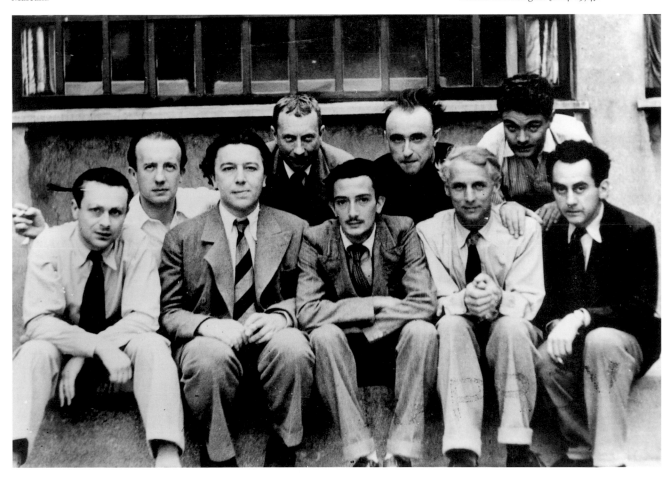

Surrealist group. Above, l. to r.: Paul Eluard, Jean [Hans] Arp, Yves Tanguy, René Crevel.
Below, l. to r.: Tristan Tzara, André Breton, Salvador Dalí, Max Ernst, Man Ray 1930

1927
Travels to New York for an exhibition of his work at the Daniel Gallery.

1929
Meets Lee Miller [1907–77], who becomes his assistant and lover until 1932. One-man show at the Chicago Arts Club.

1930
Monograph on Man Ray published in Paris by the Dadaist Georges Ribemont-Dessaignes [1884–1974].

1931
Publication of *Électricité*, a portfolio of ten gravure prints of rayographs commissioned by the Paris electric company CPDE [Compagnie Parisienne de Distribution d'Electricité].

1932
Work included in the *Surrealist Exhibition* at the Julien Levy Gallery, New York.

1934
Publication of *Photographs by Man Ray 1920 Paris 1934*, with 105 pictures by the artist.

1935
One-man exhibition of photographs at the Watsworth Atheneum in Hartford, Connecticut. Publication of *Facile*, poems by Paul Éluard [1895-1952] with thirteen photographs by Man Ray. Publishes "Sur le réalisme photographique" [On photographic realism] in *Cahiers d'art*.

1936
Buys a small house in Saint-Germain-en-Laye. Begins relationship [lasting until 1940] with Adrienne Fidelin [Ady]. Work shown in the *International Surrealist Exhibition* in London. Attends opening of *Fantastic Art, Dada, Surrealism* at the Museum of Modern Art, New York, exhibiting his own work in many media.

1937
Publishes *La photographie n'est pas l'art* [Photography is not art].

1938
Participates in *Exposition internationale du surréalisme* at the Galerie des Beaux-Arts, Paris.

1940
Leaves Europe for New York after the German occupation of Paris. After a short time there, travels

[1884–1974] veröffentlicht in Paris eine Monographie über Man Ray.

1931
Veröffentlichung von *Electricité*, einer Mappe mit zehn im Tiefdruckverfahren vervielfältigten Rayografien, die die Pariser Elektrizitätsgesellschaft CPDE [Compagnie Parisienne de Distribution d'Électricité] in Auftrag gegeben hatte.

1932
Er beteiligt sich an der *Surrealist Exhibition* in der Julien Levy Gallery, New York.

1934
Veröffentlichung von *Photographs by Man Ray 1920 Paris 1934* mit 105 Fotografien von Man Ray.

1935
Einzelausstellung von Fotografien im Watsworth Atheneum in Hartford, Connecticut. Veröffentlichung von *Facile*, einem Gedichtband von Paul Eluard [1895-1952] mit 13 Fotografien von Man Ray. In *Cahiers d'art* veröffentlicht er den Beitrag »Sur le réalisme photographique« [Über den fotografischen Realismus].

1936
Er kauft ein kleines Haus in Saint-Germain-en-Laye und geht eine Beziehung mit Adrienne Fidelin [Ady] ein, die bis 1940 andauert. Er beteiligt sich an der *International Surrealist Exhibition* in London. Er reist nach New York zur Eröffnung der Ausstellung *Fantastic Art, Dada, Surrealism* im Museum of Modern Art, an der er beteiligt ist.

1937
Er veröffentlicht *La photographie n'est pas l'art* [Die Fotografie ist keine Kunst].

1938
Er nimmt an der *Exposition internationale du surréalisme* in der Galerie des Beaux-Arts in Paris teil.

1940
Nach der Besetzung von Paris durch deutsche Truppen emigriert er nach New York, von wo aus er nach Los Angeles reist. Kurz nach seiner Ankunft lernt er in Hollywood Juliet Browner [1911–1991] kennen, mit der er bald darauf zusammenzieht.

1941
Einzelausstellung in der Frank Perls Gallery in Hollywood. In der Zeitschrift *California Arts and Architecture* veröffentlicht er den Beitrag »Art in Society«.

1931
Publication d'*Electricité*, recueil de dix gravures de rayographies commandé par la Compagnie Parisienne de Distribution d'Électricité [CPDE].

1932
Participation à la *Surrealist Exhibition* qui a lieu à la Julien Levy Gallery à New York.

1934
Publication de *Photographs by Man Ray 1920 Paris 1934*, comprenant 105 photographies de l'artiste.

1935
Exposition individuelle de photographies au Watsworth Atheneum de Hartford, dans le Connecticut. Publication de *Facile*, recueil de poèmes de Paul Éluard [1895-1952] accompagné de treize photographies de Man Ray. Publie « Sur le réalisme photographique » dans les *Cahiers d'art*.

1936
Man Ray achète une petite maison à Saint-Germain-en-Laye. Il entame une liaison [qui durera jusqu'en 1940] avec Adrienne Fidelin [dite Ady]. Participation à l'*International Surrealist Exhibition* qui s'ouvre à Londres. Inauguration de l'exposition *Fantastic Art, Dada, Surrealism* au Museum of Modern Art de New York, où il est représenté par des œuvres appartenant à plusieurs genres.

1937
Publie *La photographie n'est pas l'art*.

1938
Participation à l'*Exposition internationale du surréalisme* à la Galerie des Beaux-Arts à Paris.

1940
Man Ray quitte l'Europe pour New York après l'occupation de Paris par les Allemands, puis part pour Los Angeles. Rencontre Juliet Browner [1911–1991] quelques jours après son arrivée à Hollywood. Ils emménagent ensemble.

1941
Exposition individuelle à la Frank Perls Gallery de Hollywood. Publication de « Art in Society » dans la revue *California Arts and Architecture*.

1942
Exposition de photographies de portraits à la Frank Perls Gallery. Man Ray photographie Henry Miller [1891–1980].

to Los Angeles. Meets Juliet Browner [1911–1991] after a few days in Hollywood; the two soon take up residence together.

1941

One-man exhibition at Frank Perls Gallery in Hollywood. Publishes "Art in Society" in *California Arts and Architecture*.

1942

Exhibition of portrait photographs at Frank Perls Gallery. Photographs the author Henry Miller [1891–1980].

1943

Publishes "Photography Is Not Art" in *View*. A selection of five photographs appears in *Minicam Photography*.

1944

Retrospective exhibition at the Pasadena Art Institute.

1945

One-man exhibition at the Los Angeles Museum of History, Science, and Art. Solo exhibition at the Julien Levy Gallery, New York. Resumes connection with *Société Anonyme*.

1946

Marries Juliet Browner in a double ceremony with Max Ernst [1891–1976] and Dorothea Tanning [b. 1910].

1947

Man Ray visits France to secure his goods.

1948

Uses photographs of mathematical objects as basis for *Shakespearean Equations*, a series of paintings. One-man show opens at the William Copley Gallery in Beverly Hills. Awarded honorary Master of Fine Arts degree by Fremont University, Los Angeles.

1951

With Juliet, relocates to Paris.

1952–1957

Exhibits work in Los Angeles and Paris.

1958

Commissioned by Polaroid to work with their black-and-white film, resulting in the series *Unconcerned Photographs*. Experiments with color photography.

1942

Ausstellung von Porträtfotografien in der Frank Perls Gallery. Er fotografiert den Schriftsteller Henry Miller [1891–1980].

1943

In *View* veröffentlicht er den Beitrag »Photography Is Not Art«. In *Minicam Photography* erscheint eine Auswahl von fünf Fotografien.

1944

Retrospektive im Pasadena Art Institute.

1945

Einzelausstellung im Museum of History, Science, and Art in Los Angeles. Einzelausstellung in der Julien Levy Gallery, New York. Er nimmt die Verbindung mit der *Société Anonyme* wieder auf.

1946

Doppelhochzeit in Beverly Hills: Man Ray heiratet Juliet Browner, Max Ernst [1891–1976] Dorothea Tanning [geb. 1910].

1947

Man Ray reist nach Frankreich, um sich um seine dort zurückgelassene Habe zu kümmern.

1948

Auf der Grundlage von Fotografien mathematischer Modelle entsteht die Gemäldeserie *Shakespearean Equations* [Shakespearesche Gleichungen]. Einzelausstellung in der William Copley Gallery in Beverly Hills. Die Fremont University, Los Angeles, verleiht ihm ehrenhalber den Titel eines Master of Fine Arts.

1951

Er zieht mit Juliet wieder nach Paris.

1952–1957

Ausstellungen in Los Angeles und Paris.

1958

Aus seinen Experimenten mit Polaroid-Schwarzweißfilmen geht die Folge *Unconcerned Photographs* [Unbeteiligte Fotografien] hervor. Er experimentiert mit der Farbfotografie.

1959–1960

Ausstellungen in Los Angeles, Paris, New York und London.

1961

Auf der Biennale von Venedig wird er mit der Goldmedaille für Fotografie ausgezeichnet.

1943

Publication de «Photography Is Not Art» dans *View*. Reproduction d'un choix de cinq photographies dans *Minicam Photography*.

1944

Rétrospective de son œuvre à l'Art Institute de Pasadena.

1945

Exposition individuelle au Museum of History, Science, and Art de Los Angeles. Autre exposition individuelle à la Julien Levy Gallery à New York. Man Ray reprend contact avec la *Société Anonyme*.

1946

Man Ray épouse Juliet Browner, et Max Ernst [1891–1976] épouse Dorothea Tanning [née en 1910] lors d'une cérémonie commune.

1947

Man Ray se rend en France pour entreposer ses affaires.

1948

S'inspire de photographies d'objets mathématiques pour créer une série de tableaux intitulée *Shakespearean Equations* [Les Équatations de Shakespeare]. Exposition individuelle à la William Copley Gallery à Beverly Hills. Obtention d'une maîtrise honorifique en arts plastiques [honorary Master of Fine Arts degree] à la Fremont University de Los Angeles.

1951

Retour à Paris avec Juliet.

1952–1957

Expositions à Los Angeles et à Paris.

1958

Chargé par la firme Polaroid de travailler avec ses pellicules en noir et blanc. Cette commande aboutit à la série *Unconcerned Photographs* [Photographies étrangères]. Effectue des expériences sur la photographie en couleurs.

1959–1960

Expositions à Los Angeles, Paris, New York et Londres.

1961

Reçoit la médaille d'or à la Biennale de photographie de Venise.

1959–1960
Exhibits work in Los Angeles, Paris, New York, and London.

1961
Awarded a gold medal for photography at the Venice Photo Biennale.

1962
Retrospective exhibition at the Bibliothèque Nationale, Paris.

1963
Publication of autobiography, *Self Portrait*. Exhibition of rayographs in Stuttgart.

1964–1965
Exhibition of 31 *Objects of My Affection* in Italy and New York.

1966
Retrospective exhibition at the Los Angeles County Museum of Art. Publishes *Résurrection des mannequins* [Resurrection of the Mannequins].

1967
Awards Committee of the Philadelphia Arts Festival recognizes Man Ray for his accomplishments and the honor reflected upon his native city.

1968
Work included in two exhibitions at the Museum of Modern Art, New York: *Dada, Surrealism, and their Heritage* and *The Machine as Seen at the End of the Mechanical Age*.

1970
Oggetti d'affezione [Objects of my affection] published.

1971
Traveling retrospective exhibition shown in Rotterdam, Paris, and Humlebaek, Denmark.

1972
Exhibition *Man Ray* shown at the Musée national d'art moderne in Paris.

1974
Eighty-fifth birthday exhibition held at the Cultural Center, New York.

1976
Dies in Paris on November 18.

1962
Retrospektive in der Bibliothèque Nationale, Paris.

1963
Er veröffentlicht seine Autobiographie Self Portrait. Ausstellung von Rayografien in Stuttgart.

1964–1965
In Italien und New York werden 31 *Objects of My Affection* [Objekte meiner Zuneigung] ausgestellt.

1966
Retrospektive im Los Angeles County Museum of Art. Er veröffentlicht *Résurrection des mannequins* [Auferstehung der Mannequins].

1967
Das Preiskomitee des Philadelphia Arts Festival würdigt Man Ray als verdienstvollen Sohn der Stadt.

1968
Beteiligung an zwei Ausstellungen im Museum of Modern Art, New York: *Dada, Surrealism, and their Heritage* und *The Machine as Seen at the End of the Mechanical Age*.

1970
Oggetti d'affezione [Objekte meiner Zuneigung] wird veröffentlicht.

1971
Retrospektive in Rotterdam. Weitere Stationen: Paris und Humlebaek, Dänemark.

1972
Ausstellung *Man Ray* im Musée national d'art moderne in Paris.

1974
Ausstellung anläßlich seines 85. Geburtstags im Cultural Center, New York.

1976
Man Ray stirbt am 18. November in Paris.

1962
Rétrospective de son œuvre à la Bibliothèque Nationale à Paris.

1963
Publication de son autobiographie, *Self Portrait*. Exposition de rayographies à Stuttgart.

1964–1965
Exposition de 31 *Objects of My Affection* [Objets de mon affection] en Italie et à New York.

1966
Rétrospective de son œuvre au Los Angeles County Museum of Art. Publication du livre *Résurrection des mannequins*.

1967
Le jury du Festival des arts de Philadelphie récompense Man Ray pour son œuvre et le rayonnement de sa ville natale auquel il a ainsi contribué.

1968
Présentation d'œuvres diverses dans deux expositions au Museum of Modern Art à New York : *Dada, Surrealism, and their Heritage* et *The Machine as Seen at the End of the Mechanical Age*.

1970
Publication d'*Oggetti d'affezione* [Objets de mon affection].

1971
Une rétrospective de son œuvre est présentée successivement à Rotterdam, Paris et Humlebaek, au Danemark.

1972
Exposition *Man Ray* au Musée national d'art moderne à Paris.

1974
Exposition célébrant les quatre-vingt-cinq ans de l'artiste au Cultural Center de New York.

1976
Le 18 novembre, Man Ray meurt à Paris.

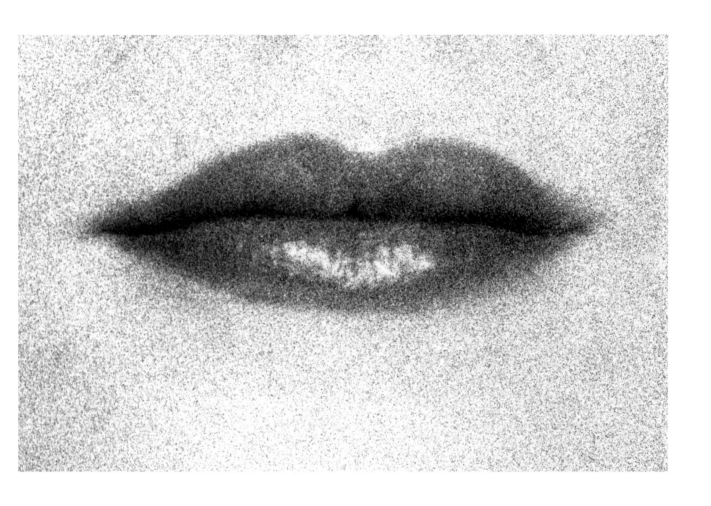

Untitled
c. 1930

Bibliography
Bibliographie
Bibliographie

Books by Man Ray
Bücher von Man Ray
Livres d'Man Ray

1922
Champs Délicieux, 12 rayographies, introduction by Tristan Tzara, Paris [Société générale d'imprimerie et d'édition].

1931
Electricité, with a preface by Pierre Bost, Paris [Compagnie parisienne de distribution d'électricité].

1934
Man Ray, Paul Eluard, André Breton, Rrose Sélavy, Tristan Tzara. *Photographs by Man Ray 1920 Paris 1934*, Hartford, Conn. [James Thrall Soby]. Unabridged republication: New York [Dover Publications] 1979.

1937
Man Ray, *La photographie n'est pas l'art*, with a preface by André Breton, Paris [GLM].

1963
Man Ray , *Self Portrait*, Boston [Little Brown]; German translation: *Selbstporträt*, Munich [Schirmer/Mosel]; French translation: *Autoportrait*, Paris [Belfond].

Books on Man Ray
Bücher über Man Ray
Livres sur Man Ray

1930
Georges Ribemont-Dessaignes, *Man Ray*, Paris [Gallimard, collection Peintres nouveaux].

1963
L. Fritz Gruber, *Man Ray, Portraits*, Paris [Editions Prisma].

1970
Rayograph, edited by Giulio Carlo Argan, Turin [Martano].

1972
Pierre Bourgeade, *Bonsoir, Man Ray*, Paris [Belfond].

1975
Roland Penrose, *Man Ray*, London [Thames and Hudson]; New York [Graphic Society]; Paris [Editions du Chêne].

1977
Arturo Schwarz, *Man Ray, Il rigore dell'imaginazione*, Mailand [Feltrinelli]; English edition: *The Rigour of Imagination*, New York [Rizzoli].

1980
Janus, *Man Ray: The Photographic Image*, London [Gordon Fraser; English edition of *L'immagine fotografica*, La Biennale di Venezia, Venice 1977].

Serge Bramly, *Man Ray, Les grands photographes*, Paris [Belfond].

1988
Neil Baldwin, *Man Ray, American artist*, New York [Clarkson N. Potter].

1990
Neil Baldwin, *Man Ray*, Paris [Plon] 1990.

Janus, *Man Ray, Œuvres 1909–1972*, Paris [Celiv].

Exhibition Catalogues
Ausstellungskataloge
Catalogues d'expositions

1966
Man Ray, with a text by André Breton, Los Angeles County Museum.

1971
Man Ray: *60 anni di libertà, 60 années de liberté, 60 years of liberties*, Milan, Galleria Schwarz.

1972
Man Ray, with a text by Alain Jouffroy, Paris, Museé d'Art Moderne.

1981
Man Ray photographe, with an introduction by Jean-Hubert Martin, Paris, Musée national d'art moderne, Centre Georges Pompidou [Philippe Sers]; German edition: *Man Ray Photograph*, Munich [Schirmer/Mosel].

1988
Perpetual Motif, The Art of Man Ray, texts by Merry Foresta, Stephen C. Foster, Billy Klüver, Julie Martin, Francis Naumann, Sansra S. Phillips, Roger Shattuck, Elizabeth Hutton Turner, Washington, National Museum of American Art, Smithsonian Institution, New York [Abbeville Press]; French edition: *Man Ray*, Paris [Gallimard] 1989.

1989
Man Ray's Paris Portraits: 1921–39, with a text by Timothy Baum, New York, Middendorf Gallery.

1990
Man Ray in Fashion, texts by Merry Foresta, Willis Hartshorn, John Esten, New York, International Center of Photography.

1994-95
Man Ray's Man Rays, texts by Christina Orr-Cahall, David F. Setford, Florida, Norton Museum of Art.

1996
Man Ray Photographien, 1890-1976, texts by Rudolf Kicken, Wendy Grossman, L. Fritz Gruber, Klaus Honnef, Kunsthaus Wien, Munich [Hirmer].

Man Ray, Paris-LA, texts by R. Berman, Tom Patchett, Dickran Tashjian, Los Angeles, Track 16 Gallery/Robert Berman Gallery [Smart Art Press].

Man Ray. La costruzione dei sensi, texts by Daniela Palazzoli, Arturo Schwarz, Janus, Turin, Galleria Civica d'Arte Moderna [Fabbri Editori].

1998
Man Ray, La Photographie à l'envers, exhibition and catalogue organized and edited by Emmanuelle de l'Ecotais and Alain Sayag, Paris, Musée national d'art moderne, Centre Georges Pompidou [Le Seuil]; English edition: *Man Ray, Photography and its double*, New York [Gingko Press]; German edition: *Man Ray, Das Photographische Werk*, Munich [Schirmer/Mosel].

Notes

1] The English translation *Surrealism and Painting* was published *1972* by Mcdonald and Co., London. Original French publication: André Breton, Le Surréalisme et la Peinture, in: La Révolution Surréaliste, no. 9–10, Paris, 1. October 1927, pp. 41–42.

2] Marcel Duchamp, Interview with James Johnson Sweeney, quoted by Michel Sanouillet, in: *Duchamp du signe*, nouvelle édition, Paris, Flammarion, 1975, p. 171.

3] Marcel Duchamp, op.cit., p. 171.

4] Marcel Duchamp, op.cit., p. 179.

5] On this subject, cf. *La photographie à l'envers*, Musée national d'art moderne, Centre Georges Pompidou, Paris [Le Seuil] 1998. English edition: *Man Ray, Photography and its Double*, New York [Gingko Press] 1998.

6] Man Ray, "L'Âge de la Lumière", in: *Minotaure*, 1933, nffl 3-4, p. 1.

7] In 1834-35 onward, William Henry Fox Talbot [1800–1877] produced imprints of objects on silver chloride photographic paper which he called "photogenic drawings".

8] Floris M. Neusüss and Renate Heyne, in: *László Moholy-Nagy, compositions lumineuses, 1922–1943*, Paris, Musée national d'art moderne, Centre Georges Pompidou, 1995, pp. 14–15.

9] Op.cit.

10] Man Ray, *Self Portrait*, New York 1963, p. 130.

11] A. Breton, *Exposition Dada Max Ernst*, Paris, Au Sans Pareil, 1921.

12] *Élevage de poussière* [Dust Breeding] is a title given by Marcel Duchamp much later on. The photo appeared for the first time in October 1922 in issue no. 5 of *Littérature* under the title: "Voici le domaine de Rrose Sélavy/Comme il est aride – comme il est fertile – /comme il est joyeux – comme il est triste!" [Here is the estate of Rrose Sélavy/How arid it is – how fertile it is – /How joyous it is – How sad it is!] and signed "Vue prise en aéroplane par Man Ray" ["View taken in an aeroplane by Man Ray"], which lent his technical work an acrobatic aspect, and fooled the reader for whom the geometric drawing appearing beneath the dust turned into the boundary lines of the fields of an "estate" – Rrose Sélavy's estate.

13] In "Corpus delicti", in: *Le Photographique, Pour une Théorie des Ecarts*, Paris, Macula, 1990, p. 164-165.

Anmerkungen

1] Die deutsche Übersetzung *Der Surrealismus und die Malerei* erschien 1967 im Propyläen Verlag, Berlin, S. 33–38. Die französische Originalfassung wurde veröffentlicht in: *La Révolution Surréaliste*, Nr. 9–10, 1. Oktober 1927, S. 41–42.

2] Marcel Duchamp, Gespräch mit James Johnson Sweeney, wiedergegeben von Michel Sanouillet in: *Duchamp du signe*, nouvelle édition, Paris [Flammarion], 1975, S. 171.

3] Marcel Duchamp, op.cit., S. 171.

4] Marcel Duchamp, op.cit., S. 179.

5] Siehe hierzu *La photographie à l'envers*, Centre Georges Pompidou [Le Seuil], Paris, 1998.

6] Man Ray, »L'Âge de la Lumière«, in: Minotaure, 1933, Nr. 3-4, S. 1.

7] William Henry Fox Talbot [1800-1877] stellte 1834/35 Abdrücke von Gegenständen auf lichtempfindlichem Silberchloridpapier her, die er »fotogenische Zeichnungen« nannte.

8] Floris M. Neusüss and Renate Heyne, in: *László Moholy-Nagy, compositions lumineuses, 1922–1943*, Centre Georges Pompidou, Paris, 1995, S. 14-15.

9] Op.cit.

10] *Man Ray, Selbstporträt. Eine illustrierte Autobiographie*, München 1983, S. 126.

11] André Breton, *Exposition Dada Max Ernst*, Paris [Au Sans Pareil] 1921.

12] Den Titel *Élevage de poussière* (Staubzucht) hat Marcel Duchamp dem Foto später gegeben. Die Arbeit war zum ersten Mal im Oktober 1922 in der Nr. 5 der Zeitschrift *Littérature* erschienen, unter dem Titel: »Dies ist das Reich von Rrose Sélavy / Wie ist es trocken - wie ist es fruchtbar - / Wie ist es fröhlich – wie ist es traurig!« und mit der Unterschrift »Aufnahme aus dem Flugzeug von Man Ray«, womit er dem technischen Aspekt seiner Arbeit etwas Akrobatisches verlieh und den Betrachter irreführte, für den die geometrische Zeichnung, die unter dem Staub aufscheint, zu Grenzlinien eines Feldes auf einem Gutshof wurde, zu einer »Domäne«, der von Rrose Sélavy.

13] In »Corpus delicti«, in: *Le Photographique, Pour une Théorie des Ecarts*, Paris [Macula] 1990, S. 164-165.

Notes

1] André Breton, «Le Surréalisme et la Peinture», dans *La Révolution Surréaliste*, n° 9 –10, 1ᵉʳ octobre *1927*, pp. 41–42. Autre édition : André Breton, *Le Surréalisme et la Peinture*, Paris [Gallimard], *1965*.

2] Marcel Duchamp, Entretien avec James Johnson Sweeney, repris par Michel Sanouillet dans : *Duchamp du signe*, nouvelle édition, Paris [Flammarion] 1975, p. 171.

3] Ibidem

4] Ibidem

5] Voir à ce sujet *La photographie à l'envers*, Musée national d'art moderne, Centre Georges Pompidou Paris [Le Seuil] 1998.

6] Man Ray, «L'Âge de la Lumière», dans : *Minotaure*, 1933, n° 3-4, p. 1.

7] William Henry Fox Talbot [1800-1877] réalisa dès 1834-1835 des empreintes d'objets sur du papier sensibilisé au chlorure d'argent qu'il intitula «dessins photogéniques».

8] Floris M. Neusüss et Renate Heyne, dans : *Laszlo Moholy-Nagy, compositions lumineuses, 1922–1943*, Paris, Centre Georges Pompidou, 1995, pp. 14-15.

9] Ibidem

10] Man Ray, *Autoportrait*, Paris 1963, p. 120.

11] A. Breton, *Exposition Dada Max Ernst*, Paris [Au Sans Pareil] 1921.

12] *Élevage de poussière* est un titre donné par Marcel Duchamp beaucoup plus tard. La photo paraît pour la première fois en octobre 1922 dans le numéro 5 de *Littérature*, sous le titre : «Voici le domaine de Rrose Sélavy / Comme il est aride – comme il est fertile – / comme il est joyeux – comme il est triste!» et signée «Vue prise en aéroplane par Man Ray», ce qui donnait à son travail technique l'aspect d'une acrobatie, et trompait le lecteur pour lequel le dessin géométrique apparent sous la poussière devenait les lignes de délimitation des champs d'un «domaine», celui de Rrose Sélavy.

13] Dans «Corpus delicti», dans : *Le Photographique, Pour une Théorie des Écarts*, Paris [Macula] 1990, p. 164–165.

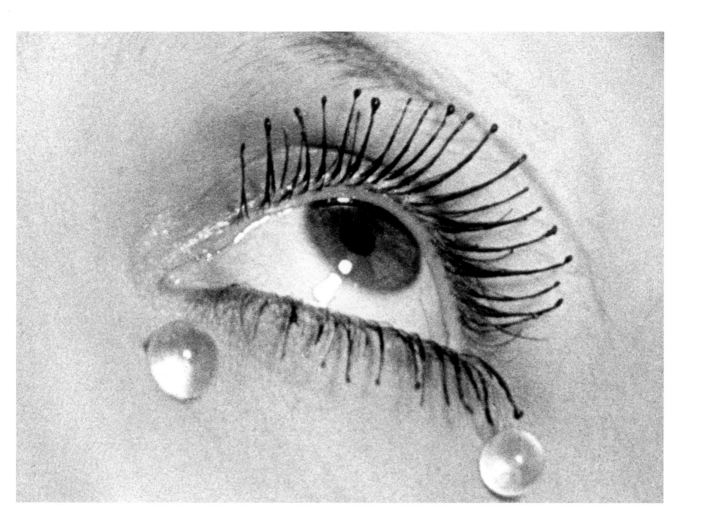

Les Larmes
c. 1932

Front cover:
Untitled, 1931

Back cover:
Les Arums, 1930

To stay informed about upcoming TASCHEN titles, please
request our magazine at www.taschen.com or write to
TASCHEN, Hohenzollernring 53, D–50672 Cologne,
Germany, Fax: +49-221-254919. We will be happy to send
you a free copy of our magazine which is filled with information
about all of our books.

© 2004 TASCHEN GmbH
Hohenzollernring 53, D-50672 Köln
www.taschen.com

Original edition: © 1999 Benedikt Taschen Verlag GmbH
Editor: Manfred Heiting, Amsterdam
Layout: Manfred Heiting, Amsterdam
Typography and cover design: Sense / Net,
Andy Disl and Birgit Reber, Cologne
Editorial coordination: Bettina Ruhrberg, Cologne
Conception of the photo series: Manfred Heiting, Amsterdam,
and Simone Philippi, Cologne
German translation: Wolfgang Himmelberg, Düsseldorf
French translation: Frédéric Maurin, Paris
© 2004 Man Ray Trust, Paris/VG Bild-Kunst, Bonn
© Text 2000 Emmanuelle de l'Ecotais, Paris
2000 Katherine Ware, Philadelphia

Printed in Italy
ISBN 3-8228-3483-1

The publishers wish to thank the Museums and
Private Collections for granting permission to
reproduce works and for their support in the
making of this book.

Der Verlag dankt den Museen und Privatsamm-
lungen für die erteilten Reproduktions Genehmi-
gungen und ihre freundliche Unterstützung bei
der Realisierung dieses Buches.

La maison d'édition remercie les musées et les
collections privées de leur authorisation pour la
reproduction des œuvres et de leur aimable
soutien lors de la réalisation de ce livre.

The J. Paul Getty Museum,
Los Angeles:
p. 8|10|20|56|60|65|69|120|124|
127|139|166|167|169|172|173|174|175|
177|178|179|184|185|201|208|212/213/214.

Musée national d'art moderne, Centre Georges
Pompidou:
p. 12|13|47|54|55|115|119|122|123|
183|187|188|189.

Collection Michael Senft, New York:
p. 17|82|24|49|101|105|110|111|117|121|129|130|138|
160|161|162|163|165|180|196|200|203|207.

Collection Alain Paviot, Paris:
p. 18|19|23|70|72|73|125|134|193|209.

Collection Virginia L. Green, New York:
p.140|141|142|143|144|145|146|147.

Ray Hawkins Gallery,
Santa Monica: p. 215.

Private collections:
Cover/back cover /
p. 2|7|11|21|25|26|27|29|30|31|32|33|35|36|37|38|39|
41|42|43|44|45|48|50|51|53|57|58|61|62|63|64|66|68|
71|91|102|103|104|106|108|109|113|114|118|
126|131|132|133|135|137|152|164|168|171|181|191|192|
195|197|199|202|205|206|211|219.